LANDSCAPE GRAPHICS

Plan, Section, and Perspective Drawing of Landscape Spaces

Revised Edition

Grant W. Reid FASLA

Special thanks to:

EDAW, Inc., Fort Collins, Colorado, for professional illustrations on pages 6, 25, 45, 59, 109, 156, 167, 168, 169, 180, 181, 182, 183.

Winston Associates, Inc., Boulder, Colorado, for professional illustrations on page 11.

Colorado State University students Jordan Mestas, Jeromy Montano, and Matt Wittman for their assistance with illustrations.

Editor: Elizabeth Wright
Designer: Sivan Earnest
Production Manager: Ellen Greene
Text set in 9 point Univers 45 Light

First edition published in 1987 in New York by Whitney Library of Design, an imprint of Watson-Guptill Publications.
Revised edition published in 2002 by Watson-Guptill Publications, a division of VNU Business Media, Inc.,
770 Broadway, New York, NY 10003
www.watsonguptill.com

Library of Congress Control Number: 2002110266

ISBN: 0-8230-7333-5

Printed in the U.S.A.

First printing, 2002

2 3 4 5 6 7 8 9 / 10 09 08 07 06 05 04 03

Biography

Grant W. Reid was born in New Zealand where he completed a Bachelors of Horticultural Science at the University of Canterbury in 1965. He received his Masters of Landscape Architecture from the University of California, Berkeley, in 1969. For seven years he worked with landscape architects in the San Francisco Bay Area and in New Zealand as a park planner. In 1976 he returned to the USA to take up his current position in the Department of Horticulture and Landscape Architecture at Colorado State University, where he is a tenured full professor. Since 1978 he has also operated his own landscape architectural consulting business called Grant Reid Designs, specializing in garden design. In 1987 he passed the national licensing exam for landscape architects and is registered in the state of Kansas with license #479. Apart from this book, he also authored the book *From Concept to Form*.

Contents

Foreword

Landscape Graphics is an instructional book. The emphasis is on easy, timesaving techniques. The format is how to. Although directed primarily to the person just taking up landscape design, it also contains techniques and reference material that will be of value to established professionals who wish to refine their graphic skills.

The language of landscape graphic communication is too extensive to cover in one book. For that reason, the focus here is exclusively on black-and-white techniques. In addition, simplified techniques are featured instead of complex ones. For example, there are more technical and perhaps more accurate methods of perspective drawing than those shown here. But the ones demonstrated in this book have the advantage of simplicity and comprehensibility.

The very important area of computer graphics is touched very lightly here. The computer is now able to perform many graphic tasks, which were formerly done only by hand, including some manual techniques described here. Yet computer graphics is far too specialized a subject for inclusion in a basic book like this one.

There will always be a need for landscape architects who can draw well and fast. Graphic instructional aids are, at best, only twenty percent of the learning process. The rest is confidence and practice. Improved graphic skills will have a positive effect on your ability to develop creative design ideas and on your success at selling those ideas. It is up to you. Accept the challenge; practice a lot and have fun doing it.

How to Use This Book

If you are a beginning student or a graphics instructor, you will get the most out of this book if you study each chapter, then try the exercises at the end of the chapter. You might choose which exercises are most relevant to your goals and existing skill level rather than doing every exercise. The sequence of chapters has a logical progression to give you the necessary skills to proceed to the next chapter. Similarly the exercises at the end of each chapter progress from basic to more challenging. It will be more rewarding if you roughly follow these progressions. The professional or more advanced student may wish to skip some sections that are too easy or of little interest, in order to speed up your learning and enjoyment.

All of the principles and techniques discussed in the book are adaptable to both the Imperial (English) and the Metric systems of measurement. Wherever measurements occur, the Imperial numbers and units are given first, followed by the appropriate Metric numbers and units in parenthesis. e.g., 5 feet (1.5 meters).

Keep in mind that most of the black-and-white techniques discussed and illustrated can be adapted to color rendering techniques. The reader should practice quick color applications concurrently with each section studied. Some excellent color rendering books are listed in the bibliography. Also in the bibliography you will find reference to publications on freehand sketching. These would make good companions to this book.

Graphic Language and the Design Process

Designers generally follow a logical process to get from the germ of an idea to a finished, installed landscape. The exact number and sequence of steps vary considerably depending on the project type and the people involved. In this book we will consider the process as four broad phases.

Program development
Inventory and analysis
Design development
Construction documentation

In practice, the design process is often a little disorderly. Depending on the project, a phase may be skipped or repeated. Also, these phases tend to overlap or blend into each other. Keeping this in mind, we will look at various stages in the design process and deal with the type of graphic communication that is typical for that stage. These graphic and written products are generated to record, externalize and communicate ideas and information. They may range from simple, rough sketches to complex construction details.

Program development

Content and purpose
Program development is a research and information gathering phase in which data is collected from owners, developers, administrators or users. The social, political, financial, and personal characteristics of a project are established at this stage. The focus is on facts, attitudes, needs, constraints and opportunities.

Graphic character and media
Programs are often comprised of notes, completed questionnaires, budgets and other logically organized written materials. Drawings are seldom needed.

Inventory and analysis

Content and purpose
At this stage the landscape design professional gathers and records information on the physical characteristics of a site, such as its property lines and building dimensions, vegetation, topography, soils, climate, drainage, views, and other pertinent factors. The objective recording of site data is called an **inventory**. Interpretation of this data and the addition of subjective evaluations constitute a **site analysis**. This information, together with the written program, are the basic guidelines for the succeeding design steps.

Graphic character and media
Sometimes the inventory and analysis are separate graphic sheets; sometimes they are combined. In all cases they are accurate, clear, and comprehensive plan view drawings that explain existing site conditions, constraints and potential.

For small sites, the inventory and analysis may be done with pencil on vellum or graph paper and are usually heavily annotated. Felt tip pen on marker paper is also appropriate. Tape measures, topographic surveying equipment and a camera are essential tools for recording site characteristics. Larger sites may require a series of maps drawn with manual or computer-aided drafting methods. Video-, computer- and satellite-imaging techniques may also be necessary. Very complex site analyses are best done with computer manipulation of the various layers of data.

For small-scale landscape projects, graphic materials are generally for the designer's use only, so the graphics are unpolished and utilitarian in character and consist of site specific notes, arrows, and rough abstract symbols. On regional scale projects the data may be presented as detailed computer printouts since it usually analyzed by a design team and reviewed by the client.

Inventories

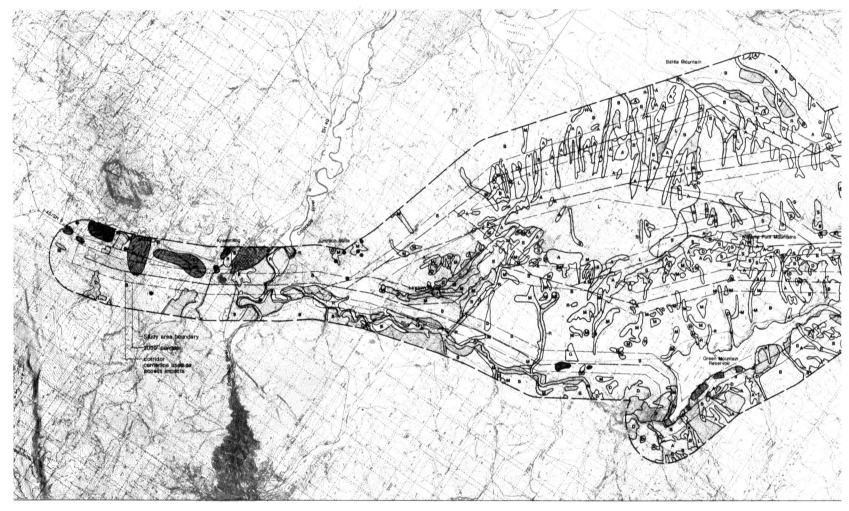

US Department of Energy
Western Area Power Administration

Blue River·Gore Pass Transmission Line

Figure 4-6
Vegetation

Shrub Types

B Big Sagebrush

M Mountain Shrub

Forest Types

A Aspen

S Spruce/Fir

D Douglas-fir/Forest

J Douglas-fir/Juniper

L Lodgepole Pine

Other

R Riparian/Wetland
(forest, shrub & herbaceous)

Urban

Disturbed

Threatend or Endangered
Plant Species (under consid-
eration for federal listing)

Plant Association of
State Interest

Plant Species of State Interest

Herbaceous Types

G Grassland (meadow)

Agriculture

Sources

• Aerial Photography
 - SE of Lawson Ridge: USFS color
 photography, 1'-550', Sept. '81.
 - NW of Lawson Ridge, Tri-State
 color photography, 1:20,000,
 about 1979
• Field Observations
• Colorado Natural Heritage Inventory
• Bureau of Land Management

0 1 2 5 km

0 1 2 5 mi

Site Analysis

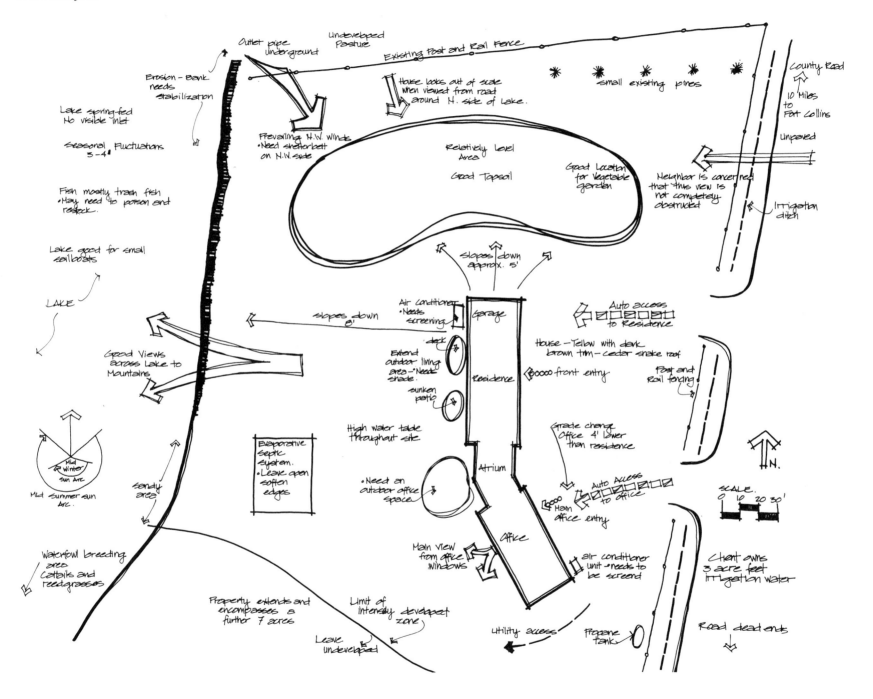

Design development

The largest proportion of the graphics in this book deals with products and techniques applicable to this phase of design. It is helpful to break the design development phase into two main steps: **conceptual design** and **preliminary design**. Although at times they may flow together seamlessly, each step has its own purpose and a different graphic expression.

Conceptual design

Content and purpose

Here is where the earliest spatial design ideas begin to develop. The graphic products at this stage can be called **functional diagrams, concept plans** or **schematic plans**. Their main purpose is to explore functional relationships.

Graphic character and media

For small projects, conceptual plans are usually very fast, rough abstract drawings for the designer's eyes only. On larger and more complex landscape projects, the graphics need to be a little more flashy since they could be reviewed by other designers and the client for early feedback. The drawings begin as honest, open, rough freehand drawings that may appear to be just creative scribbles and jumbled diagrams. They are loose, approximate, and should look like the decision-making, idea-development, conflict-resolution drawings they are. Too much polish at this stage can stifle the goal of encouraging change. These are all drawings that should suggest more drawings. Simple plan view diagrams, quick sections or perspectives, and even cartoon-like drawings are appropriate. See the section on **conceptual diagramming** in Chapter Four.

For lower budget projects, soft pencils or felt tip pens on trace paper are effective media. Higher budget projects may take advantage of colored markers on marker paper to project a more vivid image. In both cases, the drawings should remain tentative yet vigorous and powerful so as to invite change.

Concept Plan

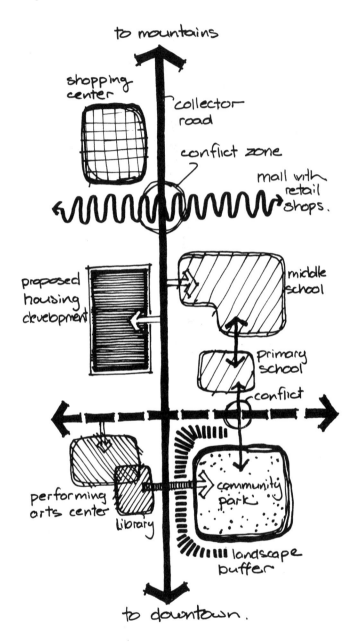

Concept Plan

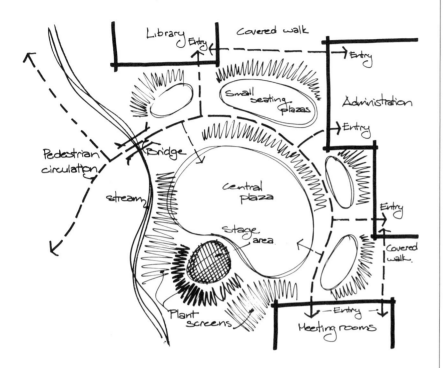

Library
Entry
Covered walk
Entry
Administration
Small seating plazas
Entry
Pedestrian circulation
Bridge
stream
central plaza
Entry
Covered walk
stage area
Plant screens
Entry
Meeting rooms

Schematic Plan

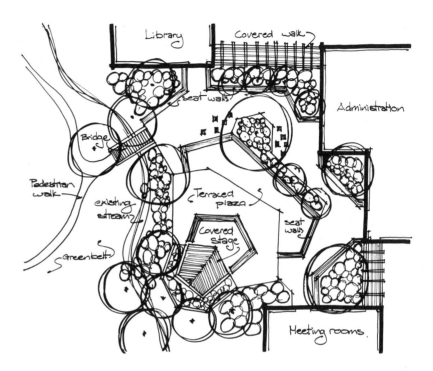

Library
Covered walk
seat walls
Administration
Bridge
Pedestrian walk
existing stream
Terraced plaza
seat walls
greenbelt
Covered stage
Meeting rooms

Preliminary design

Content and purpose

As the ideas from the previous design stage are refined to integrate all the various social, environmental, economic and aesthetic criteria, the drawings contain much more information about spatial organization, form materials, color and user potential. There comes a time when the ideas have to be presented to the client. At this stage the designer has the responsibility to clearly communicate and sell the ideas as well as to obtain feedback or critique from the client for later design refinement. Typical titles for drawings at this stage are:

presentation plan,
illustrative section,
perspective,
preliminary plan,
master plan
proposed development plan.

Chapters 5, 6, 7, and 8 provide more detail on these types of graphics.

Graphic character and media

Refined drawings for presentation to a client or user audience need to be fairly realistic and convincing. Most effective is a colorful package of drawings that combines plans, sections and perspectives. They need to be self-explanatory drawings with limited script. Digitally modified photographs, models and computer-generated perspectives can be effective at this stage. Presentation drawings require a fairly durable surface medium, such as marker paper, heavy print or bond paper, or board-mounted artwork. To produce powerful presentation drawings it is often necessary to combine freehand techniques, mechanical drafting, photography and computer-aided graphics.

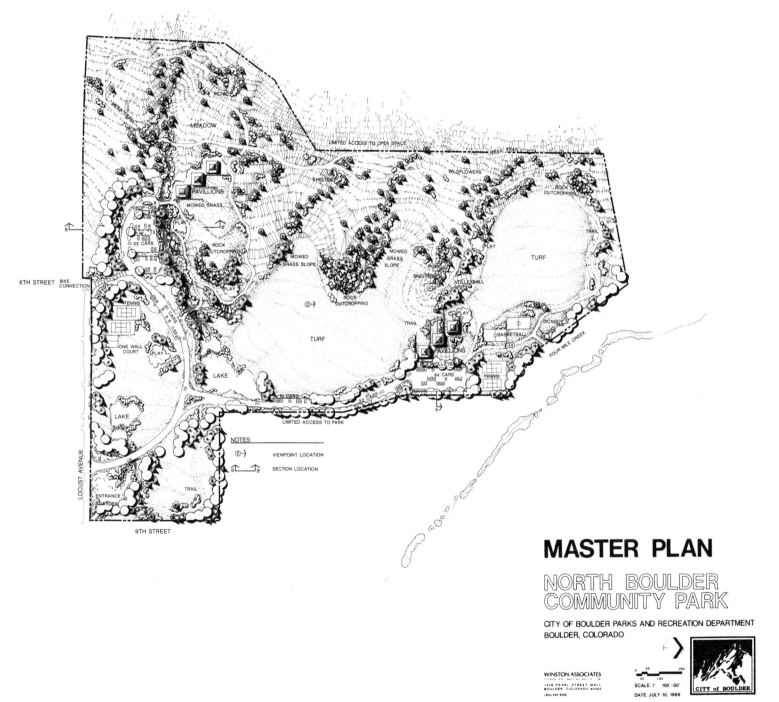

NOTES:

②→ VIEWPOINT LOCATION

B→ ←B' SECTION LOCATION

MASTER PLAN

NORTH BOULDER COMMUNITY PARK

CITY OF BOULDER PARKS AND RECREATION DEPARTMENT
BOULDER, COLORADO

WINSTON ASSOCIATES

1428 PEARL STREET MALL
BOULDER COLORADO 80302

(303) 440 9200

SCALE: 1" 100'-00"

DATE: JULY 10, 1986

CITY of BOULDER

Construction documentation

Content and purpose

At some point in the design of a buildable project the ideas have to be "finalized" into a set of construction documents. Refinements sometimes occur between the presentation drawings and the construction documents, but once this stage is reached there is much less acceptance of change. The purpose of these documents is to communicate to the people who are responsible for building or bringing the project to reality. Detailed written instructions called specifications go with a set of drawings that show exact sizes, shapes, quantities, types and locations of all the elements. Contractors use these documents initially for estimating and bidding, then later as a guide to construction. A typical set of landscape construction drawings may contain a site plan, grading plan, layout plan, irrigation plan, planting plan and detail sheets.

Graphic character and media

These are technical drawings that must be precise, complete and easy to interpret. Computer-aided drafting or mechanical drafting techniques are necessary for this kind of accuracy and clarity of communication. Since multiple copies are usually needed, computer-generated drawings are plotted out onto translucent bond paper, and manually-drafted drawings are done on vellum or film.

Grading Plan

Shows existing and proposed contours, spot elevations, drainage and other earth moving requirements.

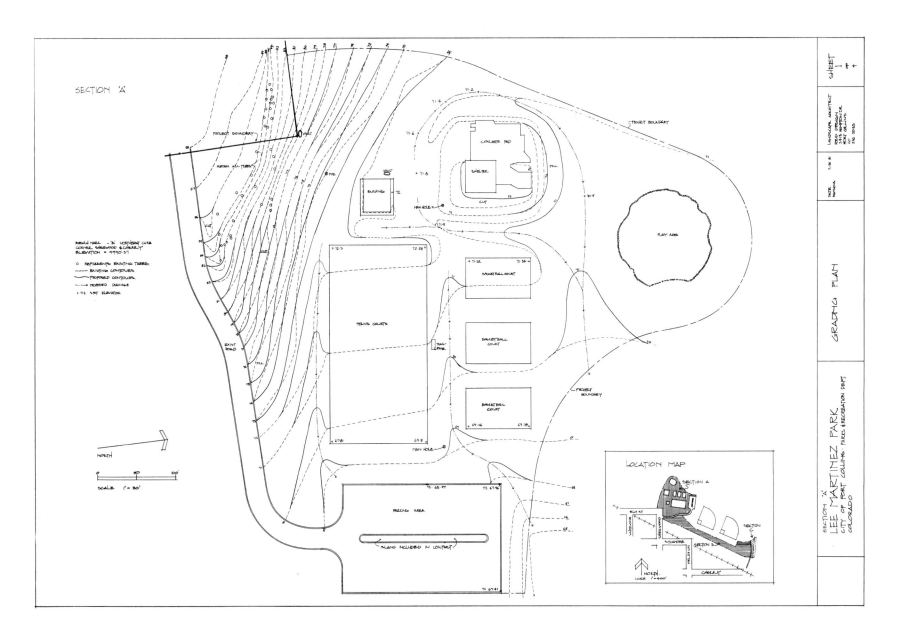

Layout Plan

Shows location, size, shape and material type for built elements of the landscape.

Planting Plan

Shows plant material locations as well as common name, botanical name, size and quantity of each.

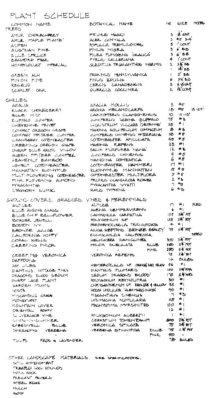

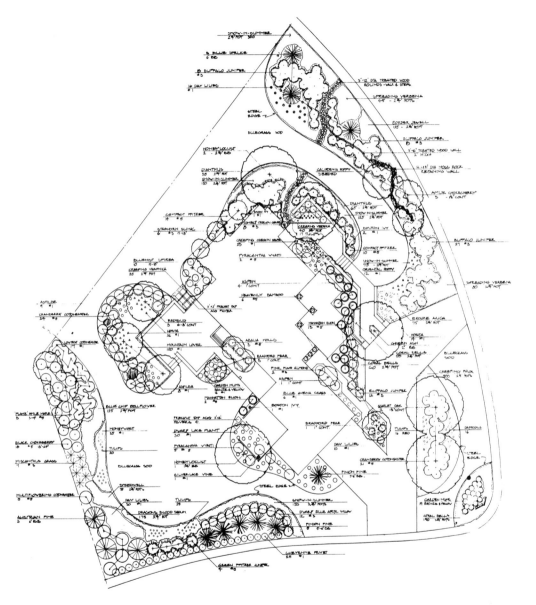

Construction Details

Show enlarged sections and plans for specific pieces of the built elements. May also include the internal elements and instructions on type of material, quality standards, connectors, and finishing.

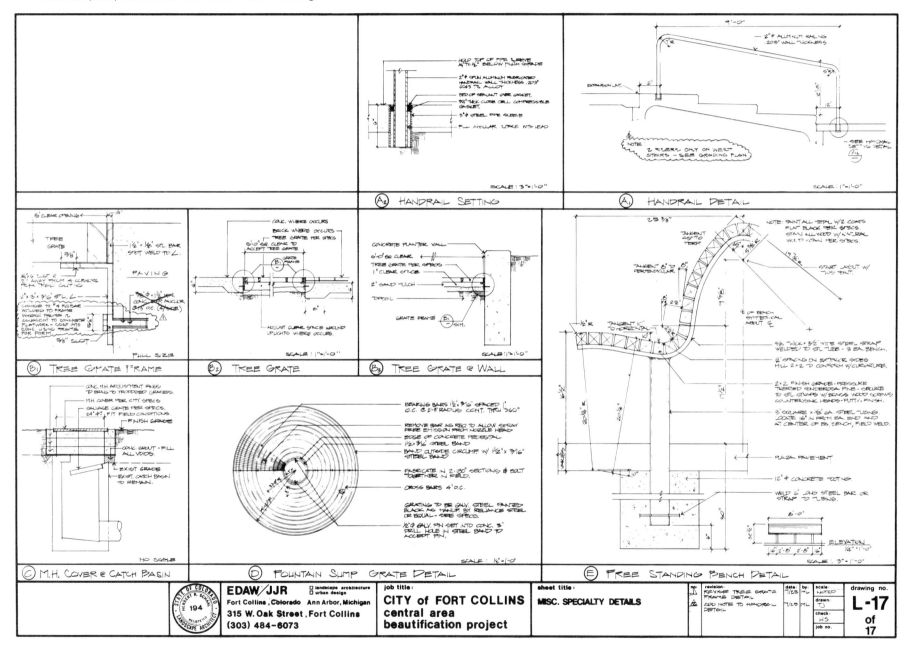

Basic Drafting

Precision drawings, whether drafted manually or on the computer, are most applicable to the later design phase of construction documentation. However, drafting is introduced at this point so that the reader can apply the techniques to other stages of the design process. This brief overview of manual drafting tools and techniques will help in the preparation of lettering, sections, perspectives and other graphic communications discussed later in the book.

Most precision drawing is now done on computers with various computer-aided drafting and design (CADD) programs. Although manual drafting skills are becoming less necessary, they still have some value in many phases of landscape design. In smaller companies where there is a predominance of unique, non-repetitive, intensive design, manual drafting will continue to be a part of graphic communication. Many companies are combining computer drawings with manual drawings to take advantage of the speed and accuracy of the computer yet also retain the loose expressive style of freehand graphics.

Pencil Drafting

Pencil is still a favorite medium for many designers and drafters because it is easy to manipulate its line width and density. It is also easy to erase and modify. The major disadvantage—compared to ink on Mylar—is that pencil drawings are less permanent and less durable. They have a tendency to smudge, and they produce a weaker blueprint.

Equipment and Materials

Mechanical pencil or lead holder

This is the main tool for pencil drafting. There are many different brands available.

Leads

Available in a variety of hardnesses, the most commonly used leads are:

HB soft.
For wider, dark in-fill lines or texturing. Smudges easily but also erases easily.

H medium.
Good all-purpose drafting lead. Ideal for lettering on vellum. Prints well.

2H medium to hard.
Good for layout lines and precision work. More difficult to erase but will not smudge as easily.

4H hard.
For guidelines and light layout lines. Use with a very sharp point and a light touch. Will not print well.

Softer leads, ranging from the extremely soft 7B to soft B, are available but are more suited to sketching than to drafting. Harder leads, up to the extremely hard 9H, are also available but are seldom used.

Nonphoto blue is used for drawing guidelines because it does not reproduce when photocopied.

Pencil Pointer

A pointer is used for sharpening lead. Empty the bowl before putting it away.

T Square and Parallel Rule

These are for drawing parallel lines and guiding other drafting tools, such as triangles. The recommended length for a T square is 24 inches.

For larger work, use a parallel rule, which attaches to the table with wires and brackets. It rolls over the drafting surface, maintaining a precise parallel relationship. Recommended lengths are 36, 42, and 48 inches.

A drafting arm is a more expensive, adjustable straightedge.

Triangle

Combined with parallel rules, triangles are used to draft straight lines in a variety of directions. Adjustable triangles save time and allow precise angles to be drawn. If made of plastic, do not use as a cutting edge. Also, do not use triangles with markers, and avoid damage to the edges.

Compass

For drawing larger circles a compass is necessary. Buy a good one. The cheaper ones tend to be inaccurate and difficult to use. For very large arcs, a beam compass is used.

Template

The template most commonly used by landscape architects is the simple circle template. Get one with very large circles and another with medium to small circles. Many other template shapes are available as well.

Dry Cleaning Pad

Filled with powdered rubber, it is used to prepare a surface for drafting and to reduce smudging. Use sparingly.

Eraser

Everyone makes changes. The kneaded eraser is good for initially removing graphite without smudging. Follow-up erasing can be done with any of the softer pencil erasers.

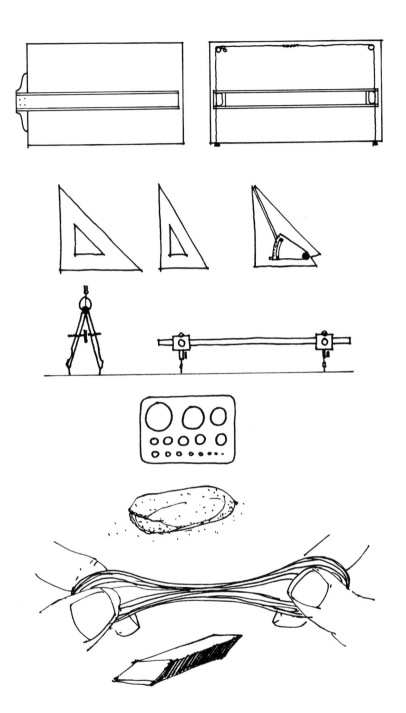

Erasing Shield

For use with erasers to mask areas that should remain, a shield is crucial when using an electric eraser.

Drafting Brush

Available in various sizes, it is used to sweep drafting surfaces clean.

Flexible Curve

Many brands are available. An excellent aid for drafting freeform, flowing lines and better than French curves for landscape work. Get one that can be used with both pencil and ink.

Scales

Architects' scales and engineers' scales are used in the United States more often than elsewhere. Landscape architects in most other countries use metric scales of various types. Do not use scales as straightedges.

Sandpaper Block

A block is used for putting a wedge or chisel point on the lead when lettering and for sharpening the compass lead. Store the block in a sealed envelope with one end slit open.

Drafting Tape

Supplied in rolls or as strips of "dots," it is used to secure the paper to the drafting surface. The best brands hold well yet peel off easily without ripping the paper.

Drafting Paper

Vellum is a fairly stable paper suitable for pencil drafting. Some brands include Clearprint 1000-H and K & E Albanene. These are 16- to 20-pound, 100-percent rag papers. Not recommended for ink work.

Drawing Board Cover

A vinyl covering is recommended because it is durable and resists small holes. Attach to the board with double-sided tape along the top and bottom. To avoid buckling, keep out of direct sunlight and avoid close proximity to hot objects.

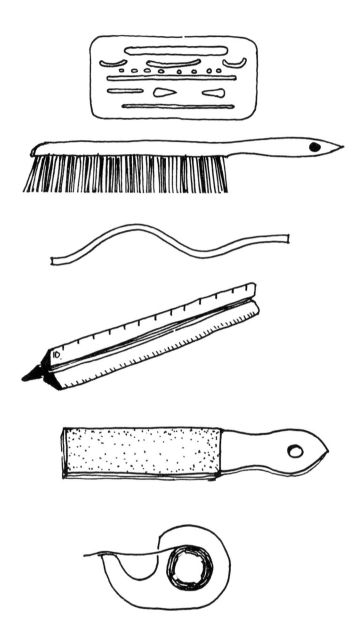

Techniques

Pencil drafting is used mainly on finished working drawings or base maps, where accuracy and precision are important. The advantages of pencil over ink are that there is no waiting period (ink needs to dry), erasing is easier, and pencil is generally faster. Ink has several advantages over pencil. (See "Drafting with Pens.")

Line Quality

The three important line characteristics of pencil drafting are: (1) the density or value of the line, (2) the width of the line, and (3) the consistency of the line. The ideal line is dense, has sharp edges and ends, and maintains a consistent width along its entire length.

The density, or darkness, of a line depends on the lead and the paper used (rougher paper needs harder leads) and the pressure applied to the pencil.

Set up the sheet of vellum by lining up the top edge with the upper side of your T square or parallel rule. Apply a light sprinkling of dry cleaning powder.

Select the appropriate lead and sharpen to a point in the pencil pointer.

Now break the very end off by tapping gently on a piece of scrap paper

Next, round the corners of the lead by quickly doodling on the scrap sheet. The end should still be fairly sharp but not needle-like.

Hold the pencil firmly (but not too tightly), so that you roll it slowly as you pull it along the straightedge.

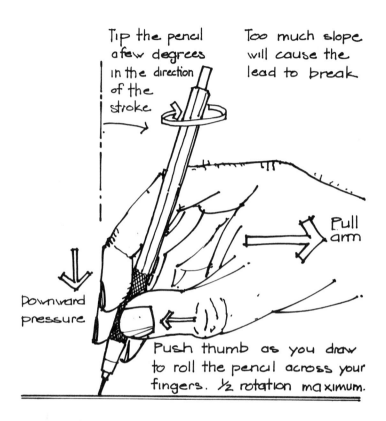

Tip the pencil a few degrees in the direction of the stroke

Too much slope will cause the lead to break

Pull arm

Downward pressure

Push thumb as you draw to roll the pencil across your fingers. ½ rotation maximum.

Use of Straightedge Tools

With your non-drawing hand, make sure the head of the T square is firmly against the edge of the board and hold the triangle firmly against the top edge.

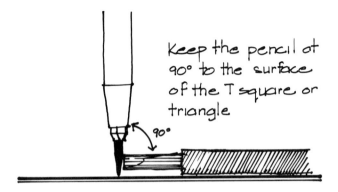

Keep the pencil at 90° to the surface of the T square or triangle

90°

For the next line, slide the triangle with very light pressure or lift and then move it to avoid smudging. If you use felt tip pens, be sure to clean the straightedge with cleaner or rubbing alcohol.

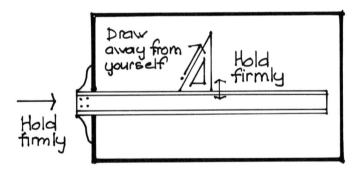

Draw away from yourself

Hold firmly

Hold firmly

The parallel rule is used in much the same manner as the triangle, except that it is held in a parallel position with wires and is not meant to be removed from the table. Adjust the wires to put a little tension on the spring.

Arcs and Circles

When using the compass, sharpen the lead to a steep angle with the sandpaper block. Test the point on a piece of scrap paper, then scribe the circle, always keeping an even pressure throughout the arc.

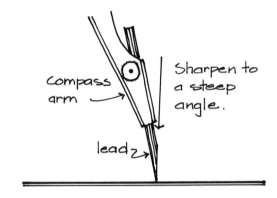

Compass arm

Sharpen to a steep angle.

lead

Connections

Make sure that all corners have positive connections.

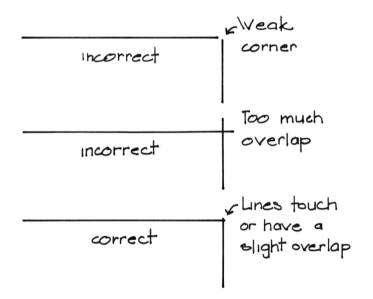

incorrect — Weak corner

incorrect — Too much overlap

correct — Lines touch or have a slight overlap

Pencil Drafting Sequence

1. Lightly dust your drafting surface.

2. Lay out shapes with very light, sharp lines drawn with needle-pointed 2H or 4H leads. (If tracing a preliminary drawing, this step may be omitted.)

3. Draw arcs.

4. Draft all major lines with F, H, or 2H leads. Work from top to bottom and from left to right.

5. Add thinner dimension lines.

6. Add lettering.

7. Finally, add textural or tonal shading with HB or H leads to work around lettering and avoid smudging.

8. When finished, check the back side of the sheet and remove any graphite that may have been picked up from the work surface or from tracing.

Drafting with Pens

Pen and ink drafting tools are most often used on drafting film. Ink on film has several advantages over pencil on vellum. Precise, consistent line widths are easier to maintain. The lines are also denser and result in clearer, more powerful copies. Some design firms and public agencies prefer film because it is more resistant to damage and more stable. It will not shrink or stretch with variations in humidity.

Drafting film

Use polyester film that is 3 to 4 millimeters thick. The most common film in the United States is Mylar, which has a roughened or matte surface on one or both sides. Draft on the matte side, not the smooth side.

Pens

There are many brands of technical pens that have refillable ink reservoirs. Most of them are expensive and take considerable care to keep clean. The best brands have jewel tips which last a lifetime. A much less expensive approach is to buy a set of disposable drafting pens. There continue to be advances in the quality of these pens. Be sure to get ones that are waterproof and have a very dense black ink. For example, Staedtler (German) makes a "Pigment Liner" series and Kuretake (Japanese) makes a "Millennium" series. Both are available in a variety of pen sizes with flat-bottom tips for consistent line width. They also have dense black ink and erase easily from film. Beware of smudging since the ink takes a little time to dry. You should be able to draft everything with four sizes; 01, 03, 05, and 07. Alvin (Austrian) makes a "Penstix" series but the ink is not quite as dark, and the points are tapered. Although not as consistent in line width when drafting, these pens are great for lettering.

Other disposable ink pens worth considering for freehand drawing, not drafting, are Staedtler's "Lumocolor 318 F" pen, Sandford's "Liquid Sharpie" and Sakura's "Pigma Brush."

Other tools

Fresh ink lines can be erased with a regular eraser or an ink eraser that has been impregnated with special erasing fluid. A little water will remove the ink faster. Rubbing alcohol will remove older lines.

Inking triangles and templates have recessed or beveled edges to prevent the ink from running beneath the guide. Some templates have bumps on one side to keep the main part of the template off the drafting surface. Other than these examples, the drafting tools are similar to those discussed under pencil drafting.

Techniques

Unlike a pencil, the ink pen should be held vertical or 90 degrees to the film in all directions. Use a very light touch and move slowly and evenly across the film surface. Keep your hands off the film as much as possible since the oils from your fingers will prevent the ink from attaching to the surface. Before drafting it is a good idea to prepare the surface by cleaning it with rubbing alcohol and a soft cloth. This removes stains and fingerprint oil.

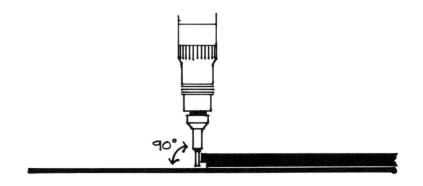

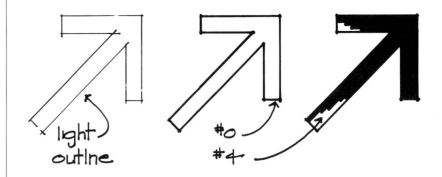

light outline #0 #4

Title Blocks

Presentation plans and landscape construction documents should have a well-organized title block. This is usually placed along the lower edge or right side of the sheet and includes several essential elements.

Elements	Examples	
Project name	Shore Pines Town Homes	
Sheet title	Planting Plan	
Project address	618 Front Street, Any City	
Sheet number	Sheet 2 of 6	
Developer or agency	King Development, Inc.	
Design company	Gordon Associates	
(with address and logo)		
Check signature	Checked by	Date
Revision dates	Revised	
Scale		
North indication		

The most efficient system when working with CADD is to prepare a standard title block on the computer for your own business and modify it for each project. Some landscape companies have pre-printed base sheets of vellum or Mylar with the unchanging repetitive elements laid out and spaces provided for the project specific information.

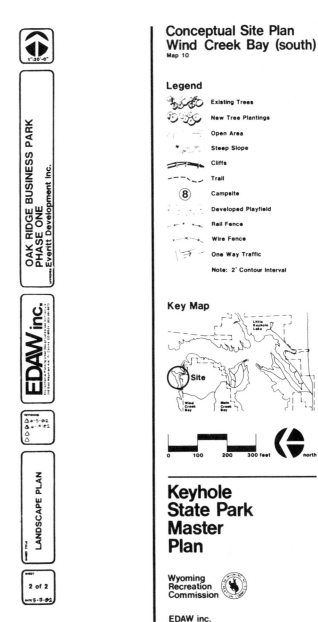

North indicators and graphic scales

North Indicators

Every landscape plan must have a north indicator. This is usually an arrow and is an essential part of graphic communication in plan view. When discussing different parts of a site, compass references are often made. They become crucial in telephone conversations when you cannot point to a part of the site. Most importantly, the north indicator is the key to understanding site orientation as it relates to sun position, wind direction, slope aspect, view direction and other directional issues. Sections and perspectives do not have north indicators.

A north indicator should:

- be simple and unobtrusive yet easy to find,
- have a prominent, straight shaft and a clear head or point
- point straight up if possible, or at some angle above horizontal
- never point down

Place the north indicator close to the scale and near the bottom or side of the sheet. Title blocks, if there are any, usually contain the north indicator. Sometimes the north indicator is combined with a graphic scale.

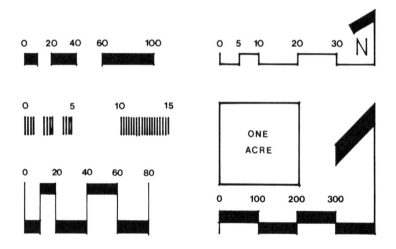

Graphic scales

A graphic scale may be used in addition to, or instead of, a written scale. The value of the graphic scale is that it retains its true relationship to the drawing in the event the drawings are reduced or enlarged.

North Indicators

Scales

Every plan view and section-elevation drawing must have a scale indication. This shows the size difference between the drawing and the actual landscape. The scale may be written, graphic or both. It is expressed either as an equation or a ratio. In both cases the left side represents a unit on the drawing and the right side represents an equivalent unit or number of units in the landscape. The physical scale used to measure plans is therefore a tool for quickly converting distances without having to perform mathematical calculations. On the following page there is a chart comparing three general types of scales: architects', engineers', and metric.

Architects' scales are always written with a fraction of an inch on the left side of the = sign and the unit of 1 foot on the right side. So the scale 1/4" = 1'-0" means that 1/4" on the drawing is equivalent to 1'-0" on the real landscape site. The architect's scale used to measure elements on a plan is calibrated in feet such that a distance from 0 to, for example, 12 on any of the scales is 12 feet on the landscape.

Engineers' scales are always written with the unit of 1 inch on the left side of the = sign and multiples of 10 feet on the right side. So the scale of 1" = 20' means that 1" on the drawing is equivalent to 20' on the landscape site. The engineer's scale used to measure elements on the plan is calibrated in tens of feet such that a distance from 0 to, for example, 8 on any of the scales is 80 feet on the landscape.

Do not mix up these scales. It is incorrect to use such scales as 1" = 4'-0", 1" = 5'-0", 1" = 6'-0", 1/4" = 10', 1 1/2" = 10', 1/2" = 20'. They do not exist in this form and will only lead to confusion.

Metric scales are written as ratios, with 1 on the left side and multiples of 10 on the right side. Thus, 1:50 means that one meter on the drawing is equivalent to 50 meters on the landscape. To put this another way, 1/50th of a meter on the drawing equals 1 meter on the landscape. The metric scale used to measure elements on the plan is calibrated in meters such that the distance between zero and say 3 on any of the scales represents 3 meters on the landscape.

Scales

	Imperial System	Metric System	Landscape Application

Architects' Scales

1" = 1'-0"

 1:10 — Enlarged construction details

¾" = 1'-0"

 1:20

½" = 1'-0"

1:25 _____

¼" = 1'-0"

 1:40 — Plans for spaces smaller than 10,000 sq. ft. or 1000 square meters

1:50

1:80 _____

⅛" = 1'-0"

 1:100 — Plans for sites 0.25 to 5 acres or 0.1 to 2 hectares

Engineers' Scales

1" = 10'

1" = 20'

 1:200 _____

1" = 30'

1" = 40'

 1:500 _____

1" = 50'

1" = 60'

1" = 80'

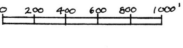 1:1,000 — Sites planning for projects 5 to 1,000 acres or 2 to 400 hectares

1" = 100'

1" = 200'

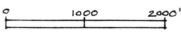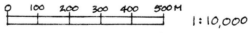 1:5,000

1" = 400'

1" = 500'

1:10,000 _____

1" = 800'

1" = 1,000'

1:24,000 — Regional scale studies for areas over 2 sq. miles or 3 sq. kilometers

1" = 2,000'

Measuring with Scales

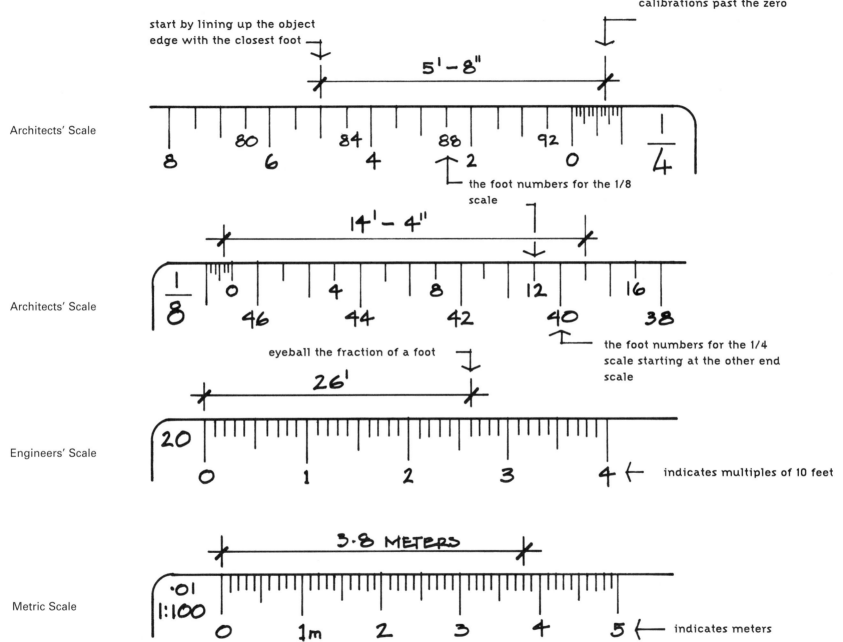

read the inches on the calibrations past the zero

start by lining up the object edge with the closest foot

5'-8"

Architects' Scale

80 84 88 92
8 6 4 ↑ 2 0 |‾1‾|
 |_4_|

the foot numbers for the 1/8 scale

14'-4"

Architects' Scale

|‾1‾| 0 4 8 12 16
|_8_| 46 44 42 40 38

eyeball the fraction of a foot

the foot numbers for the 1/4 scale starting at the other end scale

26'

Engineers' Scale

20
0 1 2 3 4 ← indicates multiples of 10 feet

3.8 METERS

Metric Scale

·01
1:100
0 1m 2 3 4 5 ← indicates meters

Exercises

Exercises 2.1 - 2.4 are meant as practice in using the mechanical pencil and drafting tools. Set up each page parallel to your drafting rule then dust the page with dry cleaning powder to avoid smudging. When done with each exercise check it against the following quality guidelines.

a. Blackness.
All lines should be dense and black enough to produce a high-quality print. Avoid light, grayish lines.

b. Consistent line weight.
Each line should have an even thickness, or weight, throughout its length with no narrowing or widening and no fuzzy edges.

c. Accuracy.
Lines should meet or very slightly cross, line up with precision, and have definite ends.

d. Sheet appearance. Overall the sheet should be clean and free of smudges, stains and tears.

e. Additional criteria apply to exercise 2.4 only. **Hierarchy of lines**. The various descriptive lines must be easy to distinguish by virtue of their different widths or patterns. **Tonal quality**. In-fill toning and texturing can be used to clarify the message. Avoid unnecessary tonal clutter.

2.1 Testing the leads

Media: 8 1/2 x 11" (A4), vellum, variety of leads. Landscape format. Draft a set of five horizontal lines for each of the leads HB, H, and 2H. Make all the lines very dark and even. Make the lines about 5 inches (13 cm) long and 1/4 inch (0.5 cm) apart. Leave 1 inch (2 cm) between each group as shown below. Draft a fourth set of five lines with the 4H. These guidelines should be drafted very lightly so that you can hardly see them. On the remainder of the sheet use a compass (largest circle) and the circle template (other circles) to draft four circles of different sizes. Use an H lead for the circles.

2.2 Using a triangle

Media: 8 1/2 x 11" (A4) vellum, 4H lead guidelines, H lead final lines. Landscape format. Set up two 3" (6 cm) squares using the scale and the 45 degree triangle. On the left square divide top and one side into six (1/2" or 1 cm) equal divisions. Draw three lines parallel to the base at each division, then draw 45-degree lines through the other divisions.
On the right square draw two 45-degree diagonals from the corners. Copy the diagram to create five squares inside each other.

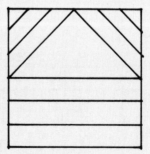

2.3 Geometric shapes

Same media and format as 2.2.

On the left side of the page follow these instructions to draft a hexagon. First draft guidelines AB, CD. With the intersection as the center scribe a very light circle with a radius of 1 1/2" (3 cm). With the 30/60 triangle and light 4H lines, draft six guidelines touching the edge of the circle as shown. Finish the hexagon with dark sharp H lead lines.

On the right side of the sheet draw a 3" (6 cm) square with vertical and horizontal guidelines through the center. Draw 45-degree diagonal guidelines to these center lines and place them 1/2" (1 cm) apart. Now draft two concentric semicircles on each side as shown using a 1 1/2" (3 cm) radius and a 1" (2 cm) radius. Intertwine the diagonals and semicircles as you draft the final lines with the H lead.

2.4 Using various tools

Media: Pencil on 8 1/2 x 11" (A4) vellum.

Using a variety of leads and pencil drafting techniques expand the landscape plan features shown below to fill the sheet. Copy approximate shapes and relative sizes. Do not measure dimensions. Draft straight lines with the T square and triangles. Draft the trees and walk curves with a circle template. Draft the freeform curve with the flexible curve. Draw the dashed line contours, shrubs and conifers freehand.

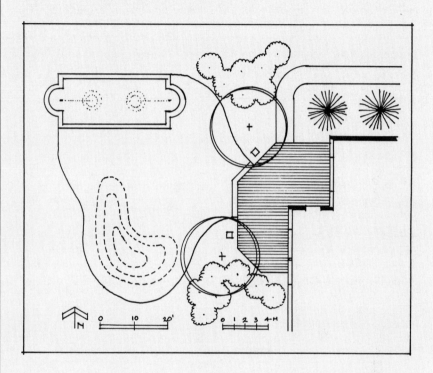

2.5 Testing the pens

Media: Ink pens on 8 1/2 x 11" (A4) mylar. This is one of the few exercises where you can trace. Make a copy, then overlay one of the sections in chapter 6 with the Mylar. Try to reproduce the variety of line widths by using several pen sizes. Some lines need to be drafted and others drawn freehand.

2.6 Reading scales

Media: Ink pen (0.5 mm) on 8 1/2 x 11" (A4) Mylar, landscape format. Draft four horizontal lines across the entire sheet, 2" (5 cm) apart. Draw a vertical line near the left end through all four lines. This vertical line will be used as the beginning of each measurement. Using the scales indicated on each horizontal line, draft small vertical lines to represent the following distances from the beginning line:

3'- 4" (1.2 meters)
6'- 9" (2.4 meters)
10'-6" (3.6 meters)
18'-6" (5.8 meters)
25' (8 meters)
39' (12 meters)
53' (16 meters)
76' (24 meters)

Line 1: use scale of 1/4" = 1'-0" or 1:50
(only six measurements will fit)
Line 2: use scale of 1/8" = 1'-0" or 1:100
Line 3: use scale of 1" = 10' or 1:200
Line 4: use scale of 1" = 30' or 1:400

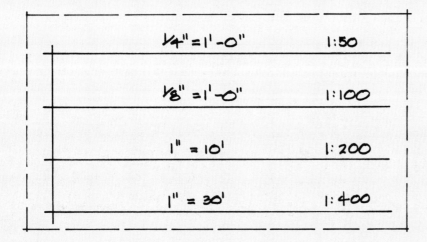

2.7 North and graphic scale indicators

Media: Ink pens on 8 1/2 x 11" (A4) Mylar.
Fill a sheet with north indications and graphic scales copied (not traced) from this chapter.

Lettering

Lettering on a drawing fulfills an important requirement. Information that can not be easily understood from graphic shapes, lines and colors must be included in the form of notes, labels, dimensions, and titles. Give careful thought to the composition, size and placement of lettering since it becomes part of the overall composition. Lettering can either enhance the drawing by making it easy to interpret and pleasing to look at, or it can detract from an otherwise good drawing by making it unsightly and difficult to read.

Prepared Lettering Systems

The most efficient lettering system by far is to use the computer. In CADD it is fast and easy to select font types, sizes and placement to integrate lettering into the graphic product directly on the computer screen.

Designers who are not using CADD can still develop notes on the computer, print them onto sheets with adhesive backing (sticky back transfers) and then cut and paste them manually onto a landscape graphic sheet. An undesirable ghosting effect due to the density of the adhesive material may result with this system, but the newer brands of adhesives reduce the problem.

Another quick and effective method for large lettering is to trace letters printed from the computer. Prepare the size and font type appropriate for your message and composition, print out the exact title and trace the outline onto your drawing.

Concept

fountain

PLAZA

Concept

fountain

PLAZA

Marker Lettering

Wide-tip color markers are versatile tools for quick, functional diagrams, freehand title lettering, and color rendering. It is appropriate at this point to learn how to use them properly. Before beginning, put a backing sheet of tracing paper under the drawing surface. Markers will bleed through many papers and can permanently stain the drafting table surface. Keep markers tightly capped when not in use.

Marker Grip

A light touch is all that is needed. Even moderate pressure will destroy the tip. Wide-tip markers with a rectangular end need to be held so that this end touches the paper along the entire edge.

Side view

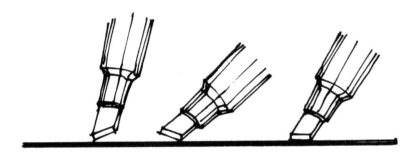

Wrong
Only the toe
is touching

Wrong
Only the heel
is touching

Right
Entire edge
is touching

Larger lettering done freehand with a wide-tip marker as a base form gives your drawing a special flare unique to your own style and brings a softer human feel to the presentation. This technique is especially effective when color is added to the letters before or after outlining.

Top view

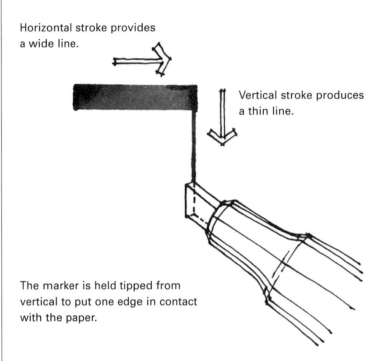

Horizontal stroke provides
a wide line.

Vertical stroke produces
a thin line.

The marker is held tipped from
vertical to put one edge in contact
with the paper.

Freehand Lettering

Freehand titles and subtitles requiring larger letters can be accomplished with markers and felt tip pens. This technique is good for schematic and preliminary drawings on marker paper, but the freehand outlining techniques shown can be adapted to other media.

Begin with guidelines about 1 1/2 inches apart.

Hold the marker gently. Make some letters, checking these pointers as you go:

- The entire tip edge touches the paper.
- The edge is aligned vertically all the time for vertical, diagonal, and circular strokes.
- The marker is not rotated with the fingers, which would tip the marking surface onto its point or the heel.
- Neither arm nor body is rotated.
- The letters are made with a light touch, letting the edge of the marker create line width changes.
- The toe and heel do not extend over horizontal guidelines.
- Vertical strokes are consistently vertical. Use light vertical guidelines if necessary.
- Smaller letters use the small edge at the tip of the marker.

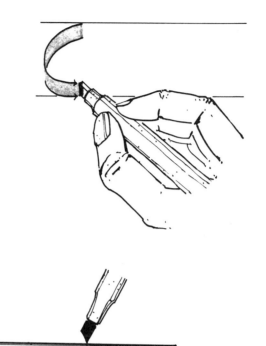

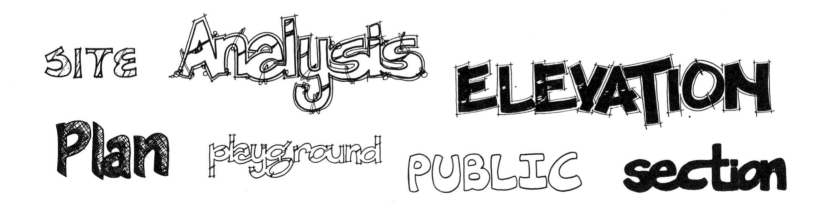

Outlining

Marker letters by themselves are weak and need the crispness obtained by outlining. One can either outline the colored shapes directly on the marker paper or overlay the presentation sheet on the shapes for outline tracing.

Start with a bold outline. Do all the verticals, then all the horizontals, then the curved shapes. Allow the lines to form definite corners, even overlapping slightly.

Follow up with a fine line outside the bold line, keeping an even white space between.

Move the paper or your arm to permit comfortable, confident strokes.

Other dots and lines may be added for character and interest.

colorado

CAMP
WITTMAN

BOUNCE

TALL

PINE

XERISCAPE

Pencil Lettering

Shape and Spacing

Most letters should fit within a slightly narrowed square. Spacing between words should be the equivalent of the letter N.

Size

Always use guidelines to obtain correct size and uniformity. The Ames Lettering Guide, shown here, will help. It has a rotating disc, which allows quick setup of guidelines of any size.

Running through the center of the disc is a row of evenly spaced holes. At the end of this row is the number ten. Rotate the disc so the number ten lines up with the frame index mark near the base of the frame. Insert a needle-sharp 4H pencil into the top hole. Move the pencil lightly across the paper, keeping a slight pressure toward the straightedge. Shift the pencil down to the next hole and repeat the back-and-forth motion until there are enough lines for the purpose. If you want closer lines, rotate the disc to a lower number.

SETTING 10 CENTER ROW
GIVES LINES WITH EQUAL
SPACING AT THIS SIZE

The rows of holes on either side of the center row produce sets of three lines (between the brackets), which have the middle guideline slightly above center. A middle guideline is helpful to obtain consistency of shape for upper case letters such as B, E, F, H, and P. This is particularly true for larger letters (3/16" or more).

Several different lettering sizes and their applications are shown on the next page.

TOO NARROW TOO WIDE
ABOUT RIGHT

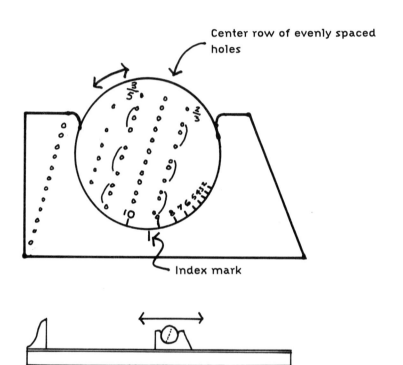

Center row of evenly spaced holes

Index mark

(LEFT OF THE CENTER ROW
(IS THE 2/3 ROW WHICH GIVES
(A SLIGHTLY RAISED MIDDLE
(GUIDELINE

MOST LANDSCAPE ARCHITECTS USE A SIMPLE UPPER
CASE (CAPITALS) STYLE WITH NO SERIFS AS SHOWN
HERE. KEEP LETTERS VERTICAL AND CONSISTENT IN
SHAPE. THIS UNIFORM STYLE IS EASY TO READ.

A B C D E F G H I J K L M M N N O P Q R S S T U V W
W X Y Z. 1 2 3 4 5 6 7 8 9 0

lower case letters are less formal and are suited
for use on concept plans, preliminary sketches and
plant lists.
a a b c d e f g g h i j k l m n o p q r s t u v w x y z

Letter Sizes and Applications

HEIGHT	LETTER GUIDE SETTING	EXAMPLE
1/16"	CENTER ROW SETTING 4	TOO SMALL FOR HAND LETTERING
3/32	CENTER ROW SETTING 6	GOOD FOR SMALL LABELS & BLOCKS OF LETTERING. CAN WRITE A LOT IN A SMALL SPACE. ALWAYS LEAVE A GAP BETWEEN LINES OF LETTERING
1/8"	CENTER ROW SETTING 8	A VERY COMFORTABLE SIZE FOR MOST LABELLING
3/16"	3/5 ROW SETTING 6	GOOD FOR SUBTITLES. USE A CENTER GUIDE LINE.
1/4"	3/5 ROW SETTING 8	UPPER LIMIT FOR PENCIL LETTERING.

Technique

After setting up guidelines and lightly dusting the surface with the dry cleaning pad, begin with a small triangle on the lower side of the parallel rule.

A 0.5 mm pencil with H or HB lead is ideal because you never have to sharpen it. Regular lead holders are better for large letters (3/16") but the lead must be periodically sharpened. For Mylar use a harder lead (2H) or plastic lead.

The Lettering Grip

Wrong: Pencil too vertical.

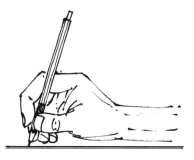

Right: Pencil held at a low angle.

Flatten the end of the lead on a scrap sheet or with a sandpaper block.

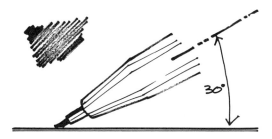

Rotate the pencil slightly, so that the flattened edge in against the vertical guide.

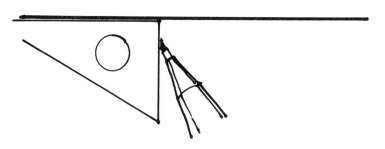

Draw verticals as thin lines with strong, dark ends.

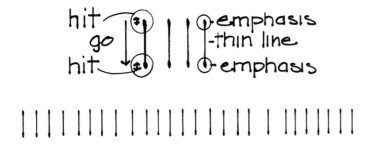

Watch the guidelines, keeping the verticals a consistent size.

The horizontals should be drawn as thicker, darker lines. Maintain a firm pressure throughout. Avoid brushing off the ends. A slight upward slope is acceptable.

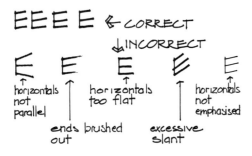

Do not move the fingers. Pivot on the palm or forearm muscle and let the fingers slide and steady the hand.

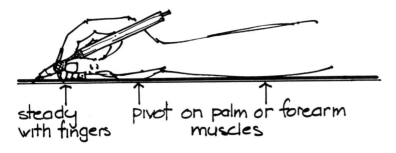

A small wrist movement may be necessary for horizontals. Remember: Make thin verticals with strong ends and thick, dark horizontals. As the lead wears down, simply rotate the pencil slightly to place the new chiseled side against the vertical guide and thus maintain the narrow verticals.

E F H I L T

Diagonal strokes and circular strokes are done with an even pressure. Some variations of line width will occur as a result of direction change. Do not move wrist or arm position. Move the vertical guide away and use quick, confident strokes with adequate pressure.

A K M N V W X Y Z
B C D O P Q R R S S

More Hints For Better Lettering

- Letter a drawing last to avoid smudges and overlapping with other areas of the drawing. This will enable you to space out your lettering and to avoid lettering over important details.
- Don't try to develop speed at first. Make each stroke quickly, but take your time between letters and between strokes until you have mastered each letter. Then gradually increase your speed. You will soon be able to letter almost as fast as you can write script.
- Organize lettering in logical blocks. Wherever possible, align notes down a vertical guideline. Place notes where they will not obscure other messages.
- Relate the size of the lettering to the importance of the labeling.
- Choose a style of lettering that is compatible with the character of the presentation and maintain that style consistently.
- Make letters bold and distinctive. Avoid a delicate, fine touch. Try emphasizing the beginnings and ends of strokes.
- Form the habit of lettering whenever possible—as you take notes, address envelopes, write letter, and compose memos.

Exercises

3.1 Computer-generated letters

On the computer, type your name, the exercise title and the number at a font size of 18. Follow this with a short paragraph (6 or 7 lines) of notes at a font size of about 14. Print this onto a sheet of sticky back. Trim excess and apply to the top portion of a sheet of 8 1/2 x 11" (A4 i.e., 210 x 297 mm) vellum or Mylar portrait format. While you are at the computer prepare another page of large letters. Make three rows of one word each choosing three different fonts and the "bold" icon. Print this page out and trace the outline of each word onto the bottom of the sheet using the ink pens. Run a blue-line print.

3.2 Marker lettering technique

Media: Color markers on marker or butcher paper 12x18" (A3 i.e. ,297x420mm). With a pencil, draft two guidelines across the sheet 1 1/2" (3.5 cm) apart. Place letters between these guidelines. You should always leave white space between successive rows of words, so leave a 3/4" (2 cm) space then add another two guidelines. Repeat for the whole sheet. Leave about 2" (5 cm) margins on each side of the sheet. On the first row follow the techniques in this chapter to make a series of linked horizontal lines and vertical lines with a light-colored marker. For now keep the marker color edges inside and very close to the guidelines. On the next row make Os. On the third row make As. On the fourth row make Ss.

3.3 Marker outline letters

Media: Color markers on marker paper 6 x 18 (150 x 450 mm).
Set up the sheet with two rows of guidelines in the same manner as in the previous exercise. With a light marker letter your first name on the top line and your last name on the second line. Try to center the words. Finish the letters with the double outlining technique shown in this chapter using two different thicknesses of ink pens. Play with more color depth added to the lower part of each letter. If you are in a group, this is a good time for a group photograph, holding your lettered name in front of you "convict style."

3.4 Pencil lettering technique

Media: Pencil (H lead) on vellum 8 1/2 x 11" (A4) portrait format.
The purpose of this exercise is to practice the pencil grip, sharpening method and line expression (thick/thin and terminal emphasis). Tape the sheet down square to your drafting rule and dust the sheet with dry cleaning powder before starting.
With the lettering guide at setting 6 and the 3/5 row set up about 16 rows of guidelines 3/16" (0.5 cm) apart with a gap in between. Use a very sharp 4H lead and a light touch.

Now with the H lead, letter two rows each of Is, Es, Os, As, and Bs. Study the shapes shown in this chapter and try to get the feel of thick/thin and hit go hit. On the next lines letter the alphabet in uppercase letters, in lowercase letters and then copy the numerals.

3.5 Pencil notes at different sizes

Media: Pencil (H lead) on vellum 8 1/2 x 11" (A4) portrait format.
Set up three 2" (5-cm) by 5 1/2" (14 cm) blocks of guidelines. Leave 1" (3 cm) between each block.
The top block is to have guidelines spaced at 3/16" (5 mm) or setting 6, 3/5 row.
The center block is to have guidelines spaced at 1/8" (3.2 mm) or setting 6, center row.
The bottom block is to have guidelines spaced at 3/32" (2.5 mm) or setting 8, center row.
Fill each block with sentences copied from a book. The top block will be easiest with a sharpened mechanical pencil, the bottom block will be easiest with a 0.5 mm pencil, and the center block could be done either way.

Pencil Lettering Evaluation

Check your pencil lettering against these quality criteria.

a. All letters are dark with no fuzzy gray lines. (Does it print well?)
b. The shapes are similar to the example alphabet and are consistent throughout.
c. There is a uniformity of size, with all letters meeting the guidelines.
d. The verticals are thin, dark lines with strong ends. The horizontals are thick, dark, and parallel and have a slight upward slant.
e. The sheet has a neat clean appearance with no smudges or tears.

Freehand Drawing and Conceptual Diagramming

The very first graphic ideas in the design process are best expressed with freehand drawings. Conceptual diagramming, quick three dimensional images or "thumbnail" sketches, and rough preliminary ideas in plan view are all open, honest, free-flowing drawings that use few, if any drafting aids. A good designer has the ability to take an incomplete embryo of an idea, rapidly transform it directly into a real image by hand movements, then immediately evaluate the image by eye. Computer drawing, which requires keyboarding to create form, loses this directness and freedom of expression. A hand moving across keys is not the same mental process as a hand moving through a shape or pattern. The objective of this chapter and the remaining chapters is to give you the confidence to express spatial ideas by hand. It is not necessary that you become an artist, but it is very useful to become skilled enough at freehand graphic expression whereby you are not afraid to quickly draw a rough sketch in front of your client.

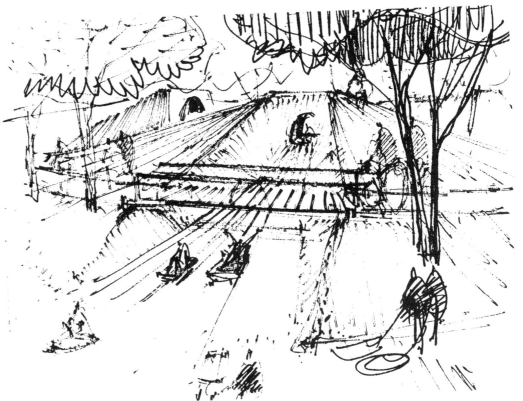

Tools and Materials

Choose the drawing tools that allow smooth, easy, gliding strokes with expressive line character. These are soft graphite-based tools, felt tip pens, and sketch fountain pens.

Soft graphite smudges easily, but allows a variety of very dark and very light lines. The ordinary 4B or 6B lead pencil sharpened to a point gives a fine line and chiseled down gives a wide line.

Lead holders are available for large diameter (3 mm) sketch leads, which are very good for bold preliminary work.

Graphite sticks get a little messy but are excellent for drawing fast, wide lines and for toning larger areas. The larger stick has a 1.35 cm width and the smaller stick has a 7 mm width.

The flat sketch pencil, or carpenterís pencil, has a rectangular cross section in the lead that allows very broad strokes.

More stable sketching media that will not smear or smudge include the following:

Soft color rendering pencil

Color art stick

Harder and waxier than graphite, this product works well for sketching on Mylar.

Felt tip pens are available in an almost unlimited variety of shapes and sizes. It is handy to have a range of point sizes, as shown in the small number of examples below.

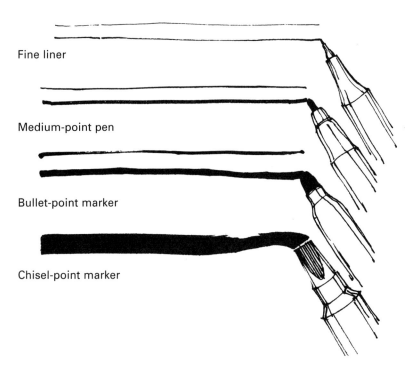

Fine liner

Medium-point pen

Bullet-point marker

Chisel-point marker

Ink fountain sketch pens give strong black lines. Pressure variation yields interesting changes in line weight. A smooth surface is needed for good results.

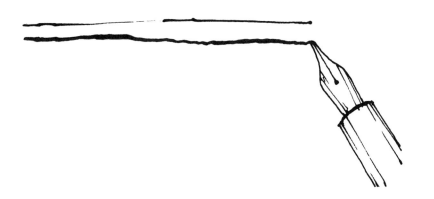

Sketching surfaces, such as lightweight tracing paper ("flimsy"), comes in rolls of various widths. The common colors are white, yellow, or buff (canary paper). This is used for freehand design development drawings, refinement overlays, and quick sketches. It is inexpensive and yet transparent enough to print, although it is not recommended for finished drawings because it rips easily. Best results are obtained with a felt tip pen or a soft pencil. A backing sheet is needed for use with markers.

Sketch paper in many different brands is available in varying weights, surfaces, finishes, and transparencies. Select a surface that suits the type of sketching tool and the desired effect. Smooth, dense surfaces are good for detailed, fine line drawings. Coarser papers provide textured interest for pencil toning. Special dense, smooth papers are available for ink sketching. For reproducible work, use the more stable transparent sketch papers.

Bleed-proof marker papers are specially treated to prevent marker fluid from bleeding through. Some lateral bleeding should be expected, but this varies significantly from one brand to another. For some drawings, lateral bleeding and blending is desirable; for others, crisper lines and detail are needed.

Some marker papers have high-contrast, dense white surfaces and are not meant for reproduction. Others have a degree of transparency that allows for printing. Select the brand to suit the purpose.

Butcher paper or freezer paper can be bought in large rolls and is excellent for outsized conceptual or preliminary drawings done with markers, though not for reproduction.

Drafting film, such as Mylar, is traditionally used with ink for technical drawings, but it is also a versatile surface for pencil sketching. A wide range of tone densities can be easily and quickly drawn on the finely toothed surface. The best sketch tools for Mylar are the sharp 2B pencil, the flat sketch pencil, the graphite block, or the more waxy art sticks.

Techniques

How you hold the drawing instrument is critical and very different from drafting. Keep the pencil or pen at a low angle and hold with a relaxed grip and extended fingers.

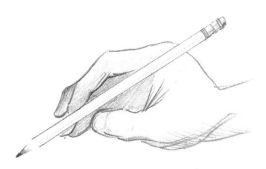

Free-flowing lines

When drawing curved, interconnected lines over an inch or so (3 cm) in size the forearm should not be supported and the wrist should not bend. All the movement comes from elbow and shoulder pivots with the small fingers gliding across the surface for stability. There is no need for finger movement.

Only as the shapes, lines and patterns get quite small (less than 1/2" or 1cm) should you bring a front and back finger movement into play.

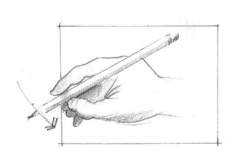 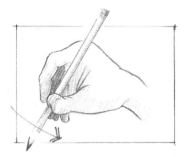

Most of your freehand sketching should be done from an **elbow pivot,** keeping your fingers still. On larger shapes keep wrist movement to a minimum also. Some wrist movement may be helpful on smaller shapes.

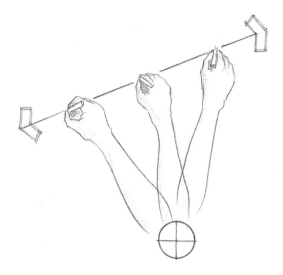

Don't curl your fingers under or hold the pencil in a "death grip."

With a soft pencil it is possible to create a variety of expressive lines which will be useful later when you draw the various landscape elements in sections and perspectives.

Free-form shapes with one line should have a clean connection, or match, with a slight gap. Multiple lines are also quick and effective.

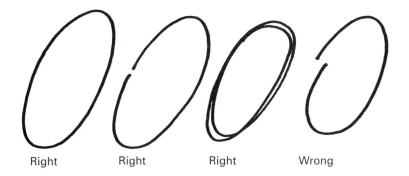

Right Right Right Wrong

Long, Straight Lines

These are easier to control by resting the elbow and using it as a pivot, keeping the wrist and fingers immobile. Horizontal lines are easiest. Stop and start if necessary, readjusting the elbow to draw very long lines.

Small gap acceptable

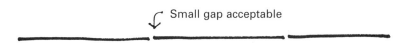

For diagonal or vertical lines, adjust body position or the paper to maintain the elbow as a pivot.

When joining two points with a straight line, start at one point, look at the other, and then draw the pencil quickly toward it.

Shorter, Straight Lines

These are done the same way as long straight lines, again with no wrist movement.

Draw each line with confidence and speed. Make definite endings by using a pressure start and a pressure stop. Let the line in between develop a tonal character.

Go fast in middle to give character to the line.

Hit at start of stroke. Hit at end of stroke.

Correct: Fast, confident lines, with strong ends and positive connections from slight crossing.

Wrong: Slow, deliberate, heavy pressure lines with weak corners.

Wrong: Hesitant hatch lines and scratch lines. Lack confidence and character.

Detail lines

Very short hatch lines or smaller curved lines are drawn with the wrist and fingers working in harmony. The hand should rest on the side.

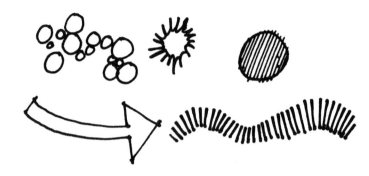

Hatching and Toning Lines

Keep lines parallel and try to connect each line to the outline. A slight overlap is acceptable.

Fine liner Pencil

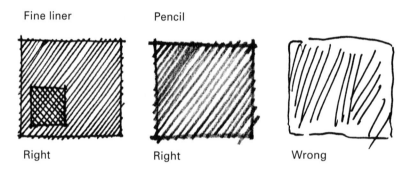

Right Right Wrong

With a soft pencil it is possible to create a variety of expressive lines which will be useful later when you draw the various landscape elements in sections and perspectives.

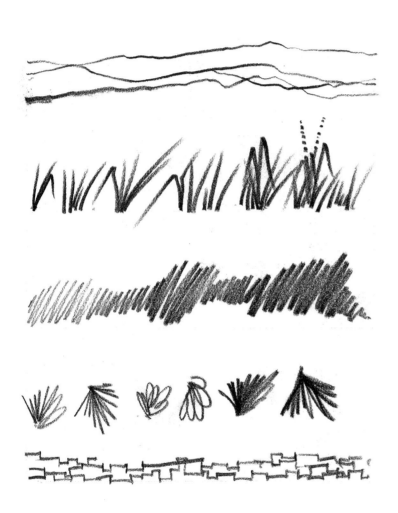

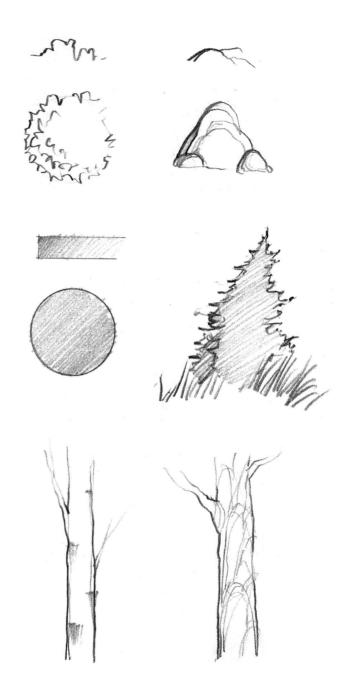

Conceptual Diagramming

Conceptual drawings use the freehand techniques just discussed since they are exploratory in purpose and loose in character. The graphics can be very abstract or somewhat representative depending on the stage of refinement. The abstract graphics can be as simple as blobs, arrows and squiggles and are used primarily to explore **functional relationships** such as activity locations and circulation patterns. No attempt is made to convey exact shapes textures, materials or forms. This is very often a rapid early step in the design process with the drawings used primarily for the designer's eyes only, then discarded when their purpose has been fulfilled.

Sometimes it is helpful to prepare a functional diagram or conceptual plan to discuss with and get feedback from your client at an early stage in design. A slightly more presentable graphic would be in order here. There are no conventional symbols that are right or wrong but some ideas are included here to save you the time of inventing your own, (see drawings page 53). Typically the symbols will indicate approximate location of buildings or building envelopes, activity and use zones, pedestrian and automobile circulation, screens, barriers and points of interest or conflict.

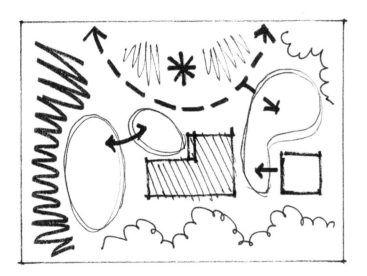

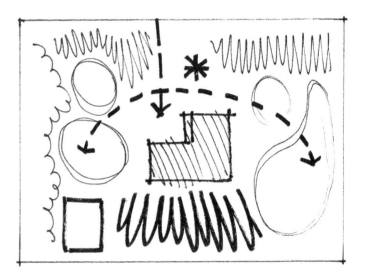

Active lineal symbols

Choose and adapt the following symbols to show:

Automobile circulation
Pedestrian circulation
Access points, exits, entries
View direction
Wind direction
Water movement
Movement of any kind

Passive lineal symbols

Choose and adapt the following symbols to show;

Barriers
Screens
Walls
Noise corridors
Ecological and landscape edges such as cliffs, embankments, forest edges
etc.

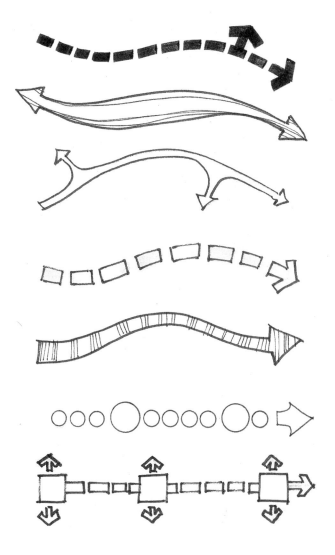

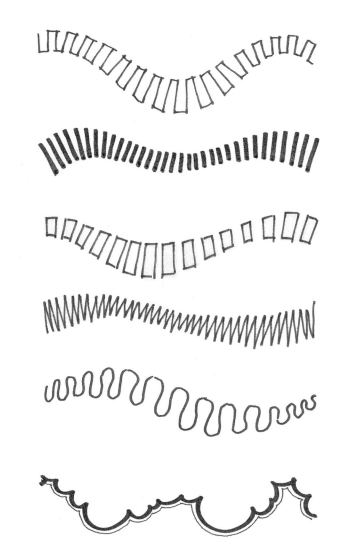

Nonlineal symbols

Activity areas, use zones, functional spaces

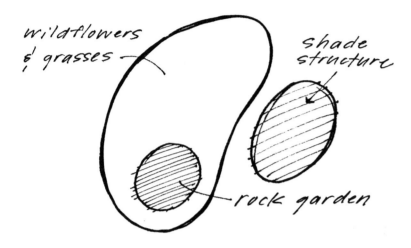

Buildings and structures

Focal areas, points of interest, conflict zones, circulation nodes.

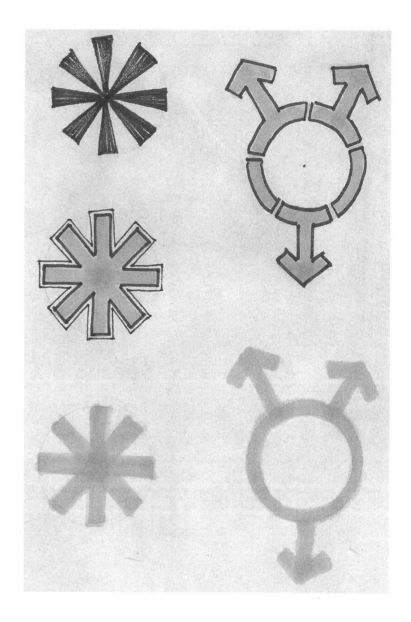

Concept Plan

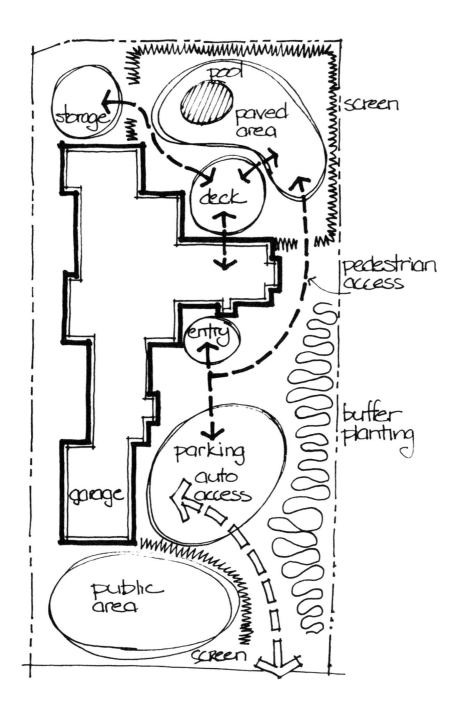

Conceptual diagram

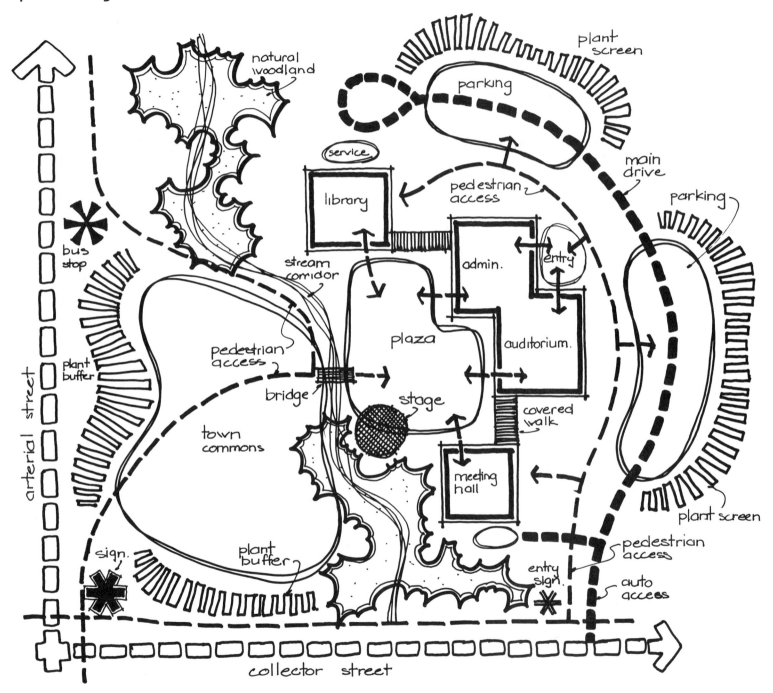

natural woodland

plant screen

parking

service

main drive

parking

library

pedestrian access

bus stop

entry

stream corridor

admin.

plant buffer

plaza

auditorium.

pedestrian access

stage

bridge

covered walk

town commons

meeting hall

plant screen

pedestrian access

sign.

plant buffer

entry sign.

auto access

arterial street

collector street

Conceptual Diagram

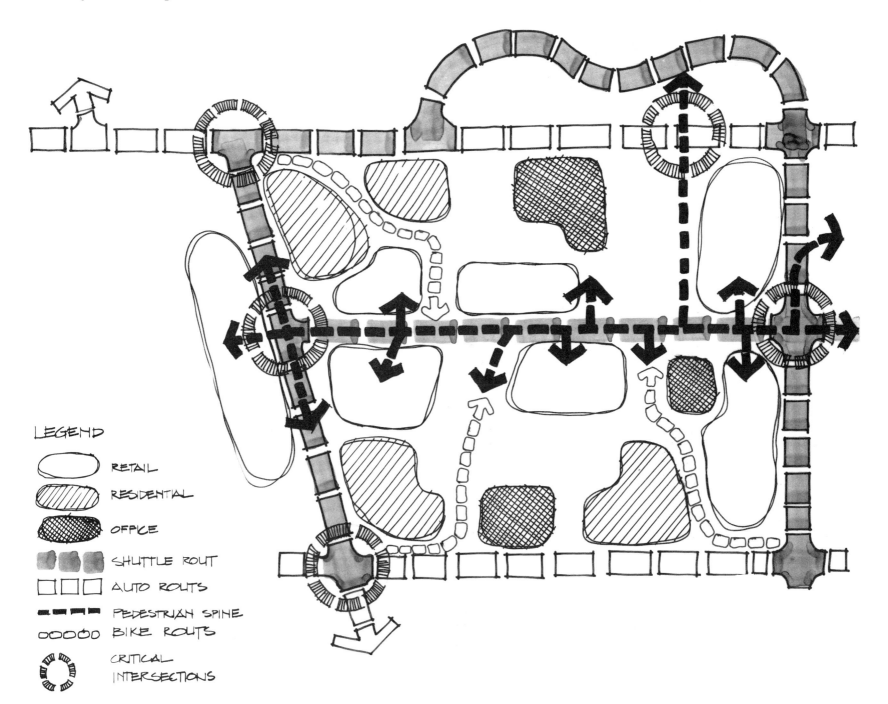

LEGEND

RETAIL

RESIDENTIAL

OFFICE

SHUTTLE ROUT

AUTO ROUTS

PEDESTRIAN SPINE

BIKE ROUTS

CRITICAL INTERSECTIONS

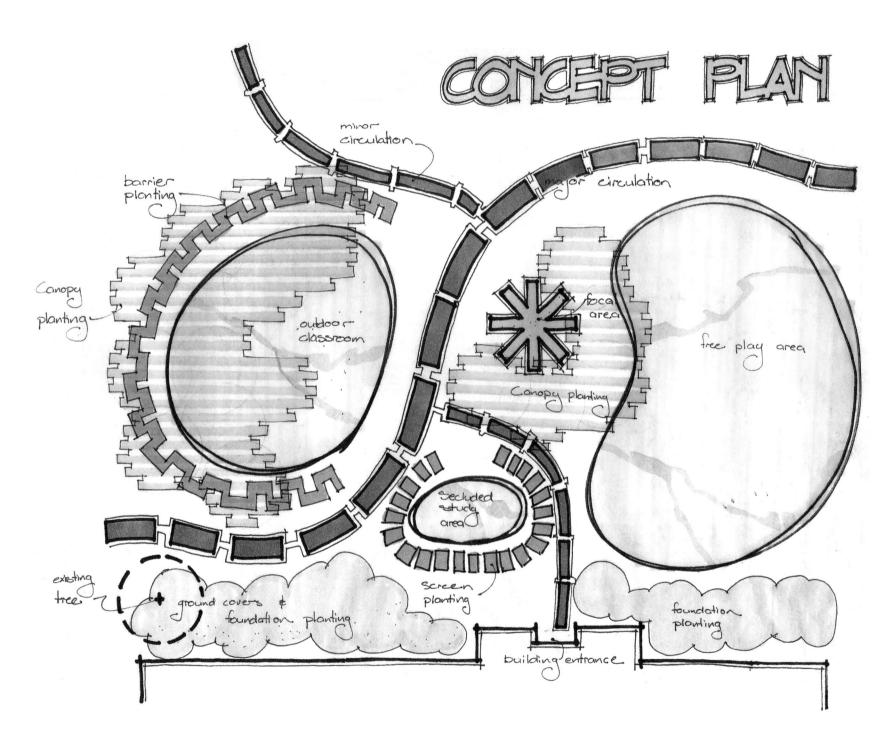

CONCEPT PLAN

minor circulation

major circulation

barrier planting

Canopy planting

outdoor classroom

focal area

Canopy planting

free play area

Secluded study area

existing tree

ground covers & foundation planting

screen planting

foundation planting

building entrance

Concept Plan

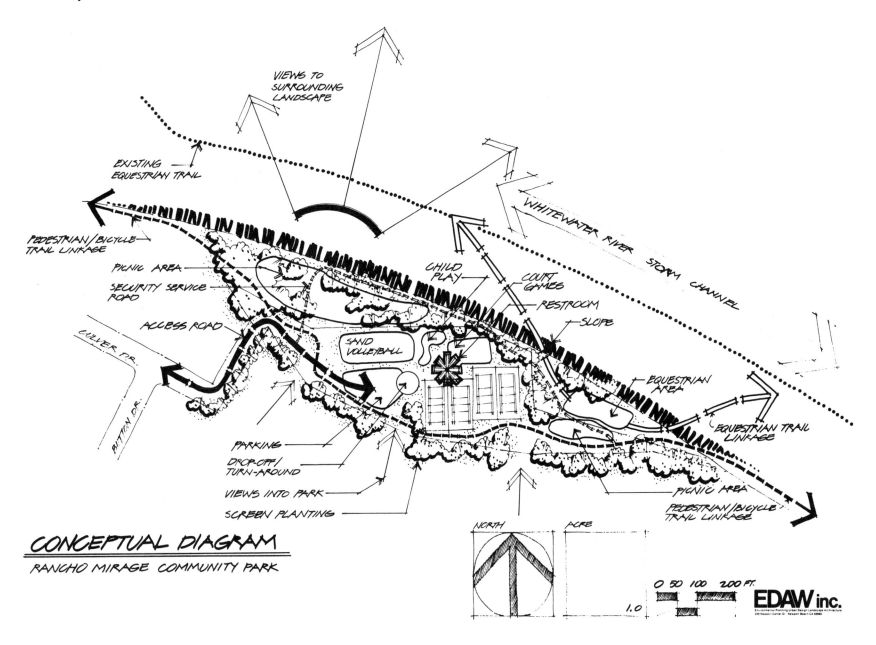

VIEWS TO SURROUNDING LANDSCAPE

EXISTING EQUESTRIAN TRAIL

WHITEWATER RIVER STORM CHANNEL

PEDESTRIAN/BICYCLE TRAIL LINKAGE

PICNIC AREA

SECURITY SERVICE ROAD

ACCESS ROAD

CHILD PLAY

COURT GAMES

RESTROOM

SLOPE

CULVER DR.

SAND VOLLEYBALL

BUTTON DR.

EQUESTRIAN AREA

EQUESTRIAN TRAIL LINKAGE

PARKING

DROP-OFF/ TURN-AROUND

VIEWS INTO PARK

SCREEN PLANTING

PICNIC AREA

PEDESTRIAN/BICYCLE TRAIL LINKAGE

CONCEPTUAL DIAGRAM
RANCHO MIRAGE COMMUNITY PARK

NORTH

ACRE

1.0

0 50 100 200 FT.

EDAW inc.
Environmental Planning Urban Design Landscape Architecture
220 Newport Center Dr Newport Beach CA 92660

Exercises

Your goal should be to draw frequently and with confidence. It is less important what you draw. The idea is to experiment and accept everything you do as okay. Keep a 9 x 12" (A4 i.e. 210 x 297mm) sketchbook and try to do three or four sketches every week. If you are in a group and have an instructor, you can get hints from others on how to improve but your work should not be competitively evaluated. It is much better to take a "just do it" attitude and not rate yourself or be rated by an instructor against others. This section of the book is deliberately superficial regarding freehand sketching because there are many excellent books which focus on pencil or pen and ink landscape sketching (see bibliography). You should find one that suits you and use it as a companion to this book. The following exercises will loosen you up and get you started. Some background music might help.

4.1 Freeform shapes
Media: Felt tip pen on 18 x 24" (A2 i.e., 420 x 594 mm) tracing paper.
Draw series of freehand ovals and blobs of different sizes and shapes. Make some forms single line and others multiple line.

4.2 Long lines
Media: Felt tip pen on 18 x 24" (A2) tracing paper.
Place three or four dots near the left and right side of the paper. Connect them across the sheet with "close to straight" lines. It is okay to stop a few times leaving a small gap. Fill the rest of the sheet with smooth, flowing, curved lines again, leaving small gaps if you wish.

4.3 Boxes and angular forms
Media: Felt tip pen on 18 x 24" (A2) tracing paper.
Invent a composition of straight sided shapes that could represent architectural or built landscape elements. Keep it entirely freehand, making positive connections at all corners. Allow some shapes to penetrate others and add tone of lines to some of the smaller shapes.

4.4 Simple line drawing
Media: Felt tip pen on any 9 x 12" (A4) paper.
Loose line sketches can be effective design development graphics. Choose one organic object and one mechanical object. Use confident freehand lines to capture the outer edges and abrupt changes of the inner planes. Do not use toning.

4.5 Continuous line
Media: Felt tip pen on any 9 x 12" (A4) paper.
Repeat exercise 4.4 with two different objects, only this time keep the pen in constant contact with the paper. Use the continuous line to abstract the dominant edges, indentations, protrusions and contour. Suggested objects: pencil pointer, knife, keys, shoe, hat.

4.6 Line expression
Media: Soft pencil on any 9 x 12" (A4) paper.
Experiment with sharpness, pressure, and angle to the paper to make at least six different line doodles. Now select three or four and use each one to create an organic landscape object or portion of an object. Suggested subjects: landform, rocks, bark on a tree trunk, leaves, branches, etc. Try to communicate form and or texture by building up zones of similar doodles.

4.7 Fast trees
Media: Felt tip pen on any 9 x 12" (A4) paper.
Fill the page with about six simplified trees copied from the page of "Fast Outline Trees" in chapter 7.

4.8 Copied concept plan
Media: Felt tip pens on 12 x 18" (A4) marker paper
Copy one of the conceptual drawings from this chapter.

4.9 Invented concept plan
Media: Felt tip pens and colored markers on 12 x 18" (A3 i.e., 297 x 420 mm) marker paper.
Incorporate most of the different functions listed and organize them in a cohesive conceptual plan composition. Use only abstract graphic symbols similar to those shown in this chapter. Do not draw lines that represent the edges of objects, such as either side of a walk, the exact edge of a water body, the edge of a plaza etc. Choose either a park or an urban plaza.

Park	Urban plaza
Public road	Bus stop
Main entry	Seating areas
Automobile circulation	Auto access to parking
Parking zone	Parking zone
Pedestrian trail system	Pedestrian access
Information center	Information kiosk
Play equipment area	Focal fountain
Picnic areas	Performance area
Concession building	Shops
Nature center	Clock tower
Forest edges	

Presentation Plans

At this stage in the design process you will be presenting your ideas to an audience for the purpose of persuading them to accept your ideas and to elicit some feedback about your design. The audience is usually your client but may also be a group of fellow professionals or the public. In any case the graphics need to create a clear understanding of your design and be appealing as well. You may need to combine several graphic projections such as plan view, section view or perspective view. This chapter deals with plan view graphics. The following chapters deal with sections and perspectives.

The main reason why the plan view is the most commonly used projection for presentation is that in this projection it is easy to manipulate and show to scale the essential horizontal relationships of a design. With a few graphic tricks, such as layering symbols and shadowing, we can hint at depth, but the plan view has serious limitations regarding the vertical relationships of landscape elements and the realistic eye-level spatial experience.

Picture the plan view as a diagram of the site as seen looking straight down from a hot air balloon. The graphic symbols represent the real objects and materials that are to be part of the proposed site improvements. Of course, this is an abstraction of reality, and the symbols chosen can create a fairly realistic message or a rather abstract message. Abstract symbols are simple and fast to create but are not as convincing as the more realistic symbols. The graphic renderer must choose the correct balance between abstraction and realism to suit the message, the budget, and the time available.

The symbols shown in this chapter have been developed to produce the most convincing message with an economy of time. In most cases presentation plan drawings would be completed in color. Only black-and-white techniques are shown here but you can adapt many of the ideas to color rendering.

Most presentation plans require the combination of both straightedge and freehand techniques. They are more precise and realistic than concept plans but looser and more expressive than construction drawings. If you are doing most of your work on the computer and want to loosen up a drawing you might wish to print out a basic plan showing the simplified structure of your design then add symbols by hand. Another possibility is to scan the symbols you like into your computer files and manipulate them directly on the computer.

Let's assume you have figured out the plan and have it in a rough outline form with no plants or other material details shown. The next step is to understand the objects you are going to represent. Think about their shape, texture, and reflective qualities. Choose line quality, tone and texture symbols that represent these qualities. Practice the symbols separately by copying from the following pages then blend them together in cohesive compositions. Eventually you will invent your own symbols and develop your own unique style.

Quick Trees

These are the fastest symbols for deciduous trees and adapt very well to the application of color. Start with a light circle template guideline. Always place a dot in the center.

Single or double circle template outline

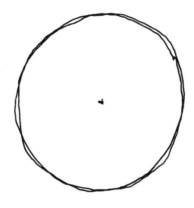

Freehand double outline

Double outline with a few radial lines

Outline with small Ws connected to double radial lines.

Thick and thin double outline.

Outline with curved radial lines

Foliage texture trees

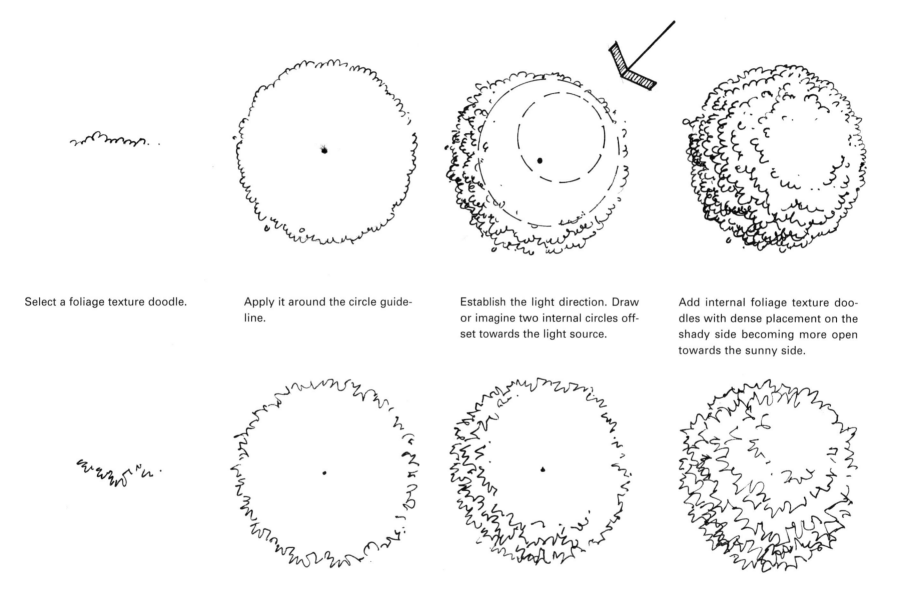

Select a foliage texture doodle.

Apply it around the circle guide-line.

Establish the light direction. Draw or imagine two internal circles off-set towards the light source.

Add internal foliage texture doo-dles with dense placement on the shady side becoming more open towards the sunny side.

Branch pattern trees

Good for showing winter effects, layering other symbols underneath, or simply adding contrast to outline plant symbols.

Sequence

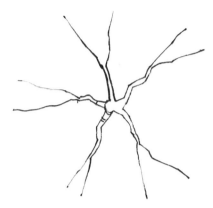
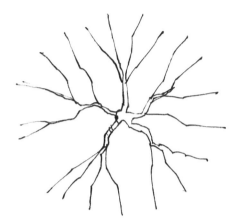
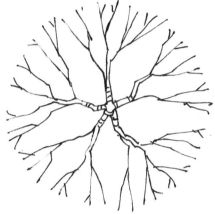

Start with five main branches within the circle guideline.

Add secondary branches starting at an internal branch and finishing at the guideline.

More small branches emphasize the edge.

Other branched trees

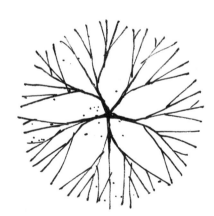
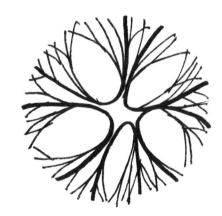
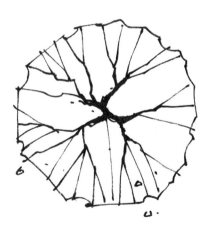

Branched pattern trees for larger scale plans 1/4" = 1'— 0" or 1:50

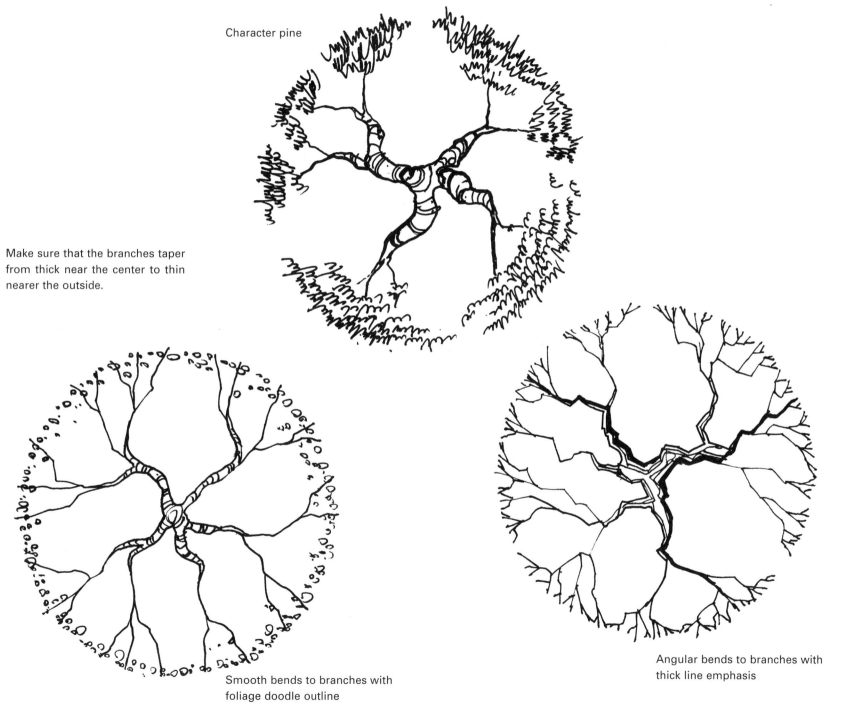

Character pine

Make sure that the branches taper from thick near the center to thin nearer the outside.

Smooth bends to branches with foliage doodle outline

Angular bends to branches with thick line emphasis

Coniferous trees

As usual start with a light guide-line center point.

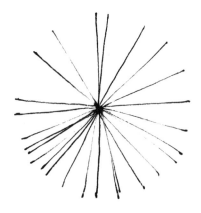

Place freehand lines from one side to the other directly through the center point.

Add more lines from the center to the edge on the shady side. A few thicker lines add character.

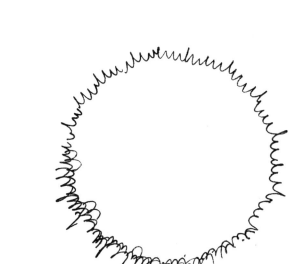

Other quick symbols for conifers

Tropical Plants
Bold, coarse, textured foliage

Overlapping foliage doodles give an appearance of depth.

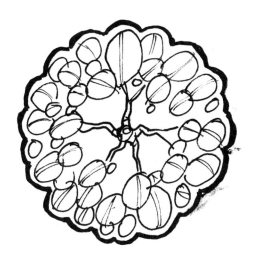

More tropical vegetation

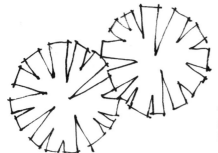

Always use a circle template guideline. Some symbols also have an inner circle.

Combine thick and thin lines to create interest.

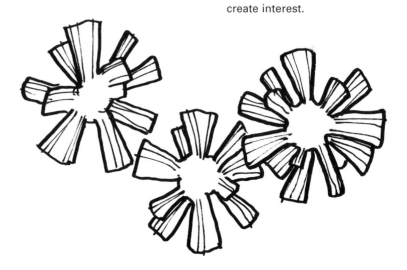

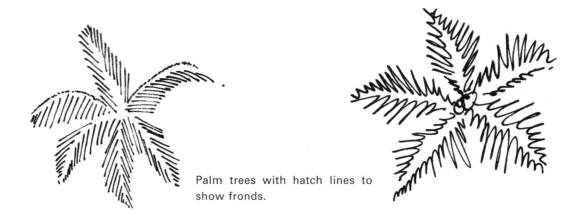

Palm trees with hatch lines to show fronds.

Desert Plants

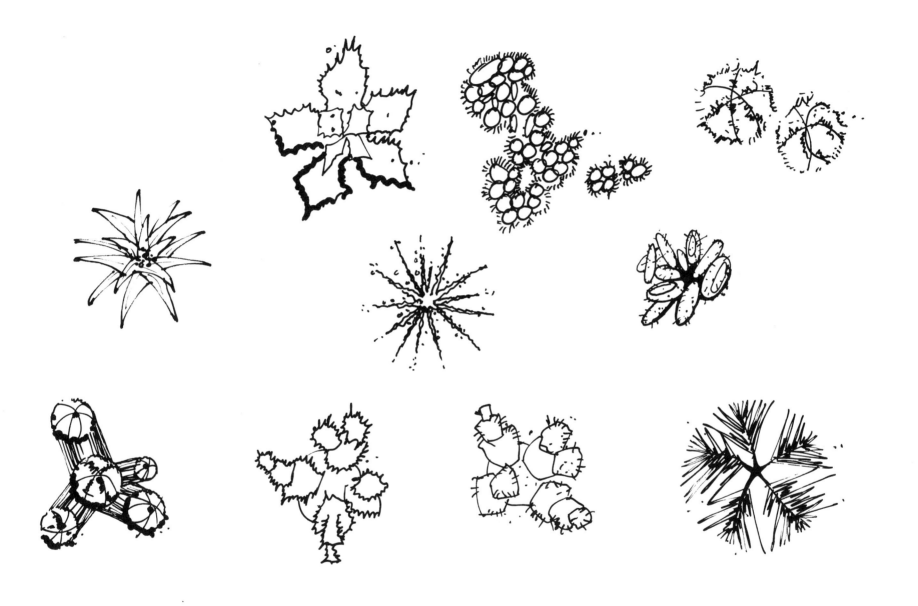

Shrubs

These can be drawn using smaller replicas of tree symbols. Usually these would be in larger groups.

Start with a cluster of light circle template outlines with each circle touching or slightly overlapping.

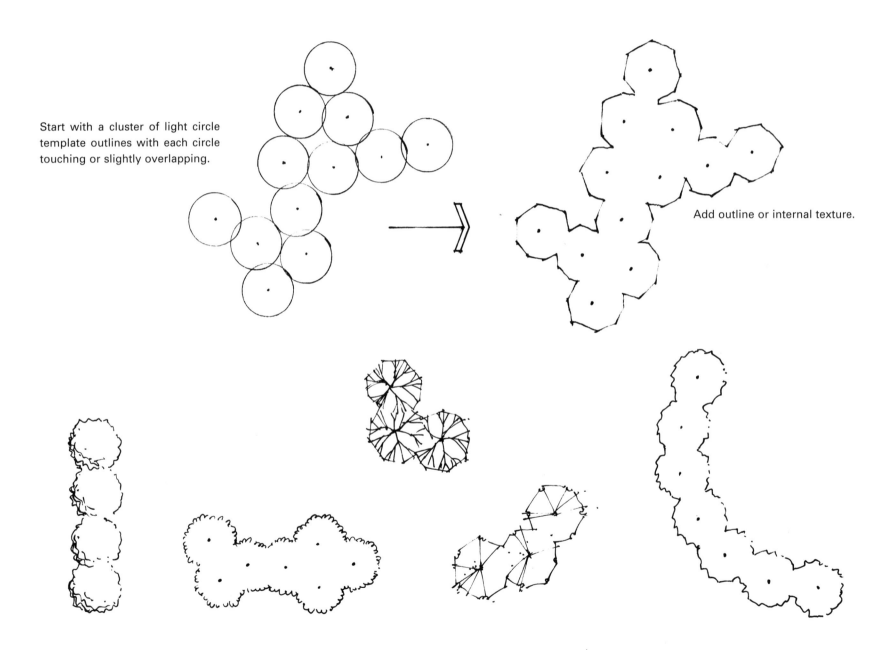

Add outline or internal texture.

More shrub groups

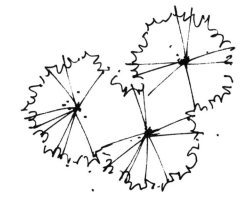

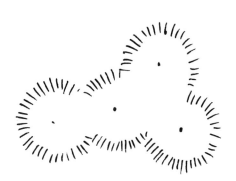

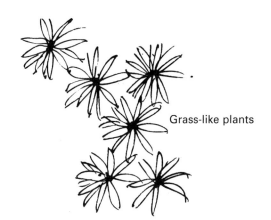

Grass-like plants

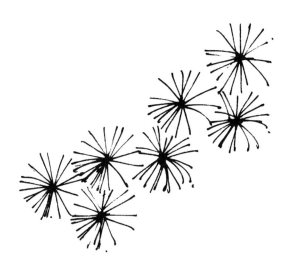

Ground Covers

Large areas of grass, flowers, spreading plants, or mulch may be left totally untouched. This is obviously the most time effective approach and is often quite adequate, especially if color is to be added later.

If some definition is in order, first try a simple doodle outlining the zone of ground cover. A graded stipple is effective for turf or sand. Other patterns might match the foliage character. If you have more time and want to add tone to the drawing, try adding more of the same doodle.

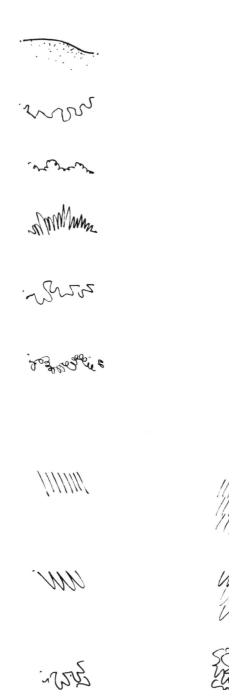

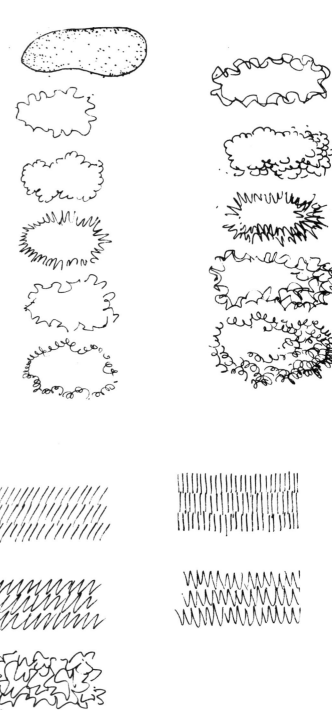

If you want a total in-fill texture, try these symbols. To rapidly create the in-fill symbols, which are lined up, try taping two triangles together and rapidly stroke between the straight edges. Best results are obtained by keeping the rows horizontal and parallel. Make sure that successive rows touch or overlap slightly.

Composite Planting Plan

When putting all the plants together you need to think about **layering**, **symbol identity** and **tonal balance**.

Layering is where some symbols overlap or appear to be underneath others.
Symbol identity refers to the ease of distinguishing one group of plants from another.
Tonal balance is the contrasting densities of lines or tones of lines. This is less important if you intend to add color but becomes very important if your plan has to read well in black and white.

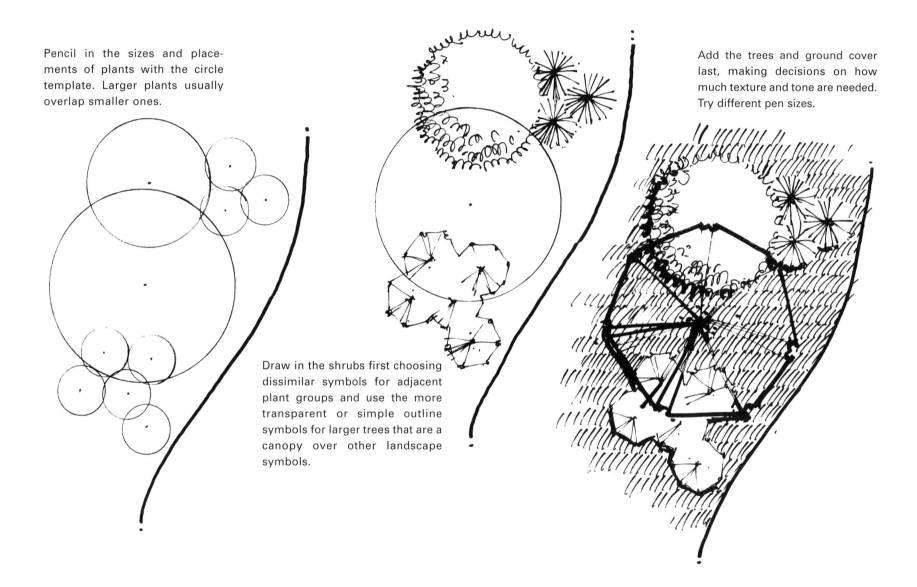

Pencil in the sizes and placements of plants with the circle template. Larger plants usually overlap smaller ones.

Draw in the shrubs first choosing dissimilar symbols for adjacent plant groups and use the more transparent or simple outline symbols for larger trees that are a canopy over other landscape symbols.

Add the trees and ground cover last, making decisions on how much texture and tone are needed. Try different pen sizes.

Composite planting plan example

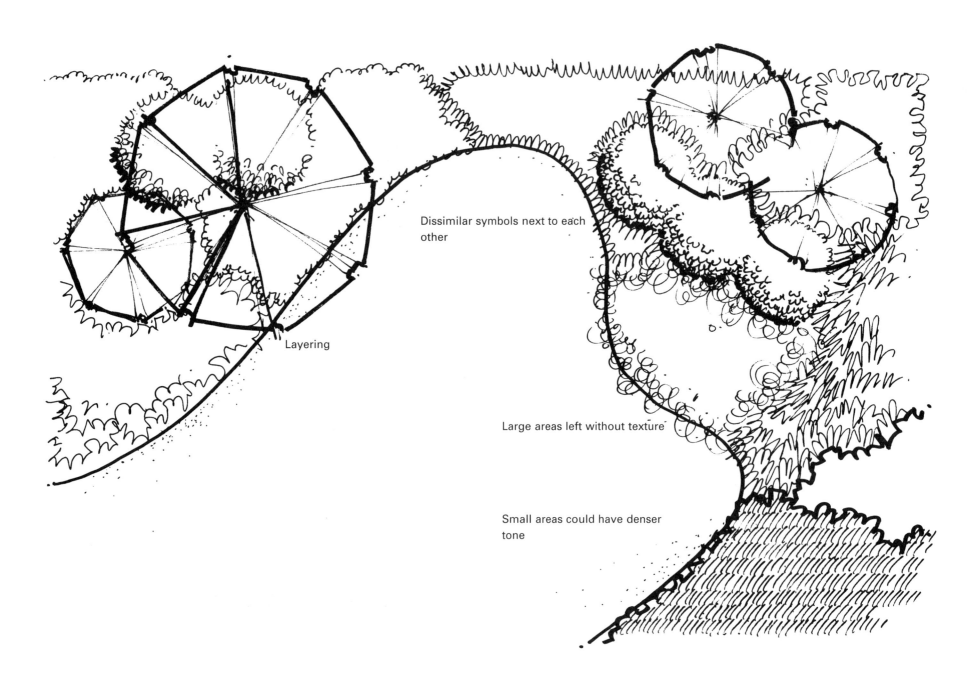

Dissimilar symbols next to each other

Layering

Large areas left without texture

Small areas could have denser tone

Planting plan with shadows

Landform

Slopes, embankments, mounds, escarpments, cliffs and other landforms are difficult to show in plan view since they involve vertical changes. Here are some possibilities.

This symbol of irregularly placed lines running perpendicular to conceptual contour lines is effective for drawings at a scale between 1"=10' and 1"= 40' (1:200 and 1:500).

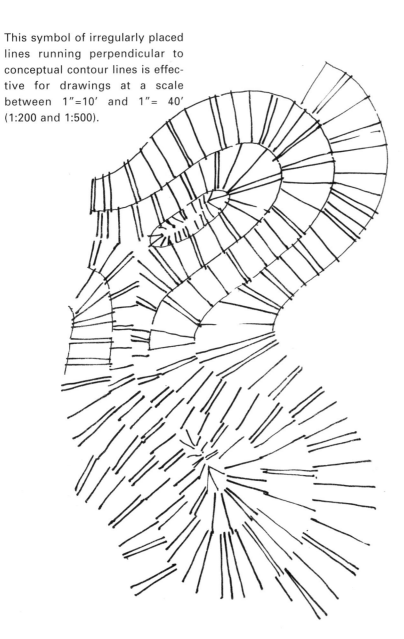

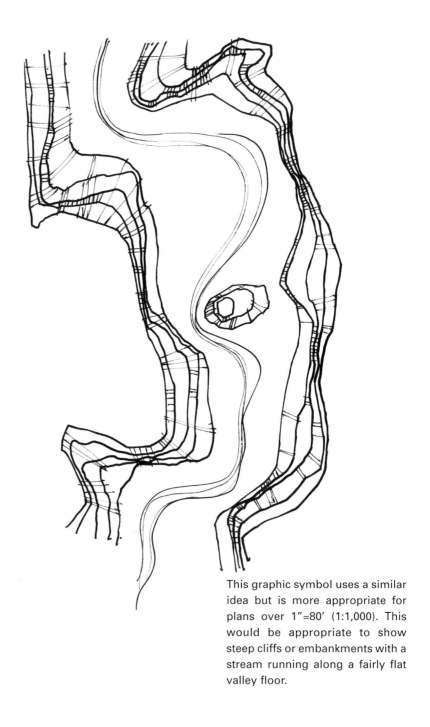

This graphic symbol uses a similar idea but is more appropriate for plans over 1"=80' (1:1,000). This would be appropriate to show steep cliffs or embankments with a stream running along a fairly flat valley floor.

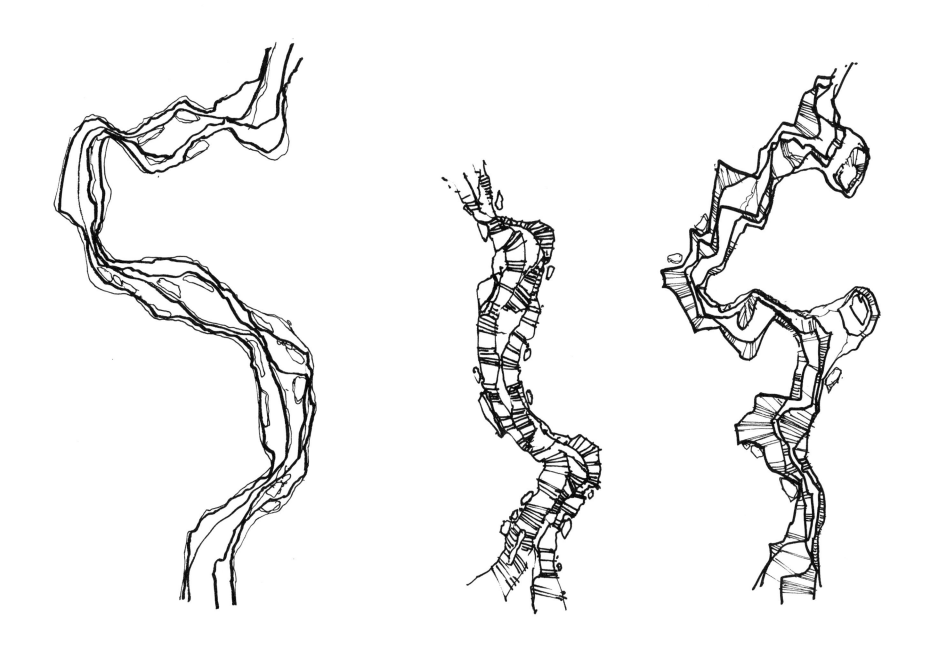

Rocks

Boulders and cobbles lining a creek bed

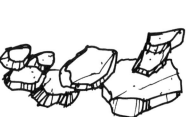

Rounded, river-worn boulders

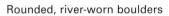

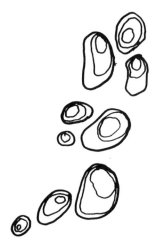

Sharp angular rocks

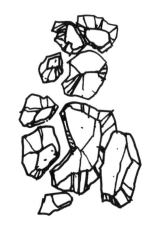

Rocks look best in groups with some touching and overlapping.

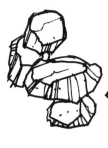

Blocky rocks with smooth corners

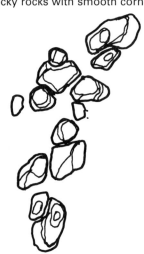

Informal stacked rock wall

Formal cut stone wall

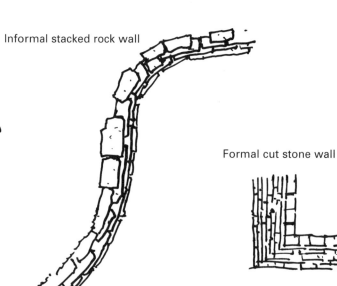

Plate-like layered or stratified rocks

Naturalistic Water Features

A meandering stream or river could be as simple as a few fine flowing lines. Some other natural waterways are shown here.

It is best to leave the water itself as mostly white space and let the edge symbols (rock, embankment, vegetation, sand) capture its form and character.

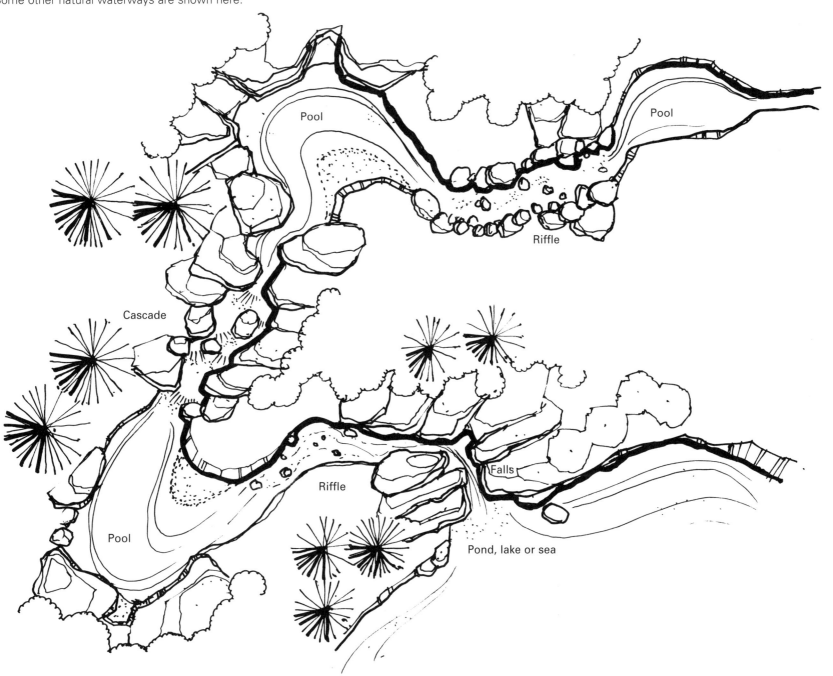

Architectural Water Features

As with all water it is best left white or lightly textured to show jets, splashing and ripples. Its form of containment sets the character and its full impact is created by adding color

Paving

At scales of 1″=20′ (1:250) it is not necessary to texture the entire surface. Place hints of fine texture in clusters at edges and corners. Fade or fragment the texture towards the middle.

At scales of 1″=10′ or 1/8″=1′-0″ (1:100) the texture becomes coarser and you can still leave some zones without texture.

At the detailed scale of 1/4″=1′-0″ (1:50) you need to show almost every paving element. Even the jointing begins to show.

cobbles or rounds

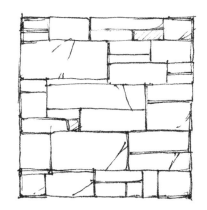
random flagstone

rectangular cut stone

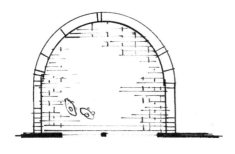

1/8"=1'-0" (1:100)

Brick patio

1/4"=1'-0" (1:50)

1/8"=1'-0" (1:100)

Wood deck

1/4"=1'-0" (1:50)

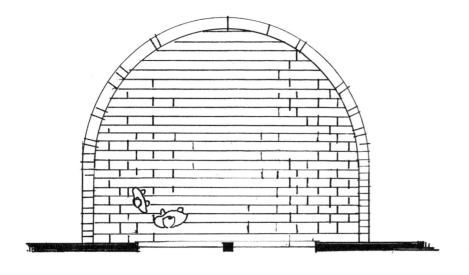

Landscape Structures

Overhead structures can be shown as having solid elements blocking some ground plane features or as dashed outlines allowing all ground plane textures to show.

Tsukubai

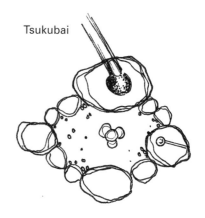

Overhead

Lantern

Bridges

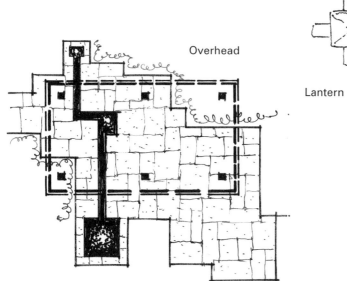

Small fountain

Pavilion or Gazebo

Seating

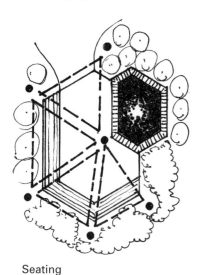

Pergola

Buildings

Landscape plans usually relate to buildings, so it is important to show them graphically in a manner that supports the landscape design.

A **singe outline**, drafted or free-hand, is often adequate especially for site planning and other drawings of sites over 5 acres (2 hectares).

A thick and thin **double outline** adds power to the building form. When adding color to the overall plan the buildings are usually left uncolored to emphasize the land-scape.

For sites less than 2.5 acres (1 hectare) and drawings at a scale of 1"=10' (1:200) and more detailed, it is often important to show where doors and windows are located. Walkways and other hard surfaces may connect direct-ly with doors. Landscape views and screening may be related to windows. Show walls as a thick solid line, windows as a double line and doors as a single outside line.

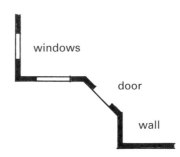

Buildings with roof character

If you wish to bring a little more realism to the buildings on the landscape plan try drawing them with some roof structure. Begin with a roof outline including breaks in roof pitch.

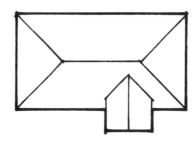

Establish a light direction and add some texture lines parallel to the contour of each roof surface.

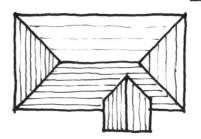

Add more texture lines on the shaded sides. Place the darkest tones on those surfaces facing most directly away from the light.

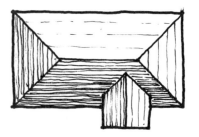

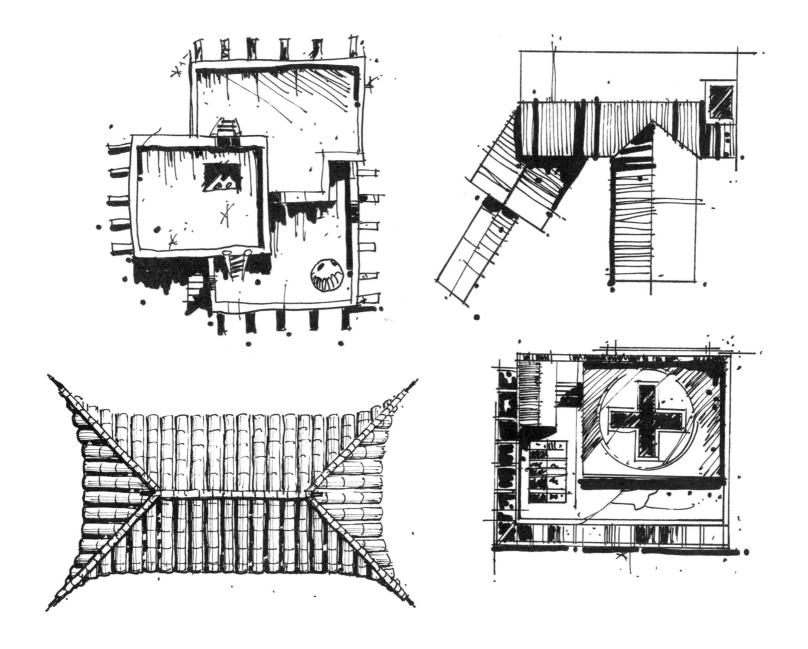

Roads and Sidewalks

Cars and people show activity and function.

Cars and Trucks

A help in showing scale and function, cars and trucks are best done freehand. Keep shapes simple.

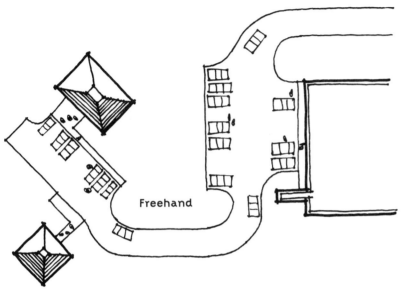

Freehand

People

Oval with a black dot for the head

Abstract shadow

Hint of feet possible on larger people

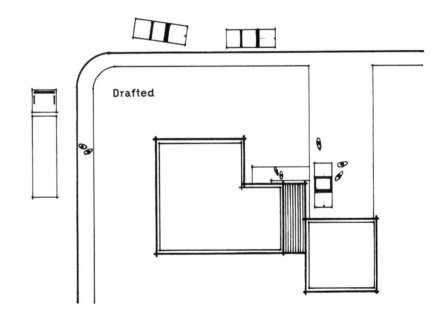

Drafted

Shadowing

It is not necessary to add shadows to all plans but dark shadows add a dimension of depth to your plan and can give hints to the some of the vertical interest in the design.

Shadow direction

Because we are used to the light coming from above, it is important to cast the shadows **down** to the left or right. This creates the most powerful three-dimensional visual impact, lifting the features off the page. If the north indication is pointing up, as it should be on landscape plans, then this downward or southerly shadow direction is realistic for southern-hemisphere countries where the sun follows a northern arc and unrealistic for northern-hemisphere countries where the sun follows a southern arc. So in the northern hemisphere it is better to favor graphic impact over realism. The one exception would be if you are doing a solar study where shadow patterns are a critical part of the design message. In this case cast the shadows exactly as the sun direction and angle dictate. In any case, all the shadows on the one drawing must follow the same light direction.

Shadow density

The most powerful shadows are solid black, a very dark gray or a very dark blue.

 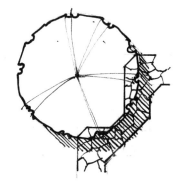

Shadows can also be done with a directional hatch or with a medium tone marker. They lose some of their impact, but have the advantage of allowing some ground elements to show through. Do not mix solid black shadows and toned shadows on the same drawing.

Shadows from plants

Establish a light direction.

Let's assume that most plants have a somewhat rounded form. Place a circle template that matches the plant size over the symbol. Slide the template away from the light source a little and draw a guideline.

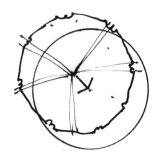

Fill in the space that looks like a new moon between the guideline and the tree symbol.

For plants that have a somewhat pyramidal form, draw a cone-like outline in place of the "new moon" outline.

The in-fill looks best if the outline is irregular.

Shadows from buildings and landscape structures

Establish the light direction as with plant shadowing. Draw lines parallel to the light direction from the corners of the structure.

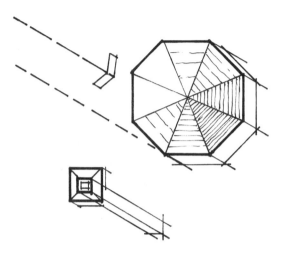

Taller objects cast longer shadows so the length of these lines should be in proportion to the height of the top corner from the ground. Finish off the shadow shape with lines parallel to the top edge of the structure.

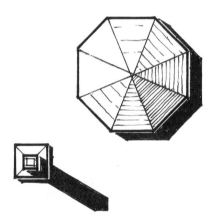

Fill in the shadow zone leaving a thin white space between the shadow and the object to maintain the object edge.

Expressing ground forms with shadows

Shadow shape will need to be adjusted when the ground is sloping or stepped and when the shadow falls on top of other landscape forms.

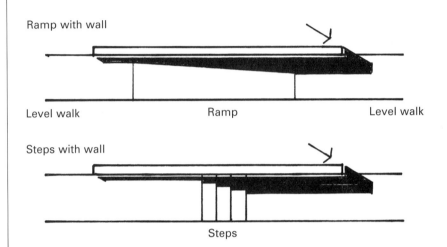

Ramp with wall

Level walk Ramp Level walk

Steps with wall

Steps

Swimming pool

Shallow end Deep end

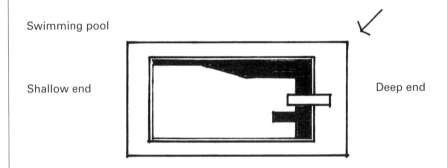

Building shadow broken up by nearby plants.

Fast shadows using markers

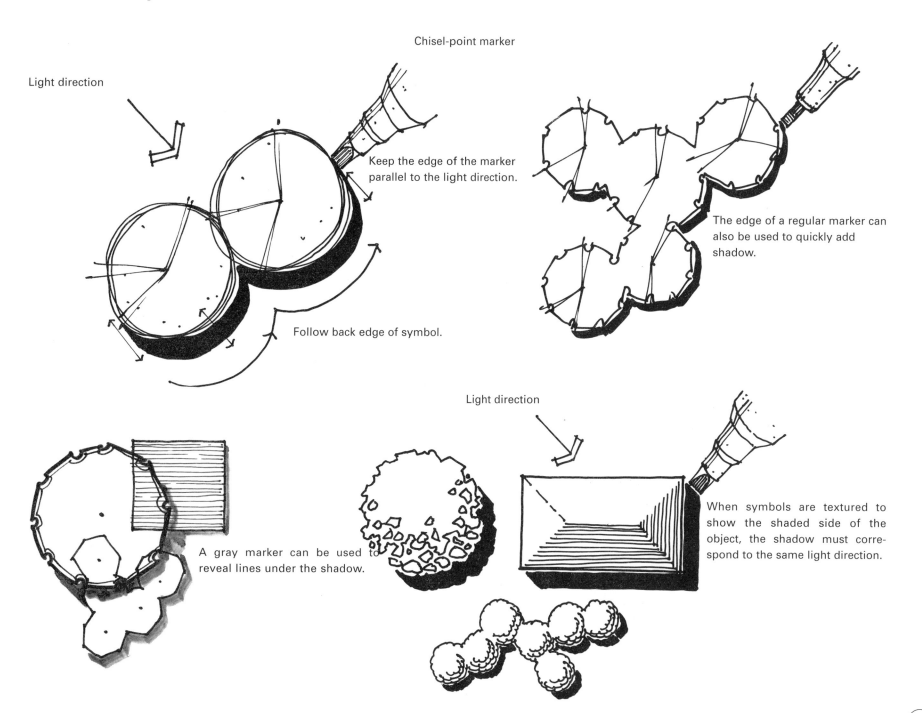

Light direction

Chisel-point marker

Keep the edge of the marker parallel to the light direction.

Follow back edge of symbol.

The edge of a regular marker can also be used to quickly add shadow.

A gray marker can be used to reveal lines under the shadow.

Light direction

When symbols are textured to show the shaded side of the object, the shadow must correspond to the same light direction.

Composite Shadows

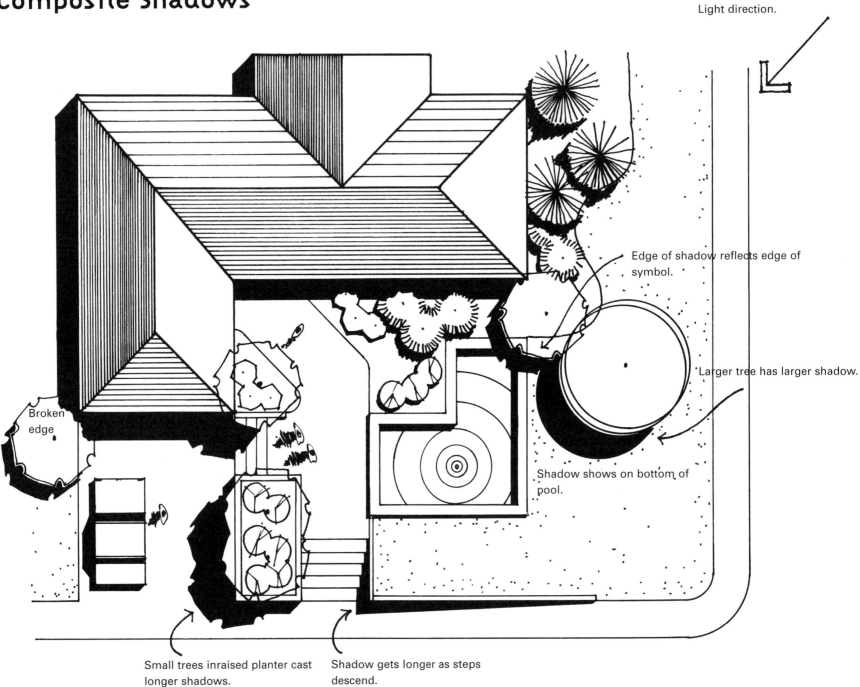

Light direction.

Edge of shadow reflects edge of symbol.

Larger tree has larger shadow.

Broken edge

Shadow shows on bottom of pool.

Small trees inraised planter cast longer shadows.

Shadow gets longer as steps descend.

Plan without shadows

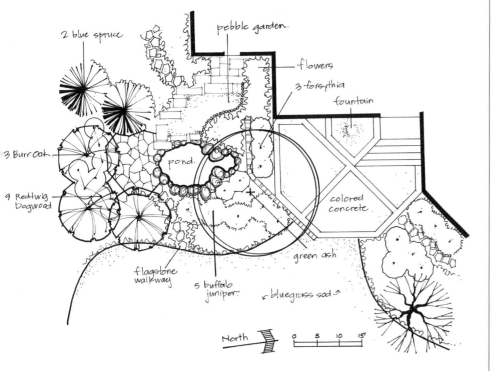

2 blue spruce

pebble garden

flowers

3 forsythia

fountain

3 Burr Oak

pond

9 Redtwig Dogwood

colored concrete

flagstone walkway

green ash

5 buffalo juniper

bluegrass sod

North 0 5 10 15'

Plan with shadows

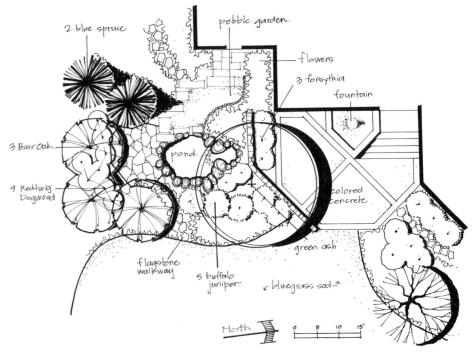

2 blue spruce

pebble garden

flowers

3 forsythia

fountain

3 Burr Oak

pond

9 Redtwig Dogwood

colored concrete

flagstone walkway

green ash

5 buffalo juniper

bluegrass sod

North 0 5 10 15'

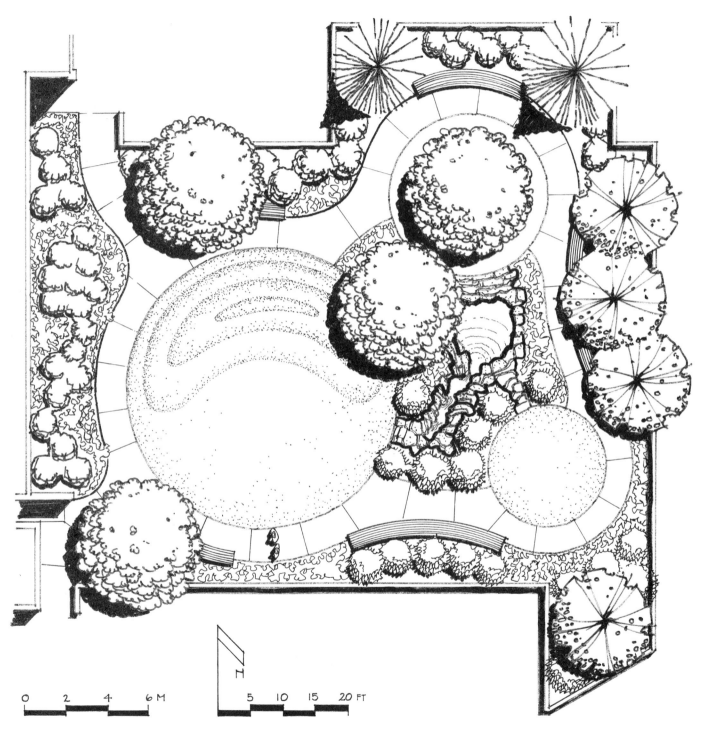

0 2 4 6 M 5 10 15 20 FT

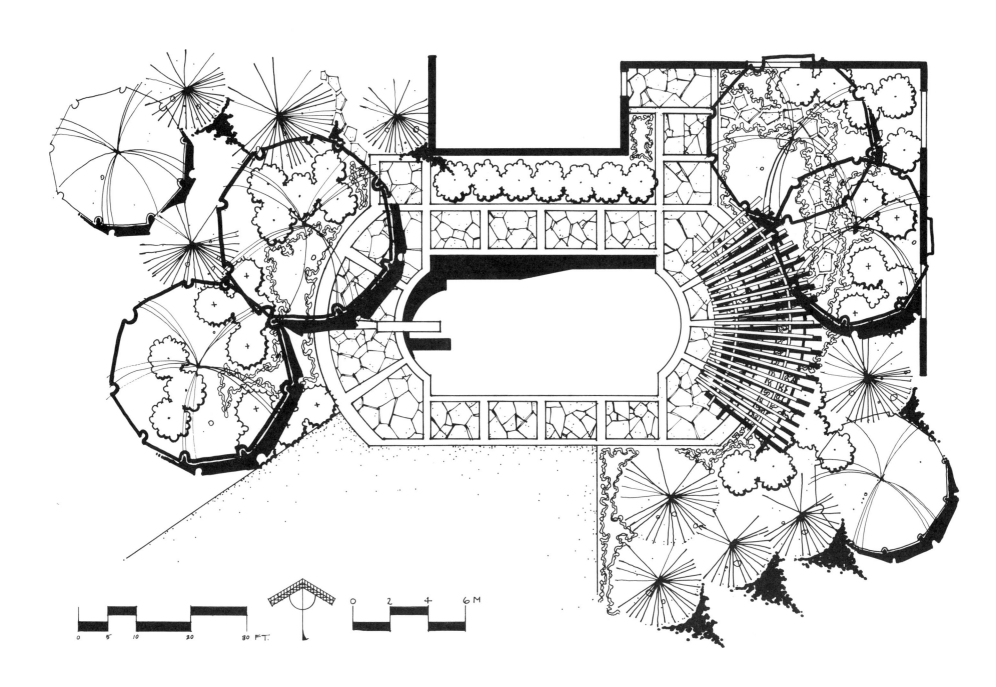

0 5 10 20 30 FT.

0 2 4 6 M

Exercises

The purpose of these exercises is to practice plan graphic symbols drawn freehand as well as to become familiar with various media. With all exercises, copy examples from the appropriate pages. **Do not trace.** Each sheet should have a well-proportioned title and your name lettered neatly at the bottom.

5.1 Deciduous trees
Media: Pencil on vellum, 8 1/2 x 11" (A4).
Fill the sheet with about four different Quick trees and four different Foliage texture trees. Vary sizes from 1 1/2" to 2 1/2" (4-6cm) diameter. Make lines dark enough to print well.

5.2 Branched trees
Media: Pen on marker or butcher paper, 8 1/2 x 11" (A4).
Fill the sheet with four branched pattern trees, 1 1/2" to 2 1/2" (4–6 cm) diameter, and one larger branched tree at about 4" (10 cm) diameter.

5.3 Conifers and tropical plants
Media: Pen on mylar, 8 1/2 x11" (A4).
Fill a sheet with about four coniferous trees and eight tropical plants. Include at least one palm tree. Vary sizes from 1" to 2" (3–5 cm) diameter.

5.4 Shrubs and ground covers
Media: Pen on marker or butcher paper, 8 1/2 x 11" (A4).
Fill a sheet with groups of shrubs and ground covers. Vary plant sizes from 1/2" to 3/4" (1 to 2 cm).

5.5 Rocks, and desert plants
Media: Pen on trace paper. 12 x 18" (A3).
Create a composition at a scale of 1/4"=1'-0" (1:50) of rock groupings and outcrops using at least four different rock types. Intermingle with clusters of desert plants. Tie it all together with a meandering flagstone walk.

5.6 Naturalistic landscape space
Media: Pen on Mylar, 12 x 18" (A3).
Invent a predominantly naturalistic landscape at a scale of 1"=10' (1:200) or 1"= 20' (1:400). The space must have large groupings of deciduous trees, coniferous trees and shrubs. Include a stream with boulders, an escarpment, a simple structure (bridge, shelter, deck), and a paved pedestrian walkway. Integrate a title, north indication, and a graphic scale. You may choose to add shadows on the original or when you apply color to the plan.

5.7 Urban landscape space
Media: Pen on marker or butcher paper, 12 x 18" (A3).
Invent a predominantly urban landscape at a scale of 1"=10' (1:200) or 1"= 20' (1:400). Include at least one building, a parking area with cars, groups of people, a kiosk or other structure, two different kinds of paving, an architectural fountain, seating, lots of trees, a few shrub groups and some ground covers. Show overlapping and layering. Integrate a title, north indication and graphic scale. You may choose to apply color to a copy of the plan or add shadows on the original.

5.8 Courtyard space
Media: Pen on Mylar or marker paper, 13" x 18" (A3). Enlarge the courtyard space shown on the next page to 1'=10' or 1:100. Copy the basic garden structure and add plan graphic symbols to clearly illustrate: plants, a stream, a pond, paving, grass, an overhead shade structure, a pavilion, seating and rocks. Include a title, graphic scale and north indication.

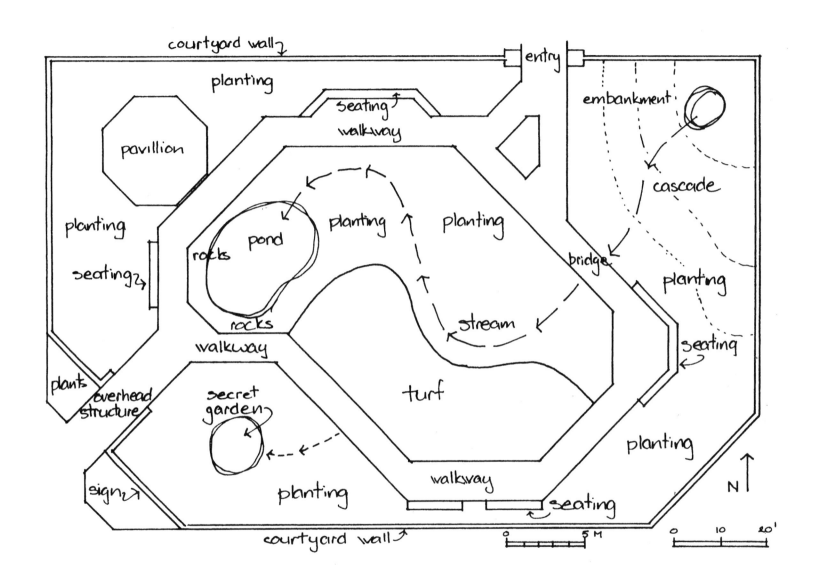

courtyard wall

planting

entry

embankment

seating
walkway

pavillion

cascade

planting

planting

planting

pond

rocks

bridge

planting

seating

rocks

seating

stream

plants

overhead
structure

turf

secret
garden

seating

planting

sign

walkway

walkway

seating

courtyard wall

N

0 5 M

0 10 20'

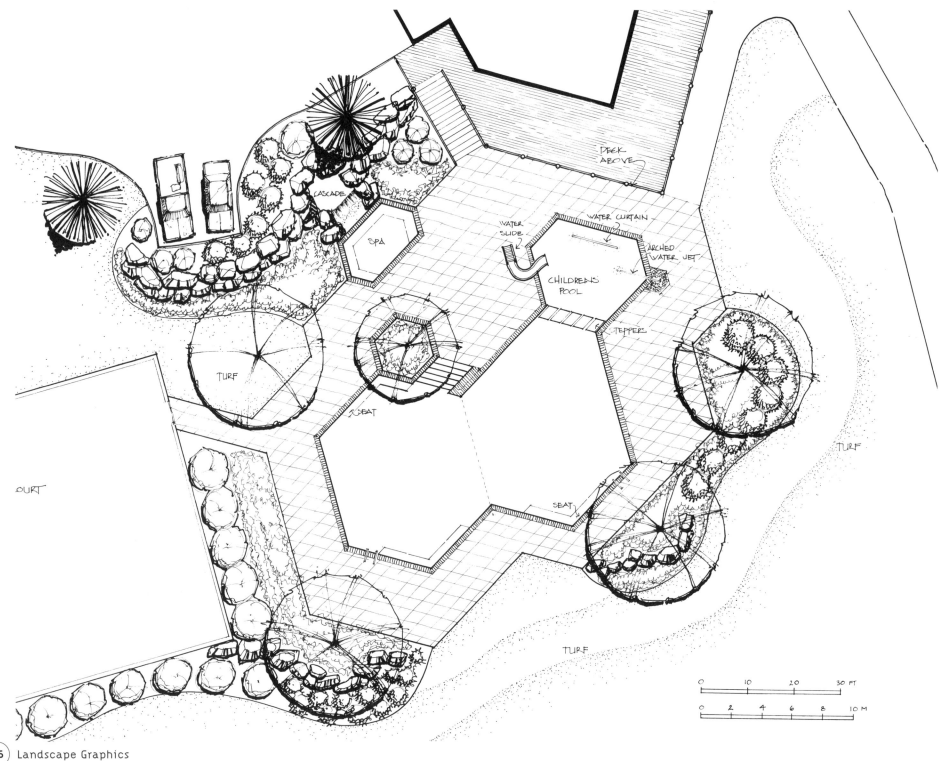

CASCADE

SPA

WATER CURTAIN

WATER SLIDE

ARCHED WATER JET

CHILDRENS POOL

DECK ABOVE

TEPPERS

TURF

SEAT

SEAT

OURT

TURF

TURF

| 0 | | 10 | | 20 | | 30 FT |

| 0 | 2 | 4 | 6 | 8 | 10 M |

Section-elevations

It is usually necessary to communicate more about a designed space than can be shown on landscape plans. Despite the use of shadowing and layering in plan views, it is not possible to communicate the detailed vertical elements and how they relate to the horizontal shapes. Section-elevations are an excellent tool for this.

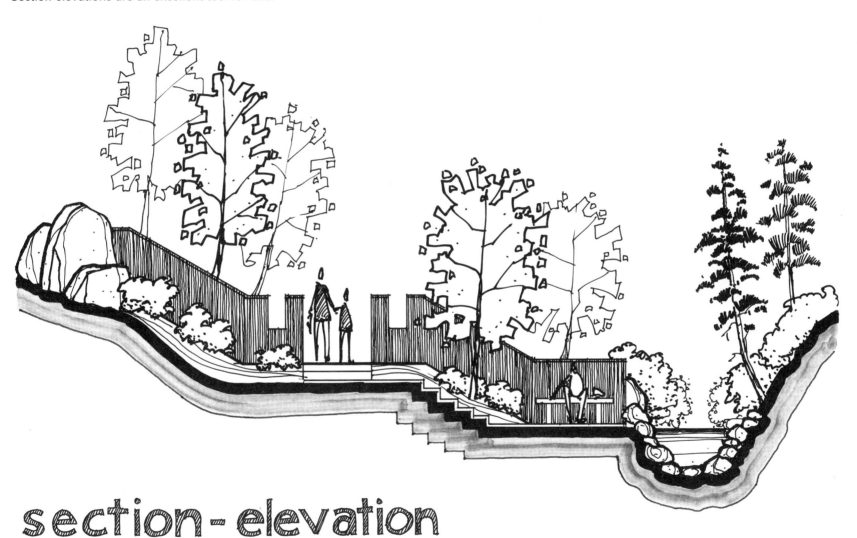

section-elevation

Section-elevations

The relationship of a section-elevation to a landscape plan is demonstrated here by theoretically slicing a landform vertically with a large cleaver. When the pieces are pulled apart, a cross section is revealed.

The vertical surface made by the knife cut is a true **section.** Nothing in front of or behind this surface is shown (Drawing A).

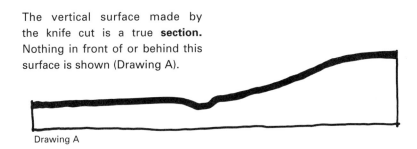

Drawing A

The elements beyond the section when drawn to scale form an **elevation.** No cut line is shown on an elevation (Drawing B).

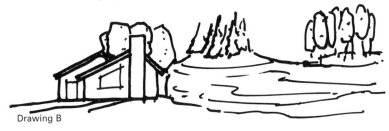

Drawing B

For landscape architects, the combined **section-elevation** is the most useful tool. These usually have the shorter title of sections. In practice, the terms are interchangeable (Drawing C).

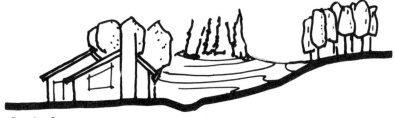

Drawing C

Elevations are more common on architectural drawings than landscape architectural drawings. They are an effective way to show surface detail on the facades of buildings. Often they relate to a plan view of the same set of drawings (Drawing D, E, F).

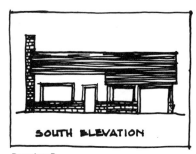

SOUTH ELEVATION

Drawing D

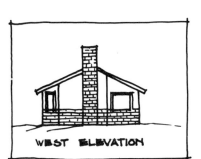

WEST ELEVATION

Drawing E

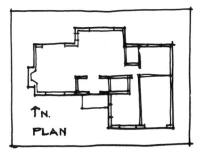

↑N.
PLAN

Drawing F

Essential Characteristics

The **section-elevation** shows the cut surfaces with a prominent profile line as well as vertical landscape elements a selected distance beyond the profile line. Everything is drawn to scale. The horizontal and vertical scales are usually (but not always) the same. How much to show beyond the cut line depends on the type of space or object and the message; however it is easiest to show elements only a short distance from the cut line as in this example.

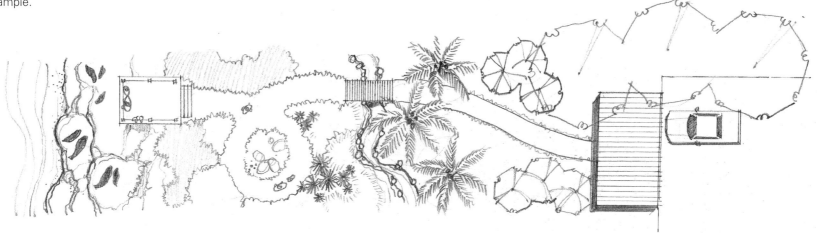

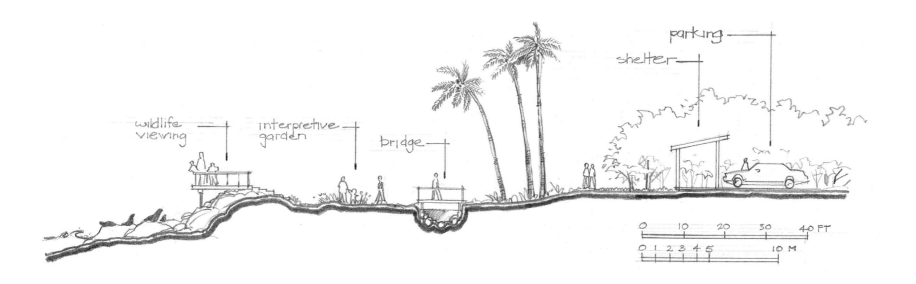

Drawing a Section from a Plan

1. On an overlay, draw a cut line (AA) through the area to be shown in section. Using known vertical information, place marks on the line corresponding to each vertical elevation. In this case, each contour line represents five more feet above pond level.

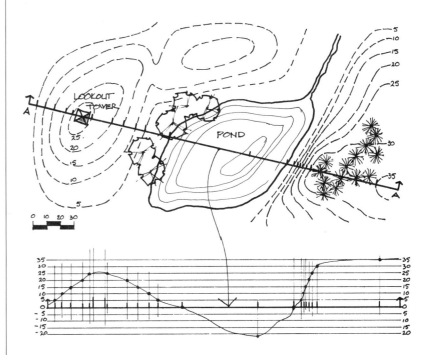

2. Remove the overlay and construct a series of horizontal lines above (and below) to represent even increments of vertical change. You may use the same scale or one, which multiplies the horizontal scale by 1.5 or 2 for exaggeration. At each mark on the base line, draw a vertical guideline and mark with a dot where it intersects the correct elevation. Join the dots.

3. On another overlay, sketch the appropriate landscape features at their correct heights. Make the section line bold.

Medium: 2B pencil

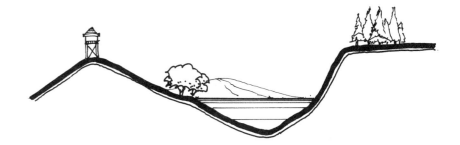

Applications

The examples shown in the rest of this chapter demonstrate the main purposes for drawing section-elevations.

1. To illustrate vertical elements and relationships

For sections showing people, activities, and the built environment, it is best to keep the vertical and horizontal scale the same to avoid unrealistic distortions.

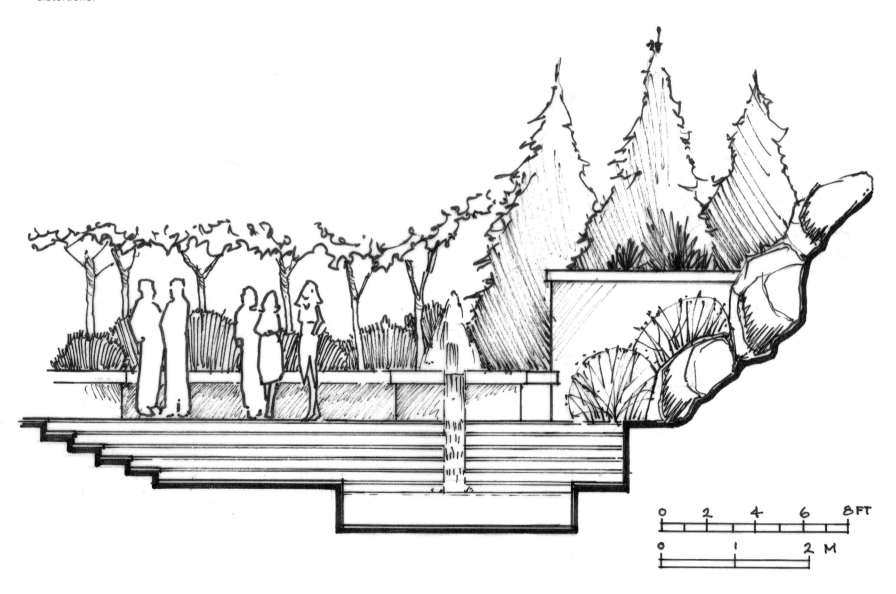

2. To analyze views

Sight line studies often require the analysis of vertical elements as they relate to screening or opening of views from a specific vantage point in the landscape.

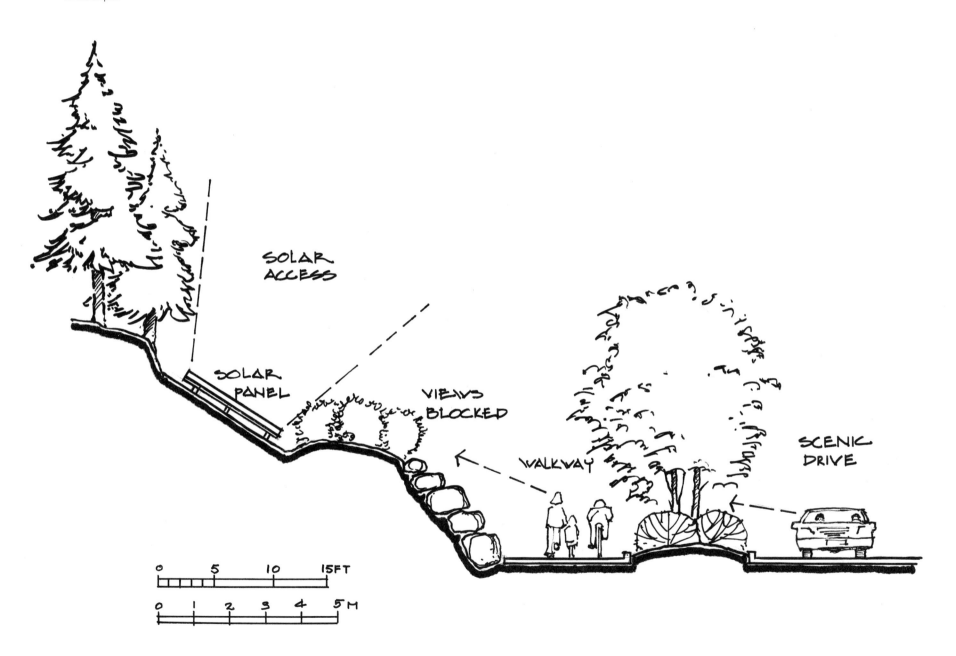

SOLAR
ACCESS

SOLAR
PANEL

VIEWS
BLOCKED

WALKWAY

SCENIC
DRIVE

```
0        5        10       15FT
|—|—|—|—|—|—|—|—|—|—|
```

```
0    1    2    3    4    5M
|——|——|——|——|——|
```

3. To illustrate landscape processes and ecological relationships

Hydrologic cycles

4. To study landforms and microclimate

Heavy seasonal rains

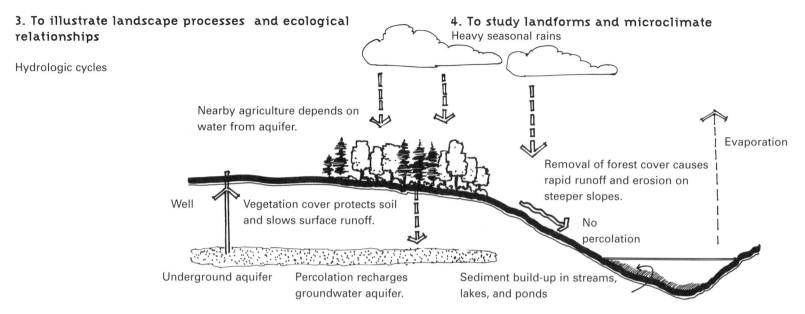

Nearby agriculture depends on water from aquifer.

Well

Vegetation cover protects soil and slows surface runoff.

Underground aquifer

Percolation recharges groundwater aquifer.

Removal of forest cover causes rapid runoff and erosion on steeper slopes.

Evaporation

No percolation

Sediment build-up in streams, lakes, and ponds

Plant communities

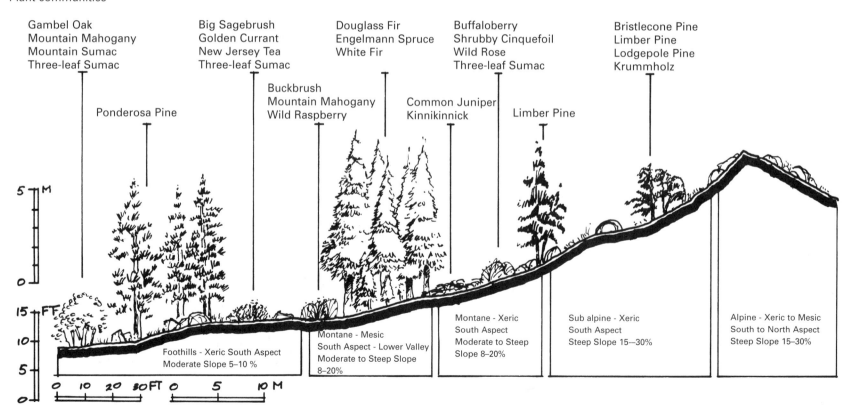

Gambel Oak
Mountain Mahogany
Mountain Sumac
Three-leaf Sumac

Big Sagebrush
Golden Currant
New Jersey Tea
Three-leaf Sumac

Douglass Fir
Engelmann Spruce
White Fir

Buffaloberry
Shrubby Cinquefoil
Wild Rose
Three-leaf Sumac

Bristlecone Pine
Limber Pine
Lodgepole Pine
Krummholz

Ponderosa Pine

Buckbrush
Mountain Mahogany
Wild Raspberry

Common Juniper
Kinnikinnick

Limber Pine

Foothills - Xeric South Aspect Moderate Slope 5–10 %

Montane - Mesic South Aspect - Lower Valley Moderate to Steep Slope 8–20%

Montane - Xeric South Aspect Moderate to Steep Slope 8–20%

Sub alpine - Xeric South Aspect Steep Slope 15–30%

Alpine - Xeric to Mesic South to North Aspect Steep Slope 15–30%

5 M

0

15 FT

10

5

0

0 10 20 30 FT 0 5 10 M

5. To reveal elements hidden in plan view

Caves, overhangs, depths of water bodies, and underground features are some of the elements that are impossible to show in plan view.

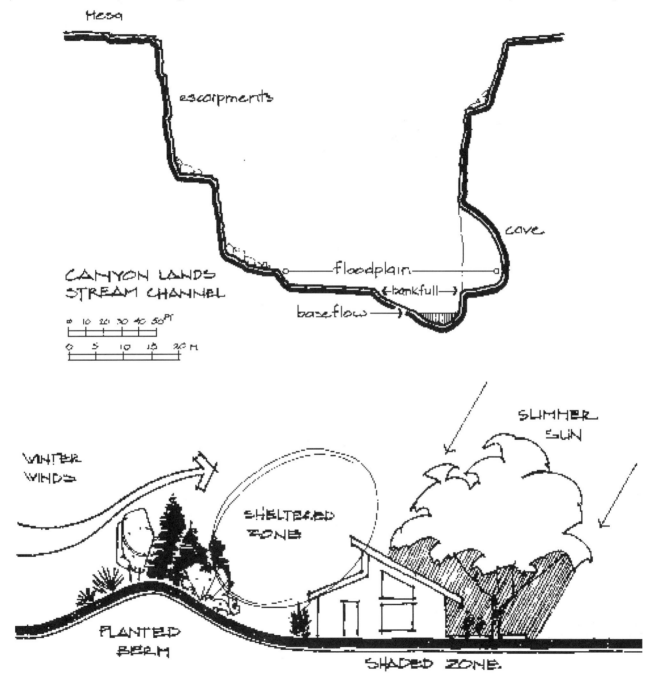

Mesa

escarpments

CANYON LANDS
STREAM CHANNEL

floodplain

cave

bankfull

baseflow

0 10 20 30 40 50 FT

0 5 10 15 20 M

WINTER
WINDS

SHELTERED
ZONE

SUMMER
SUN

PLANTED
BERM

SHADED ZONE

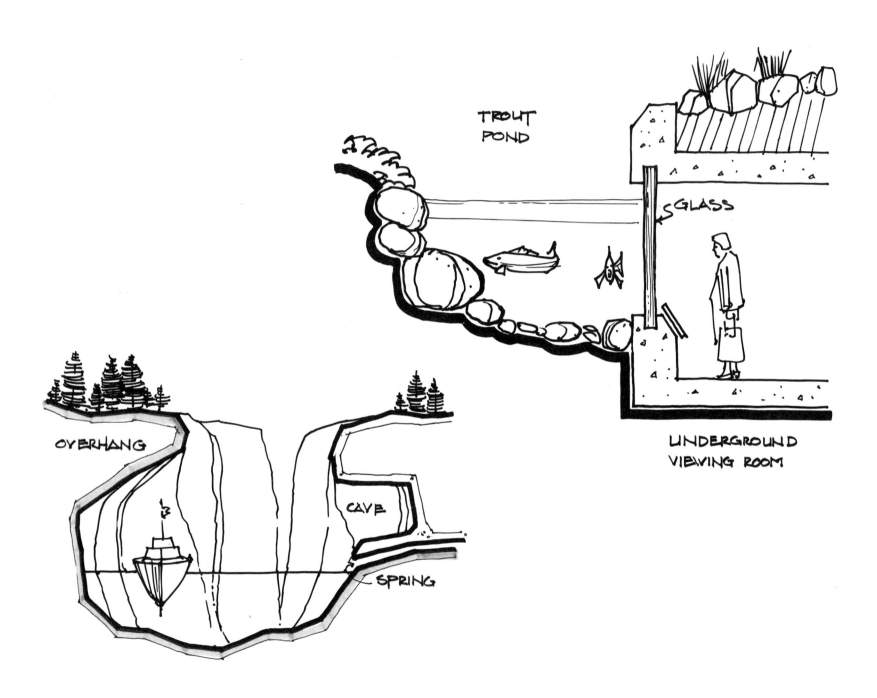

TROUT
POND

GLASS

UNDERGROUND
VIEWING ROOM

OVERHANG

CAVE

SPRING

6. To show internal structure

Sections are frequently used in landscape construction documents to show construction materials, internal components of a structure and how they fit together. Exact vertical dimensions are also appropriate in construction sections.

Pond Section
Scale: 1/2"=1'-0". (1:25)

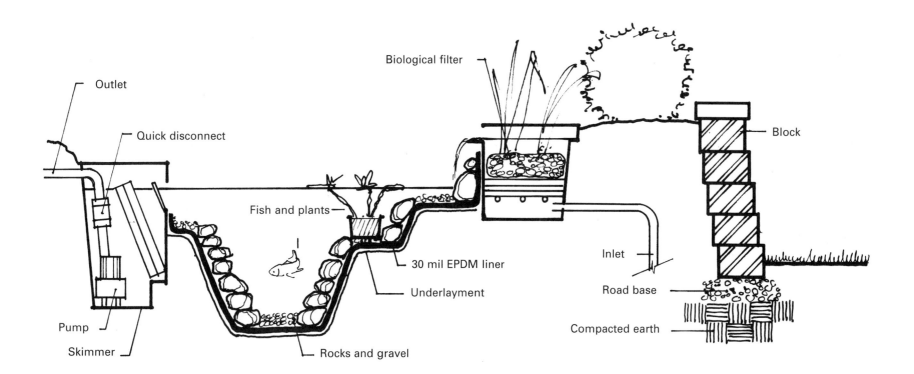

More examples

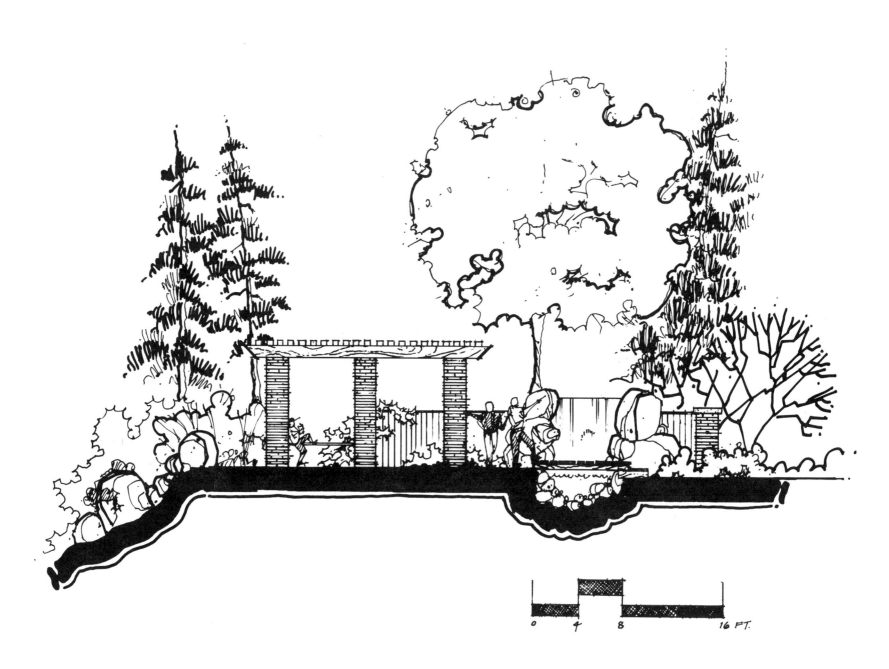

0 4 8 16 FT.

Section Sketch

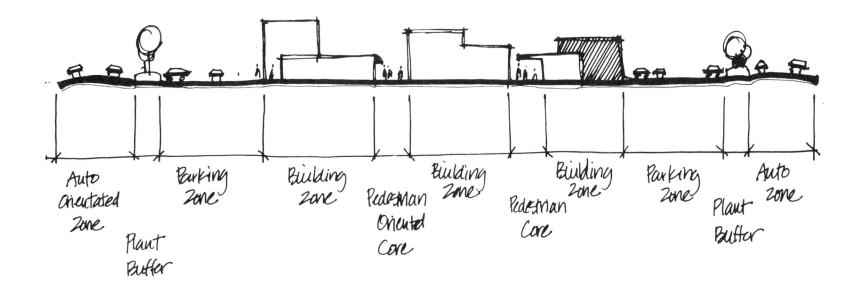

Auto Orientated Zone

Plant Buffer

Parking Zone

Building Zone

Pedestrian Oriented Core

Building Zone

Pedestrian Core

Building Zone

Parking Zone

Plant Buffer

Auto Zone

Section Drawing

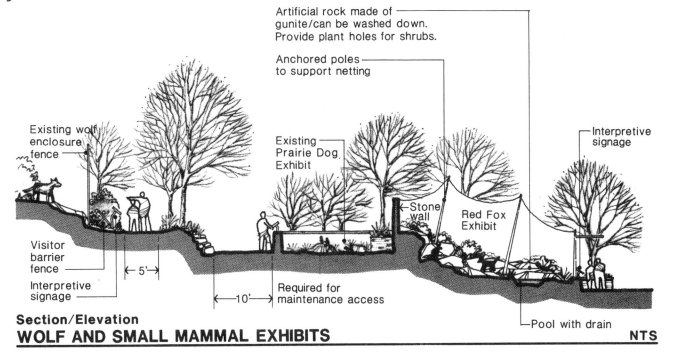

Artificial rock made of gunite/can be washed down. Provide plant holes for shrubs.

Anchored poles to support netting

Existing wolf enclosure fence

Existing Prairie Dog Exhibit

Interpretive signage

Stone wall

Red Fox Exhibit

Visitor barrier fence

Interpretive signage

5'

10'

Required for maintenance access

Pool with drain

Section/Elevation
WOLF AND SMALL MAMMAL EXHIBITS

NTS

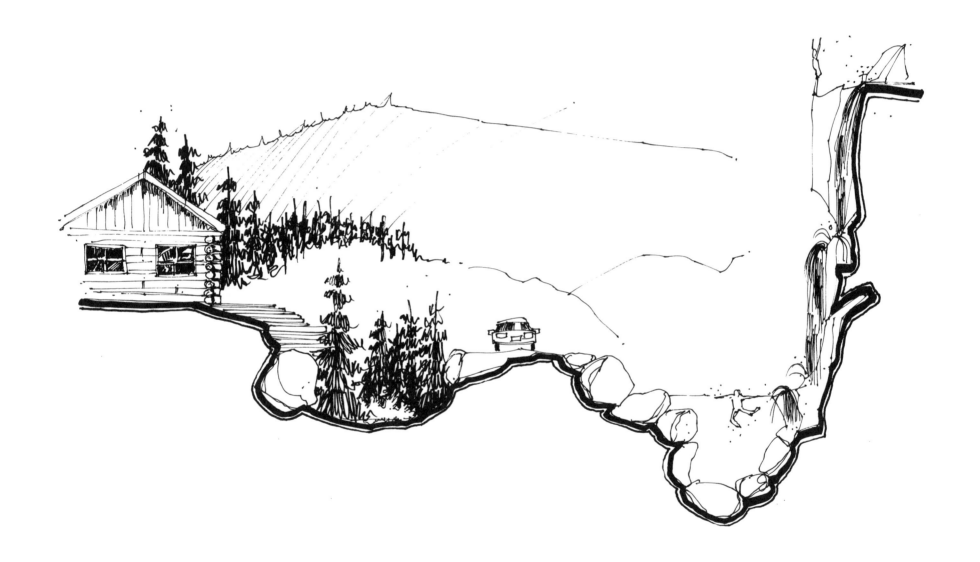

Exercises

For each of these exercises, include a neatly lettered title that is in proportion to the overall composition.

6.1 Copied section
Media: Pen on 8 1/2 x11" (A4) marker paper.
Copy, do not trace, one of the sections from this chapter.

6.2 Constructed section
Media: Felt tip pen on 8 1/2 x 11" (A4) trace.
Draw a section through the plan on the next page. The thick arrow labeled "A A" indicates the cut line and the direction of view. Keep the horizontal and vertical scale at 1/4"=1'-0" (1:50). Begin with a sheet of trace paper over the plan. Draw in the cut line. Using a parallel rule and a triangle, place small vertical check lines along the cut line. These vertical lines should line up with and coincide with the edges of all the objects beyond the cut line. Label each line. Remove the plan view and follow the directions on constructing a section at the beginning of the chapter. Assume that the "cut" line on your drawing is now a base line at the level of the plaza. Draft 1 foot (20 cm) horizontal guidelines above and below the base line. Follow the height and depth designations on the plan to construct the section. When you have it roughed out with the outline additions of plants and people, tape down an overlay (of trace paper) and redraw the entire section with more realistic texturing of the various objects.
Add color to the reverse side.

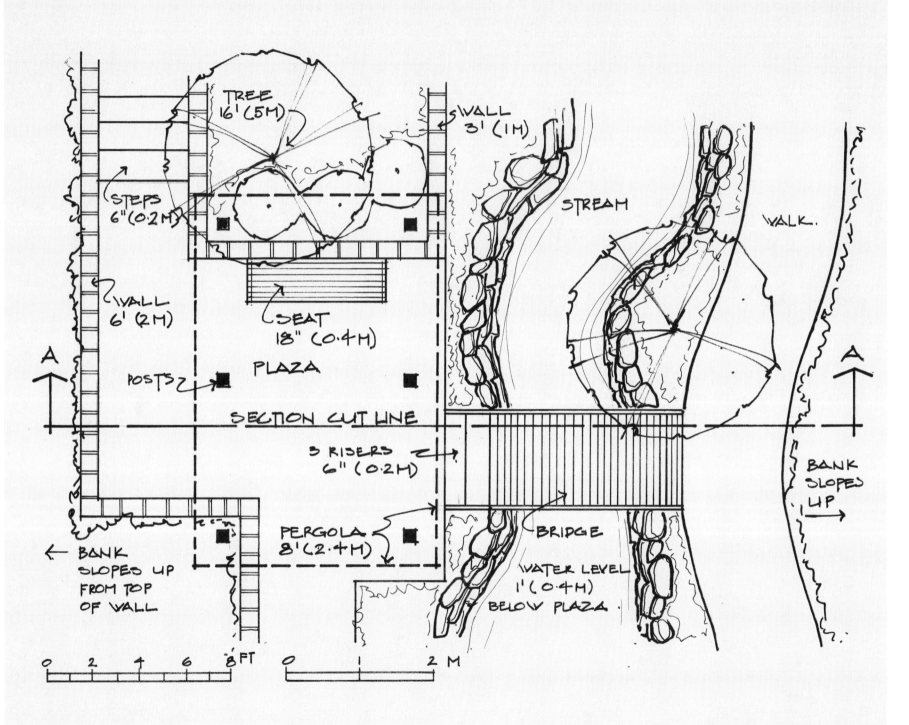

TREE
16' (5M)

WALL
3' (1M)

STEPS
6" (0.2M)

STREAM

WALK.

WALL
6' (2M)

SEAT
18" (0.4M)

A

PLAZA

POSTS

SECTION CUT LINE

A

3 RISERS
6" (0.2M)

BANK
SLOPES
UP

BANK
SLOPES UP
FROM TOP
OF WALL

PERGOLA
8' (2.4M)

BRIDGE

WATER LEVEL
1' (0.4M)
BELOW PLAZA.

0 2 4 6 8 FT 0 1 2 M

6.3 Section with house elevation

Media: Felt tip pen on 12 x 18 (A3) butcher paper.

Trace the house elevation provided and add interesting grade changes, trees shrubs and flowers. Place the house a little to the right or left of center. The tops of some trees could appear behind the house. You could also include a small garden structure or a dock at a lake edge. Add color.

6.4 Fantasy section

Media: Felt tip pen on 12 x 18 (A3) butcher paper.

Suggested scale 1/4"=1'-0" (1:50) or 1/8"=1'-0" (1:100)

Invent a section of your own imaginary naturalistic landscape. Make the vertical changes dramatic. Include water, trees, shrubs, rocks and people. A structure might also be appropriate if you wish, but the overall theme should be of nature. Add color directly to the butcher paper.

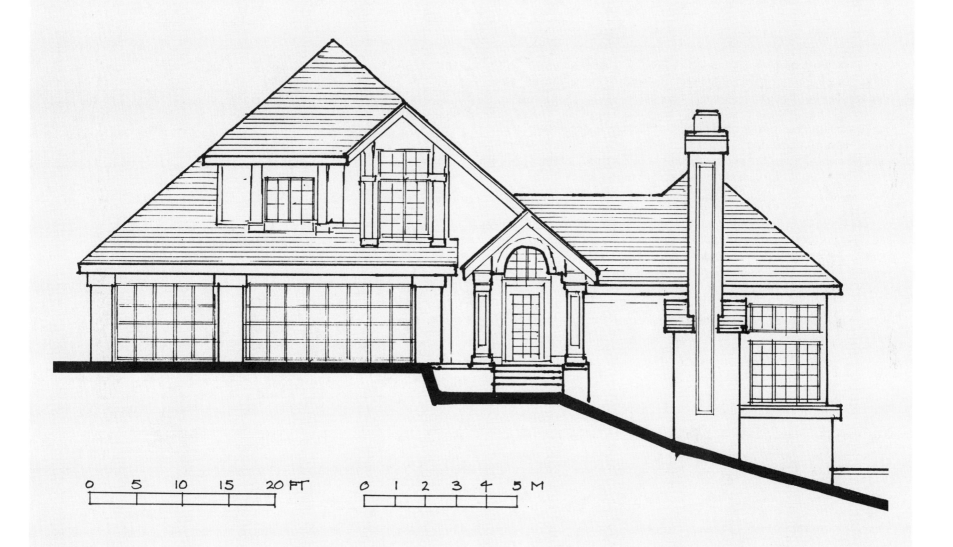

Graphic Symbol File for Sections and Perspectives

The file of drawings in this chapter shows examples of graphic symbols ready to use in sections and perspectives. Trees, shrubs and other vegetation symbols occur at the beginning of the chapter, followed by rocks and water. There are also examples of landscape paving and vertical elements (fences and walls). Near the end you will find instructions on how to draw people and cars.

Most of these examples emphasize economy of time using simple, fast techniques. Most of the vegetation and rock symbols can be applied to both sections and perspectives. Others, such as paving, fences, walls, and water are more applicable to perspectives. Wait until you have read the following chapter on perspective before trying these symbols.

First try to copy the ideas, altering the size and shapes as necessary. If some symbols seem difficult, begin by tracing them to get a feel of their essential character. Very quickly, it should be possible to copy without tracing and then to start inventing your own and injecting your unique style.

When copying the symbols, be aware of their appropriate context. Select the graphic which is appropriate to the message, the intent of the drawing and the time available. Also give thought to their combination and composition within the drawing. Some hints to guide selection and composition are included with the symbols and you can find additional tips on composition in the next chapter.

Be sure to explore the exciting realm of color. Not only can color be applied to prints of these symbols, but these black-and-white speed techniques can be adapted to direct color media.

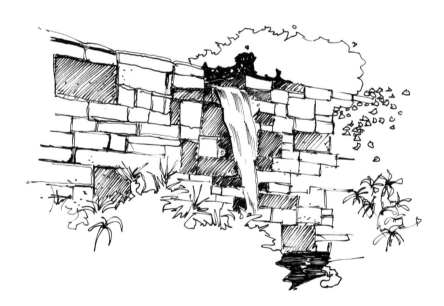

Fast outline trees

Each of these symbols can be done in 10 to 20 seconds. If you are taking more than 30 seconds then you need to loosen up.

Vary the line weight for interest and add a few "why not?" dots.

Focus mainly on form and size. Don't be too concerned about texture. These symbols are very abstract.

These outline trees are good for quick preliminary sketches and as middle or background elements in perspective.

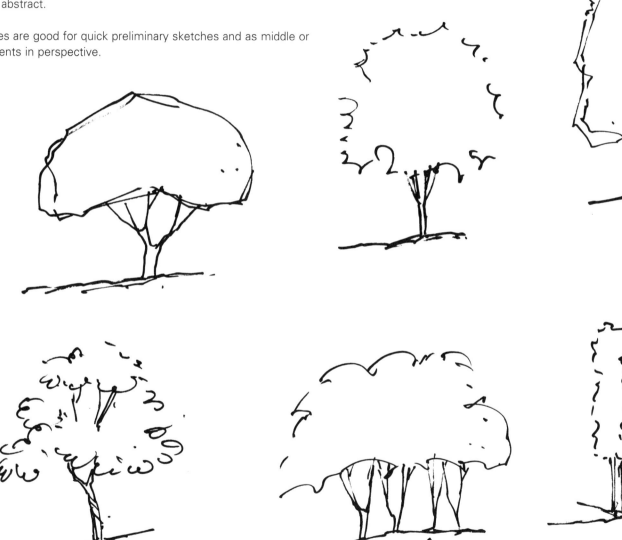

Foliage texture trees

Each one of these trees was drawn with a different texture doodle. Choose a doodle that will express the foliage character, then repeat it loosely around the outline of the tree.

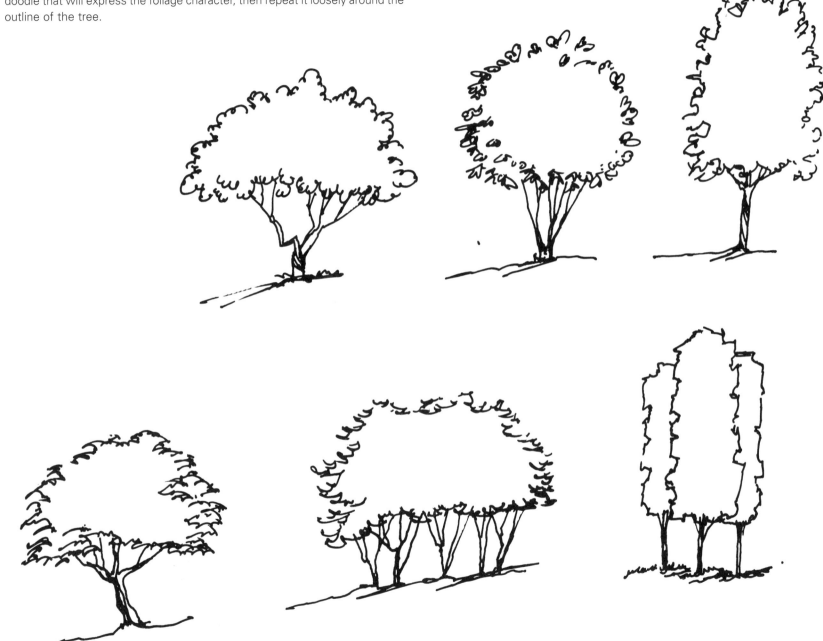

Expressing light quality

If you have a little more time it is very effective to use texture build-up to express the light direction. These trees are good for the middle ground and closer. Follow the suggested sequence.

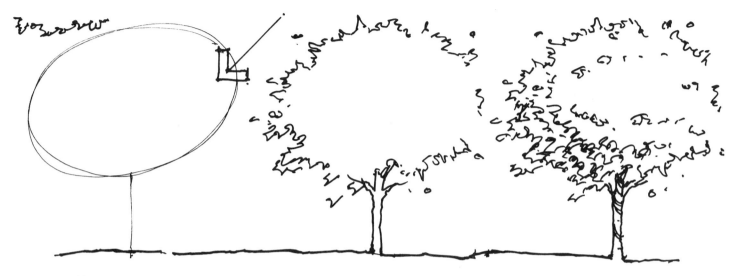

1. Lightly outline the form of the tree and select a light direction.

2. Repeat the doodle on some of the outline to define the tree's form.

3. Build up denser clusters on the shady side and bottom of the tree.

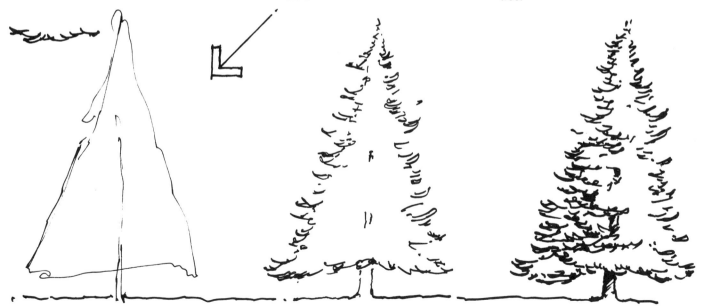

Texturing tips

Create loose lines or doodles that have an interesting character and variation of size or direction.

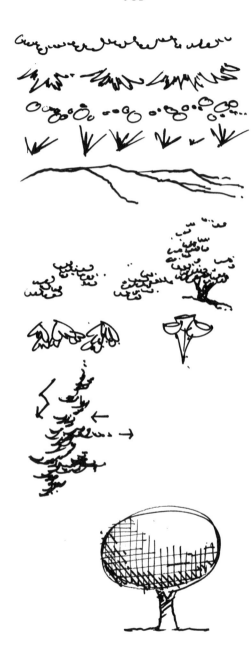

Try to make random clusters with some doodles overlapping others. Avoid evenly spaced doodles.

Apply a back and forth, zig-zag action where white space appears to penetrate your clustering. Avoid rigid, lined-up doodles.

Express the light direction by keeping the upper parts of the tree very open with few doodles.

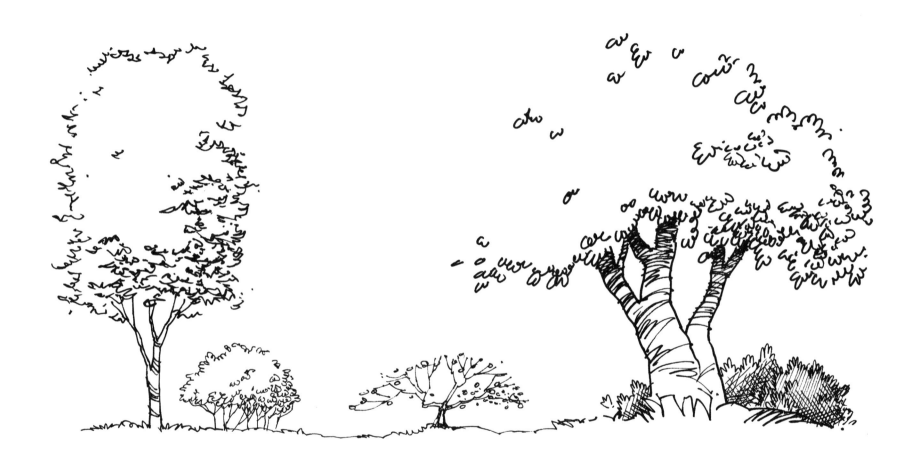

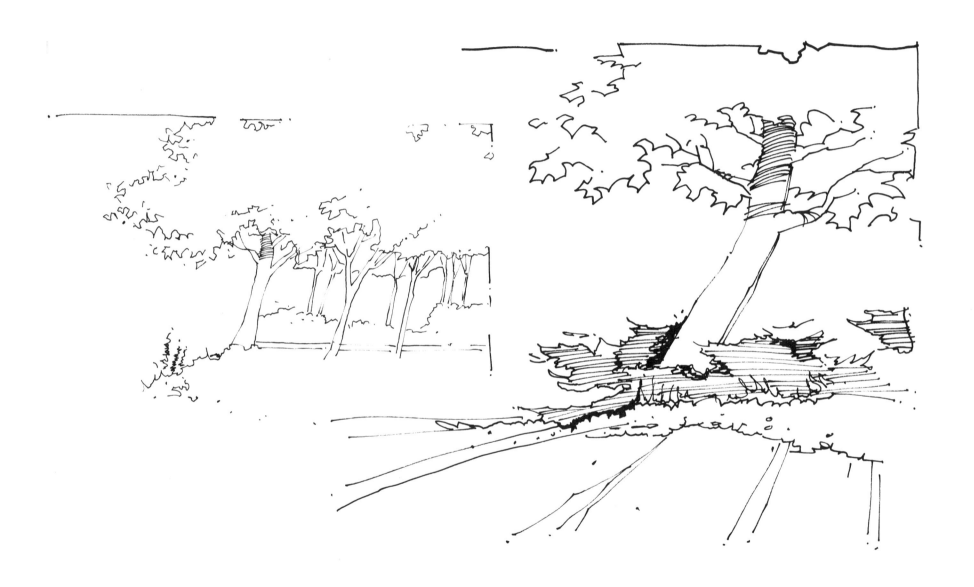

Weeping or drooping tree forms

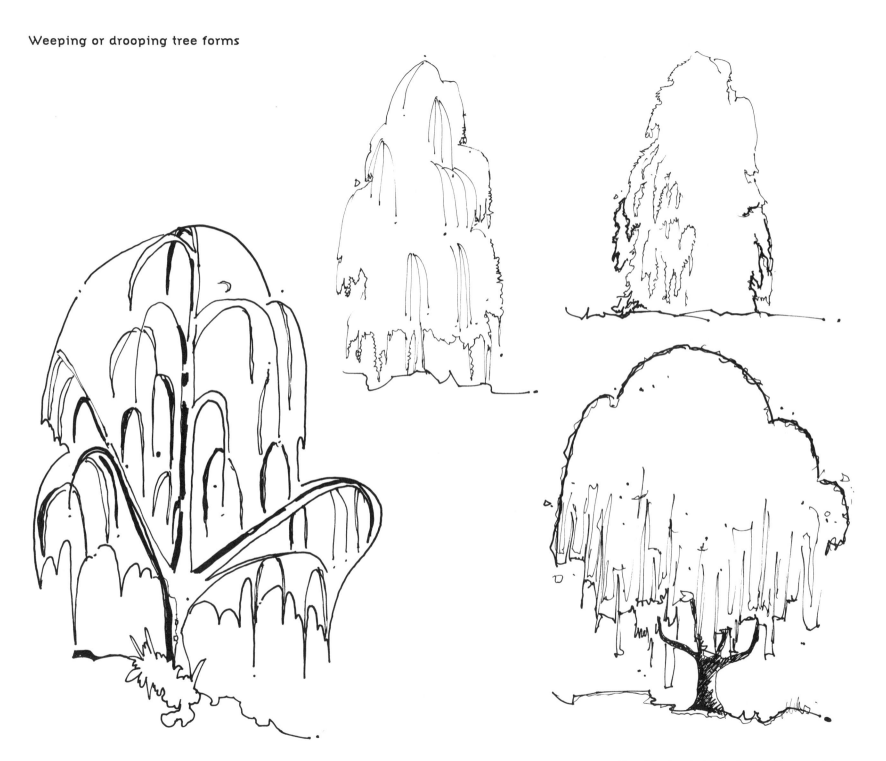

Branch pattern trees

Tree symbols with branching patterns take more time than outline trees but give an interesting sense of realism and adapt well to color application.

The major branches must get thinner towards the outer edge of the tree. A guideline is helpful to structure the limits of the branching. Notice the different branching characters.

They are appropriate as middle ground elements and are a good choice if you need to reveal architectural elements behind them. They also may be used to communicate the winter form of deciduous trees.

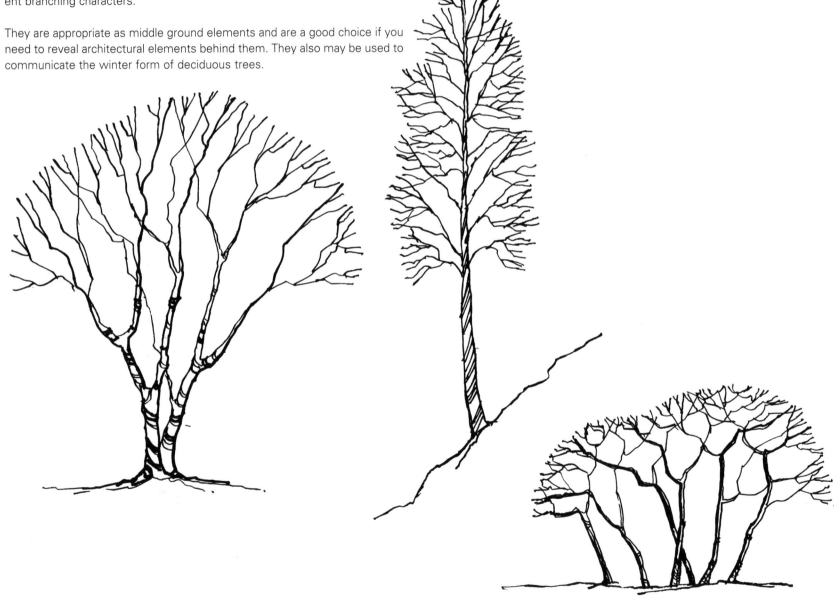

Try following this sequence

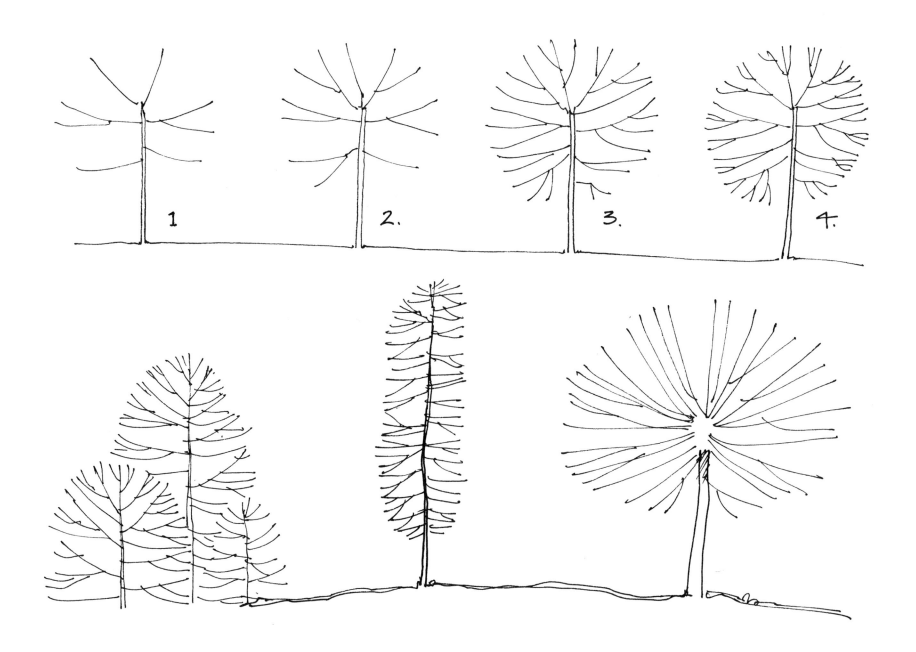

Branched trees - no outline

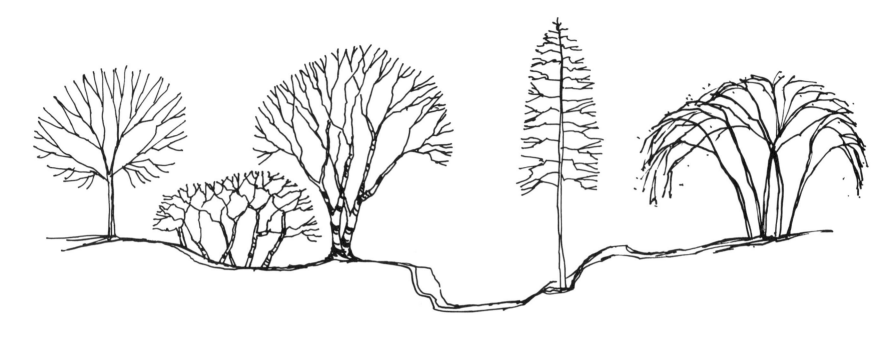

Branched trees - with outline

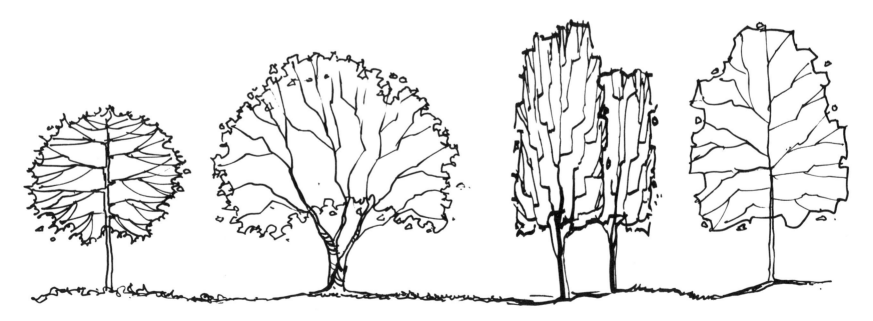

Coniferous trees

Most coniferous trees such as pine, spruce, or fir have sharp needles and a spiky texture.

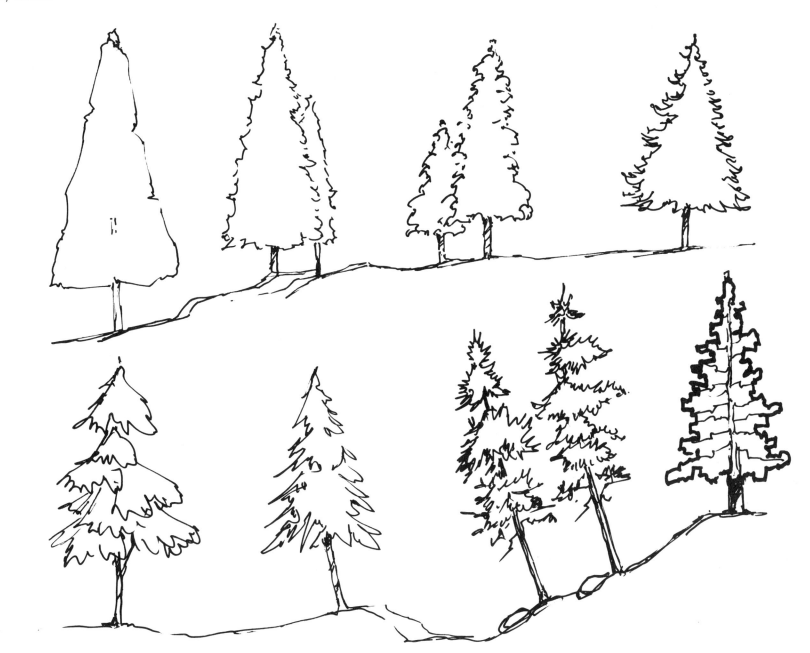

Coniferous trees

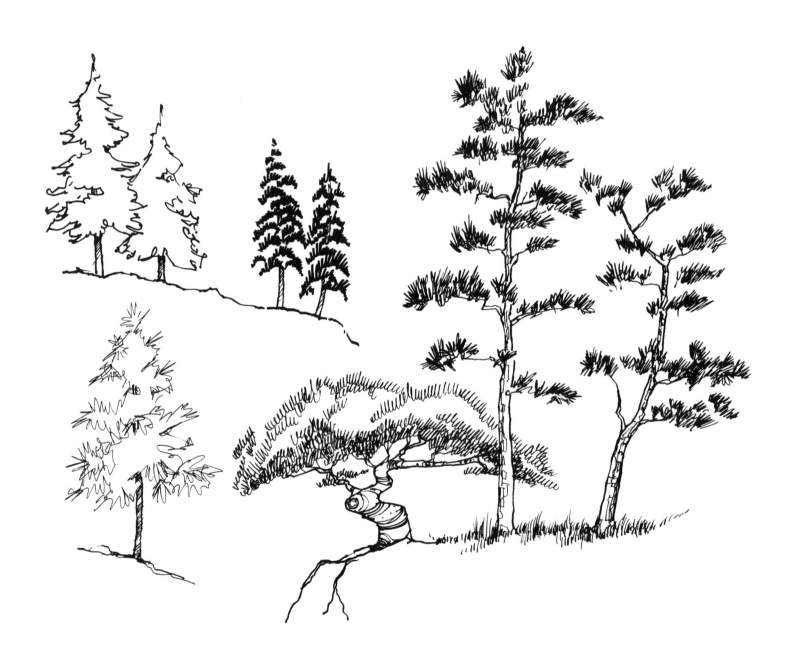

Flowers, grasses and ground covers

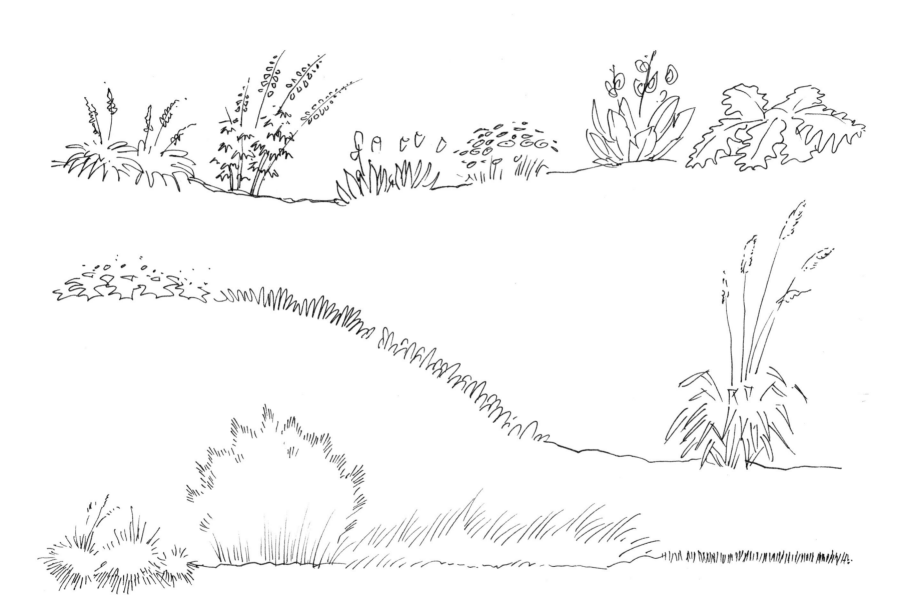

Shrubs

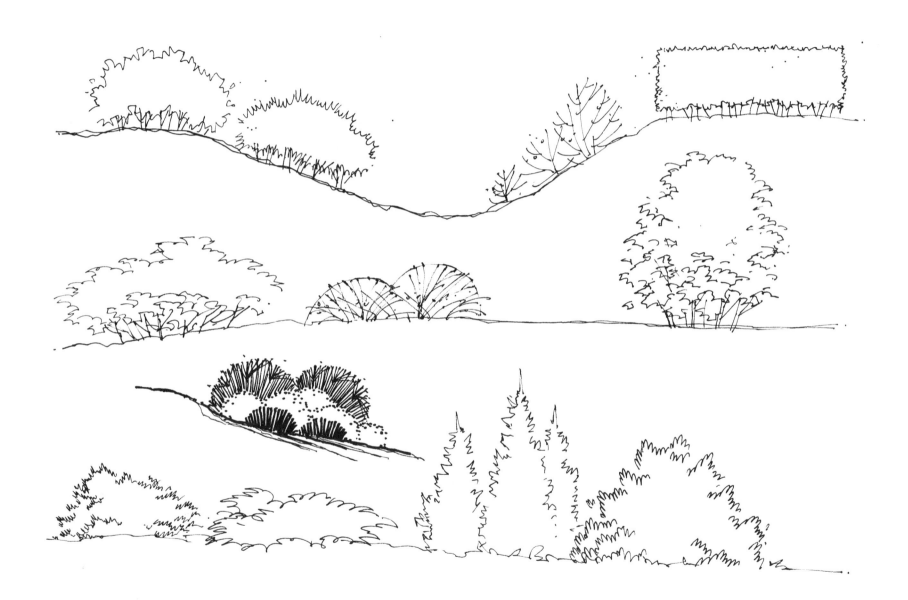

Palms

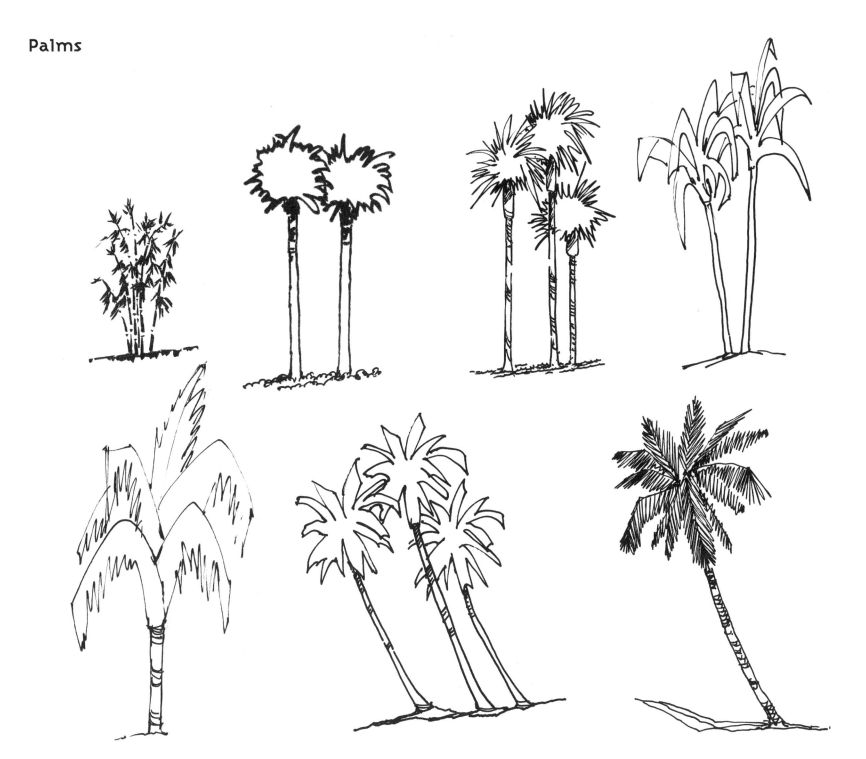

Desert or xeric plants

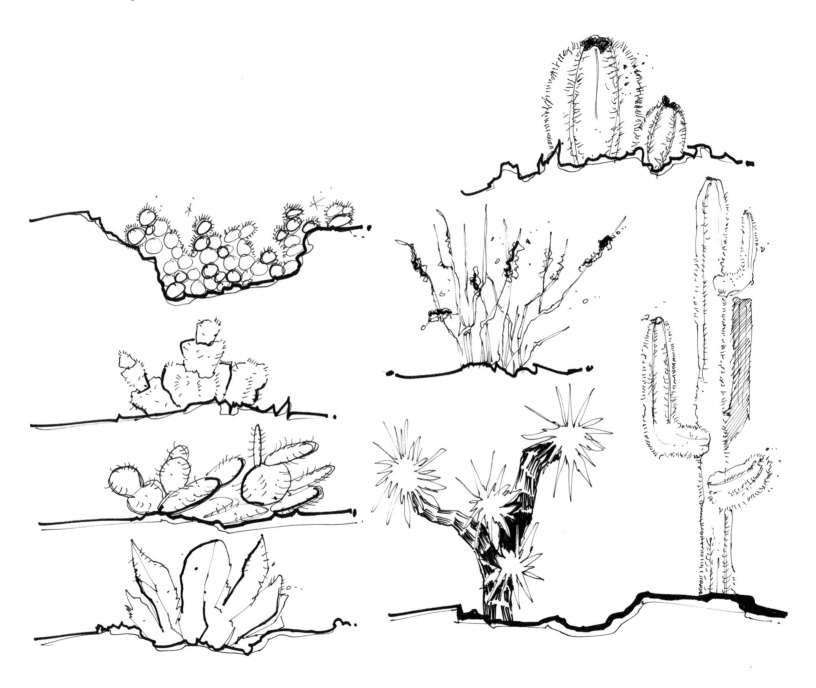

Tropical and indoor plants

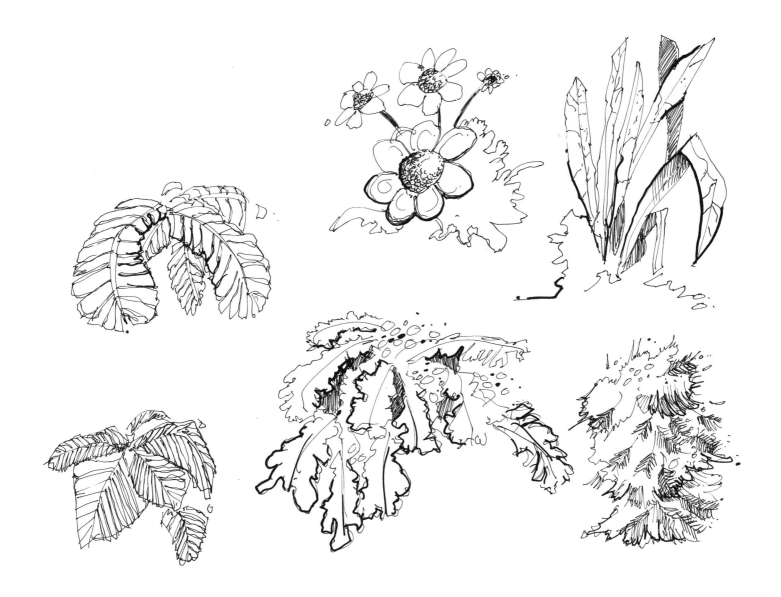

Tropical and indoor plants

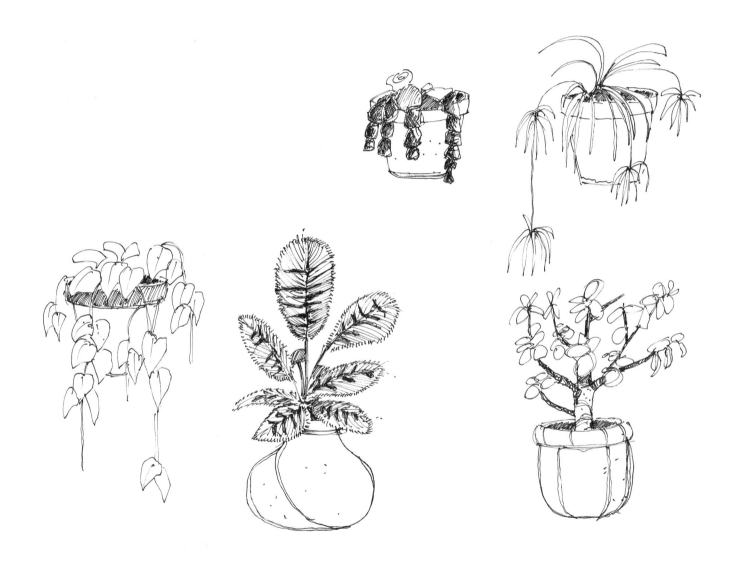

Foreground elements

This and the following 6 pages show a variety of techniques for drawing tree trunks, low plants, rocks and water when they occur close up or in the foreground of a perspective. Here is where you can show bark texture, individual leaves, flowers and other rich detail. It is also legitimate to reduce the elements to simplified edges which can then form the boundaries of the sketch. Only the lower part of trees would be shown and the trunks can then be used to frame the composition.

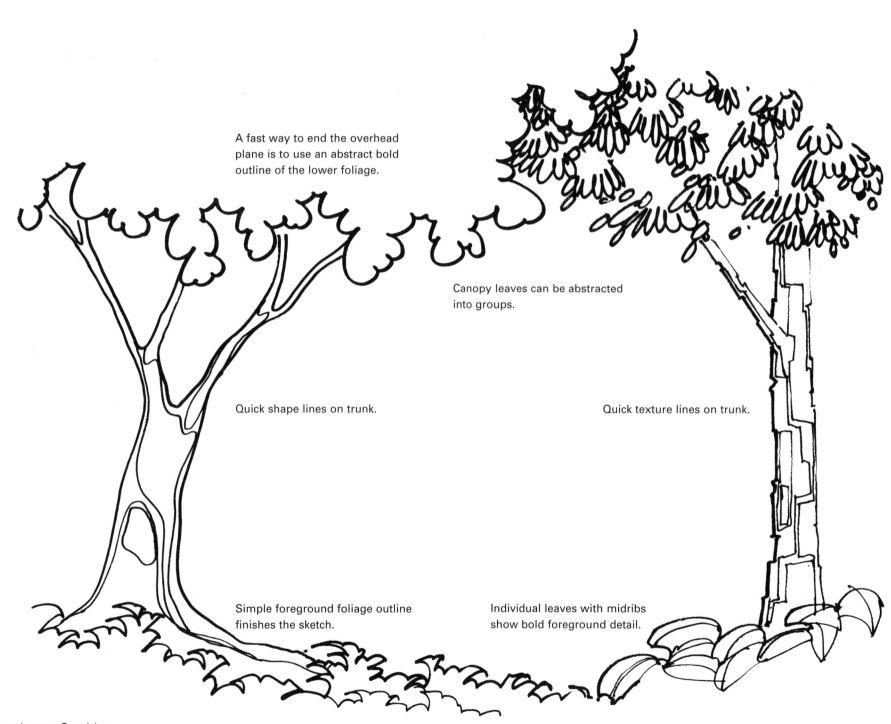

A fast way to end the overhead plane is to use an abstract bold outline of the lower foliage.

Canopy leaves can be abstracted into groups.

Quick shape lines on trunk.

Quick texture lines on trunk.

Simple foreground foliage outline finishes the sketch.

Individual leaves with midribs show bold foreground detail.

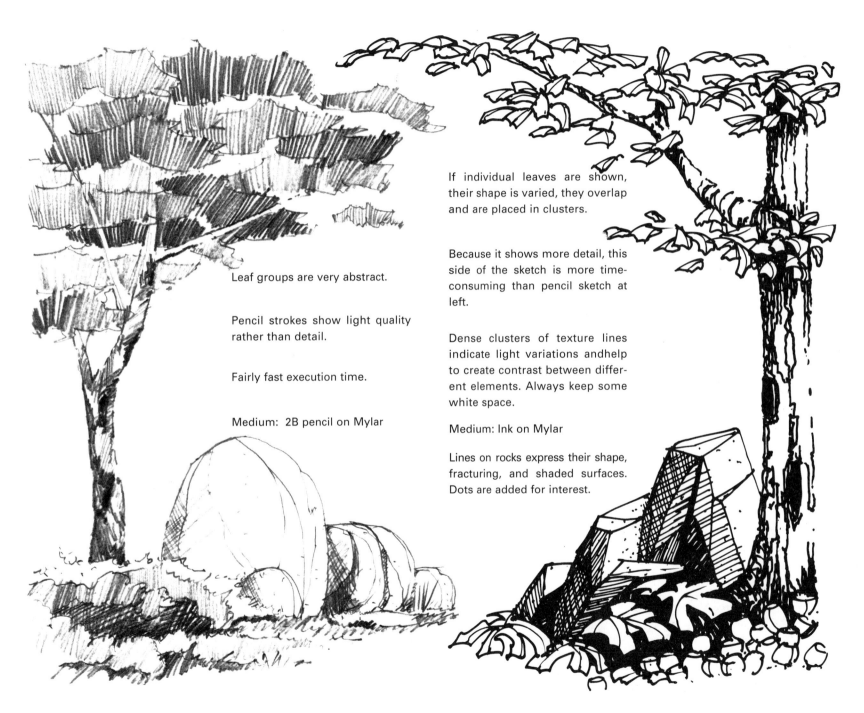

Leaf groups are very abstract.

Pencil strokes show light quality rather than detail.

Fairly fast execution time.

Medium: 2B pencil on Mylar

If individual leaves are shown, their shape is varied, they overlap and are placed in clusters.

Because it shows more detail, this side of the sketch is more time-consuming than pencil sketch at left.

Dense clusters of texture lines indicate light variations andhelp to create contrast between different elements. Always keep some white space.

Medium: Ink on Mylar

Lines on rocks express their shape, fracturing, and shaded surfaces. Dots are added for interest.

Medium: 2B pencil on Mylar

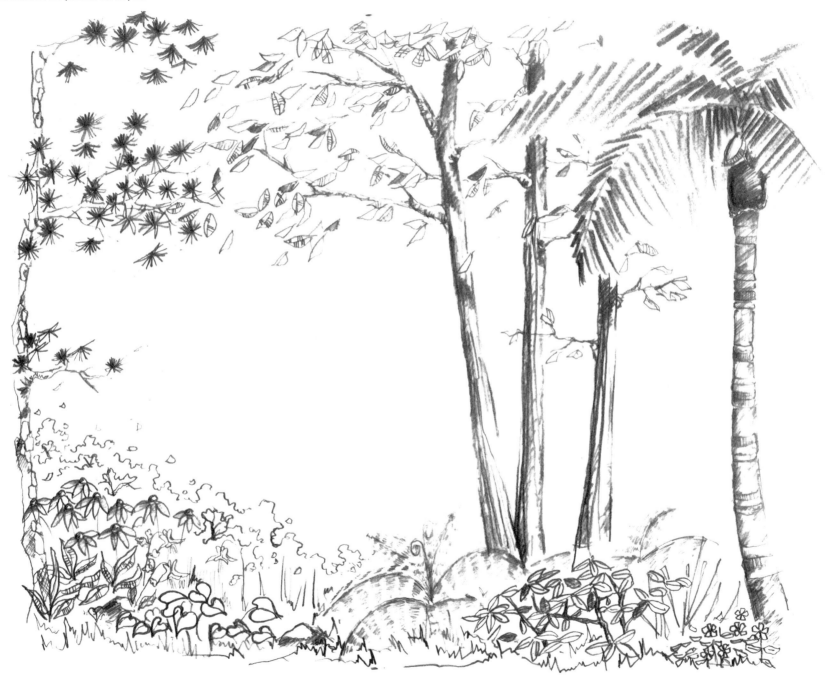

Naturalistic water, mostly light

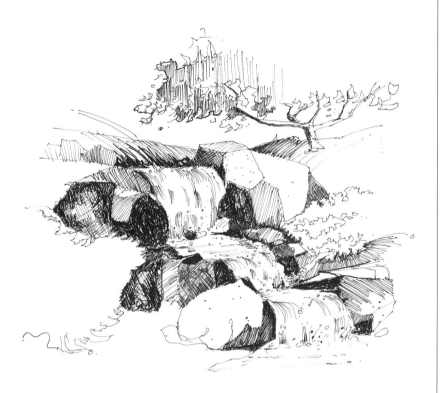

Naturalistic water, mostly dark

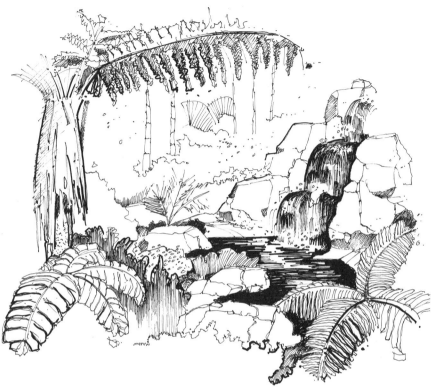

Rocks and Boulders

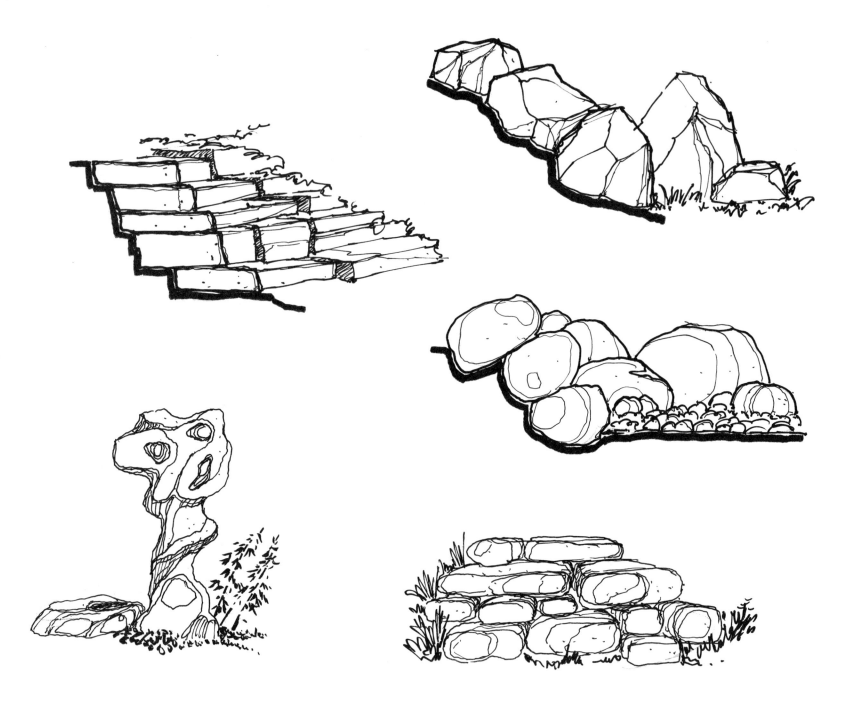

Fountains and Reflecting Pools

Water in an architectural context can be toned or left white. For reflecting pools try a series of horizontal or vertical straight lines. Air filled or bubbling water as in a fountain is best left un-textured. Flowing water might have a few flowing motion lines and dots to show falling and splashing. Up-side-down reflections are fun to play with in very still water.

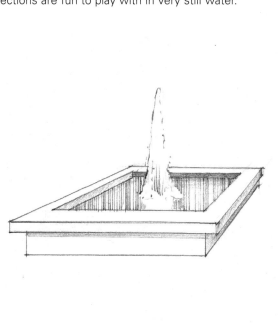

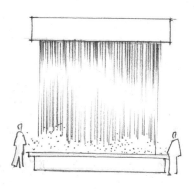

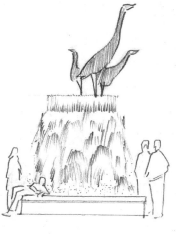

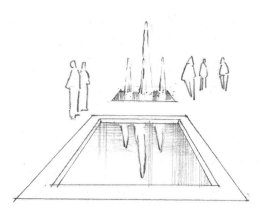

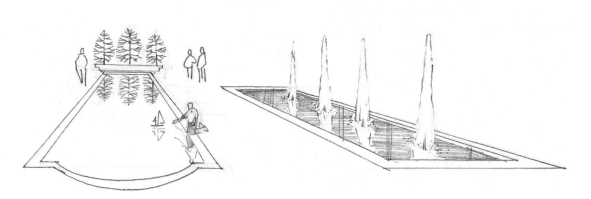

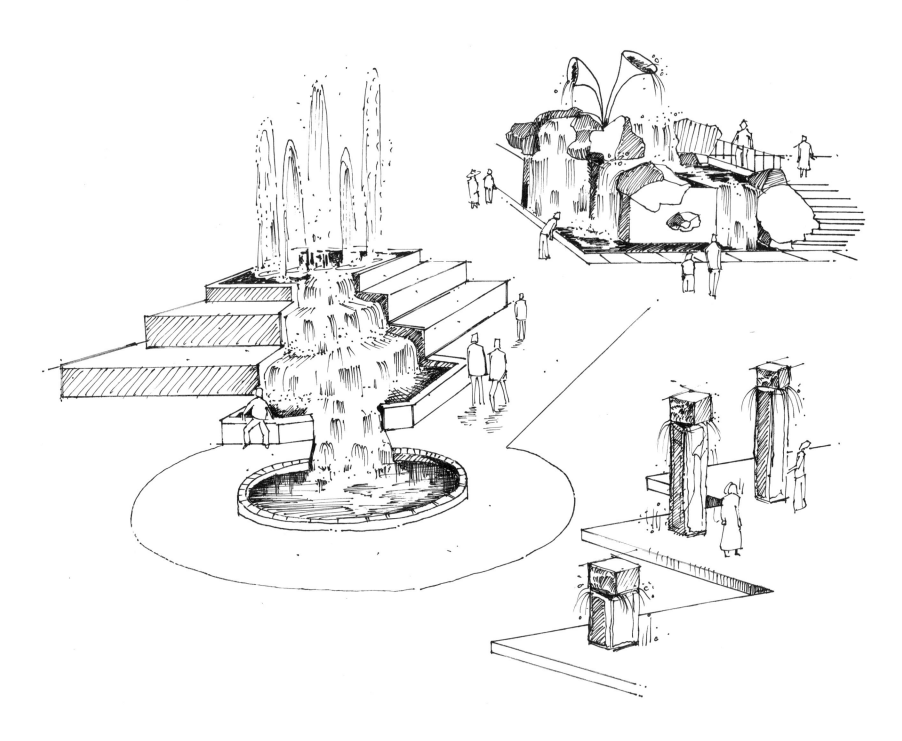

Paving

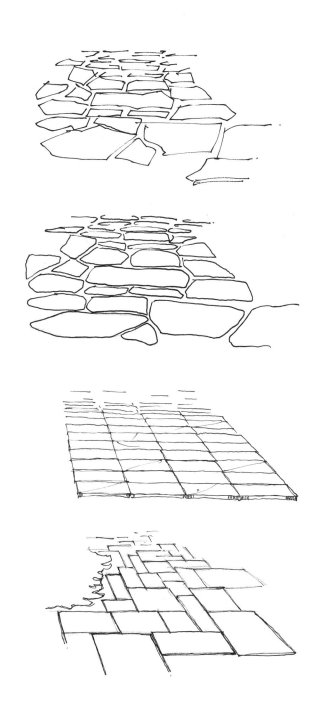

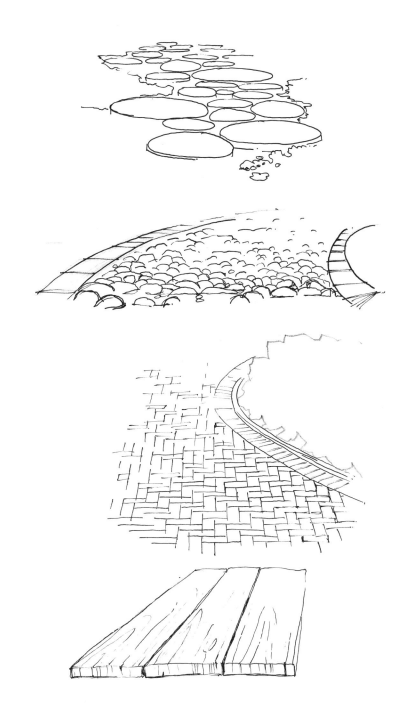

Ground Plane Elements

Make sure that shape and lines become smaller, foreshortened, and compressed as they move into the background of the sketch. This creates textural perspective.

Medium: HB pencil on Mylar

Asphalt or concrete

Brick or modular paving

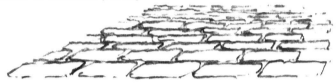

Stone

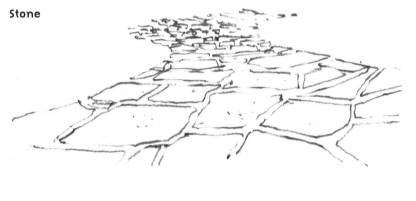

Wood deck

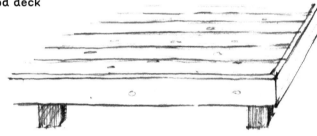

Concrete

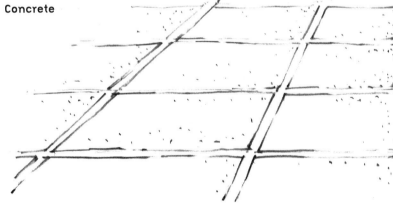

Grass or ground cover

Walls and Steps

Brick

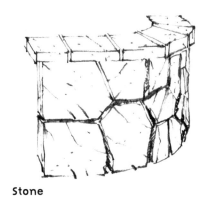

Stone

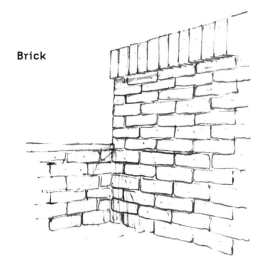

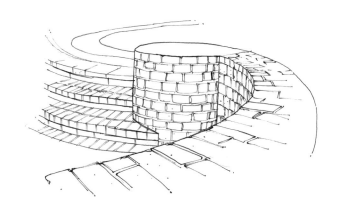

Concrete

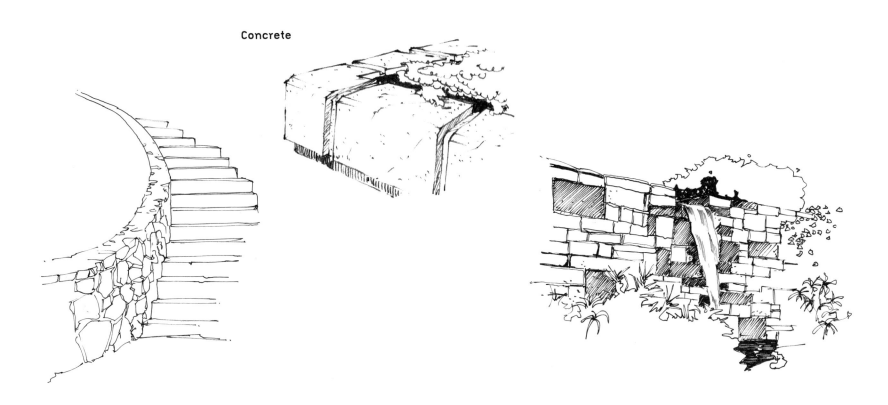

Fences

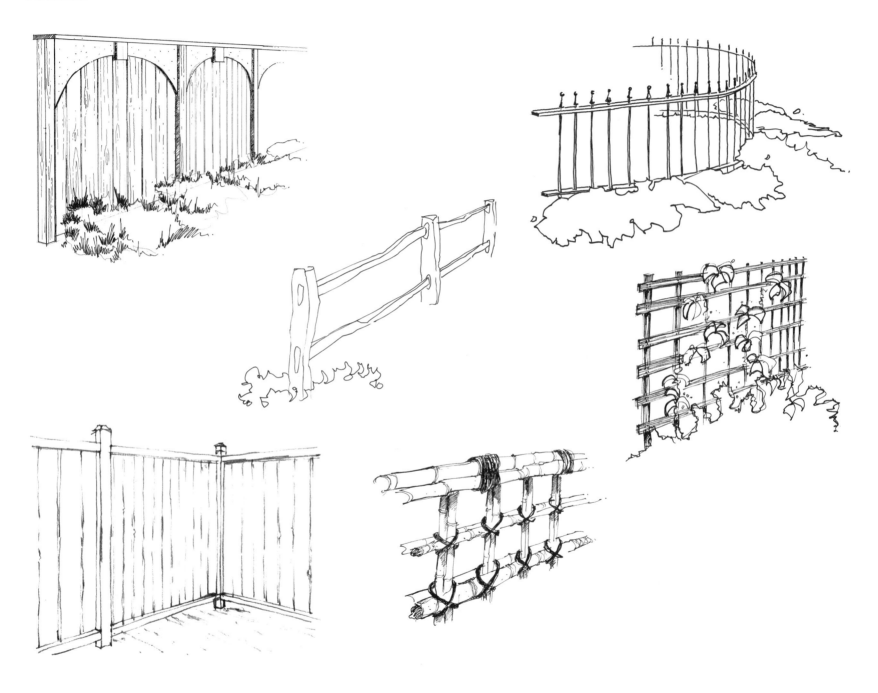

Seating

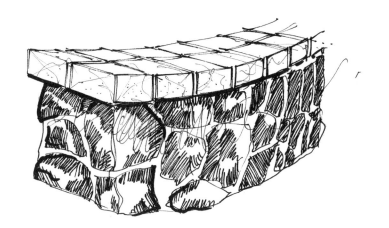

Bridges

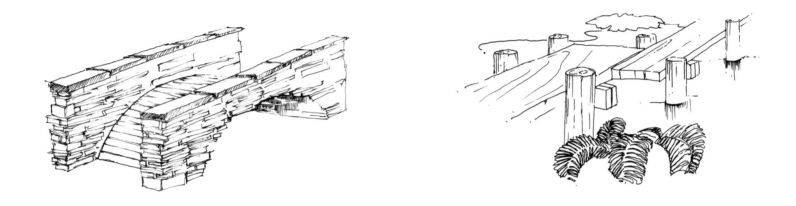

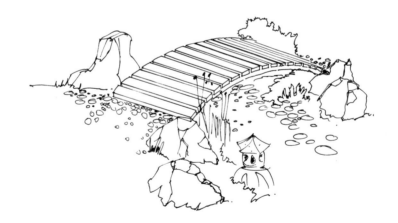

Automobiles

The easiest way to draw cars is to trace them. This section provides a tracing file of automobiles for sections and perspectives. Since the orientation of these auto symbols varies, no scale is given. In the year 2001 the average sedan size was about 15 feet (4.6 meters) long, 5'–8" (1.7 meters) wide and 4'–8" (1.4 meters) high. Compact and efficiency cars are obviously going to be smaller. Sport utility vehicles (SUVs), vans and trucks are going to be larger. Choose the size and orientation that seems to fit your drawing. You can also scan them onto the computer or photocopy them at various reductions or enlargements. Since styles change over the years you can also pick up some of the latest automobile magazines and build your own tracing file.

More Automobiles

People

Always place people in sections and perspectives. Human figures bring a drawing to life and convey the image of a well-designed space. They tell us many things about function, scale and mood.

Mood

Most of the people in your drawing should be in groups interacting with each other. Try to draw them looking happy and relaxed to create an inviting mood.

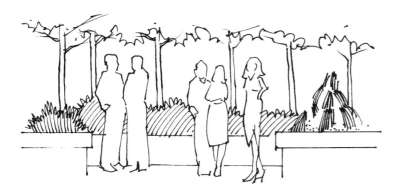

Function

People sitting on walls or climbing stairs or otherwise interacting with their environment emphasize the interesting functional opportunities in the space.

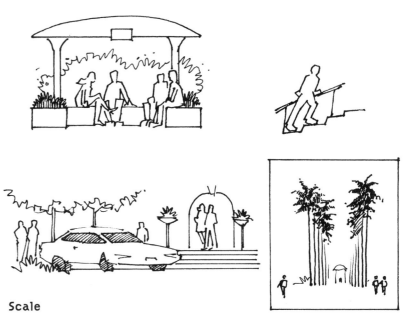

Scale

We are very accustomed to sizing things up quickly by comparing them to the human figure. With people included, the space will be recognized immediately as small and intimate or expansive and grand.

How to draw people

People are difficult to draw because the human figure is complex and any distortion becomes blatantly obvious. Here are some basic rules of proportion that can help you get started.

Establish the height of the person with one mark on the ground plane and another directly above it. Divide the distance into seven equal spaces. The head takes up one space. Now draw in the torso so that the waist is 3/7 from the top. Add legs and feet.

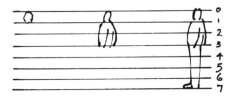

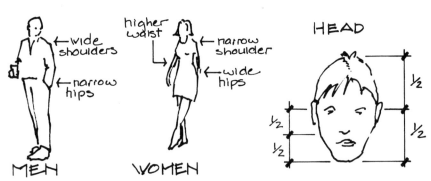

Draw from life.

Freehand drawing of people takes a lot of practice. A good exercise is to sit in a crowded public space and do quick sketches of people in different situations

Trace people.

The quickest route to drawing people well is to trace from magazines, photographs or other illustrations. The next page gives some helpful pointers on composition and placement. This is followed by a tracing file which you should photo-reduce and enlarge to expand the scale range.

Composition and placement

The most realistic perspective view of a space is where the eye line or horizon line is at five feet (1.5 meters). Since most standing people will have their eyes on this eye line, deviations from this conveys powerful messages about level change, seated figures and children. Depth or distance is also emphasized by placing small people in the background. These issues will become more obvious after reading the next chapter on perspective.

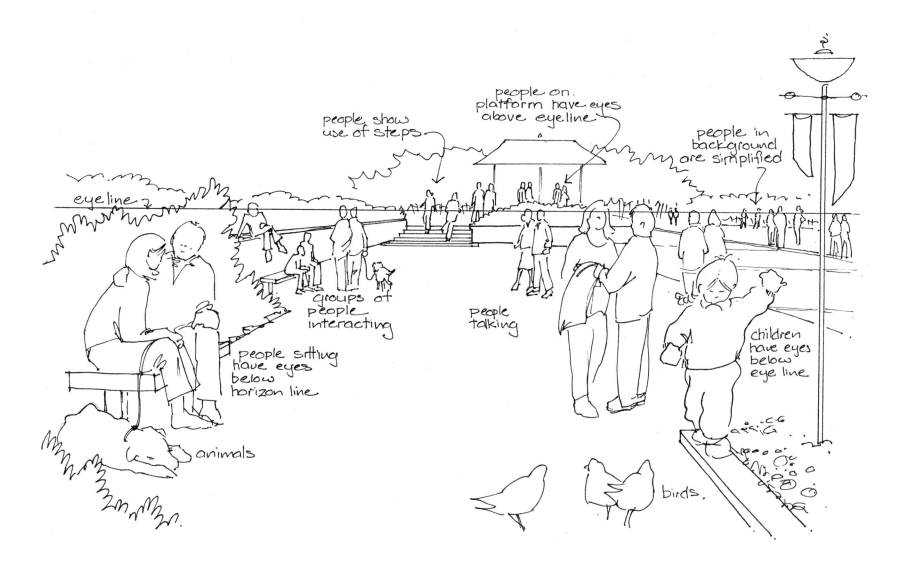

people show use of steps

people on platform have eyes above eyeline

people in background are simplified

eyeline

groups of people interacting

people talking

people sitting have eyes below horizon line

children have eyes below eye line

animals

birds.

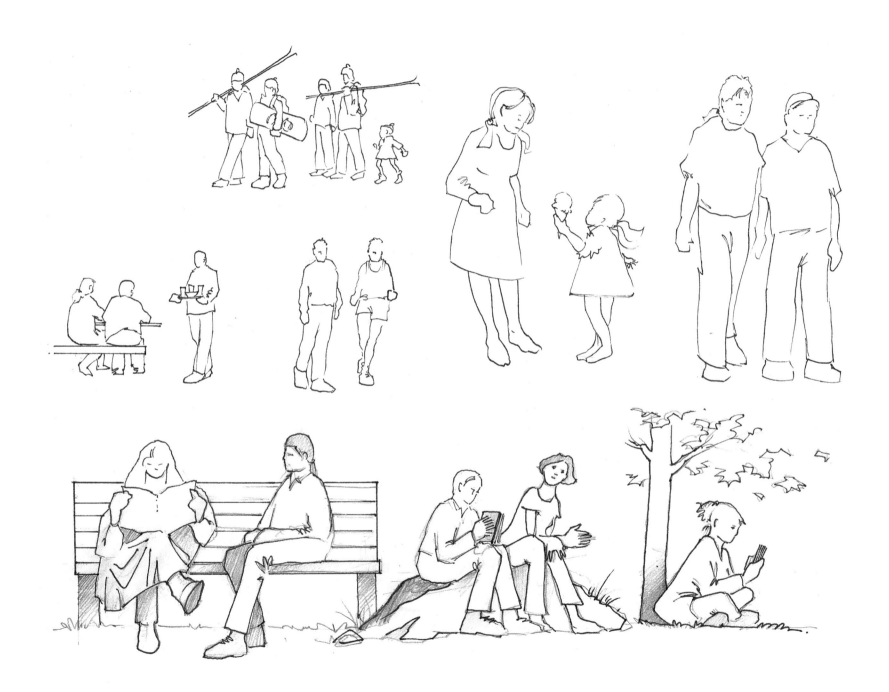

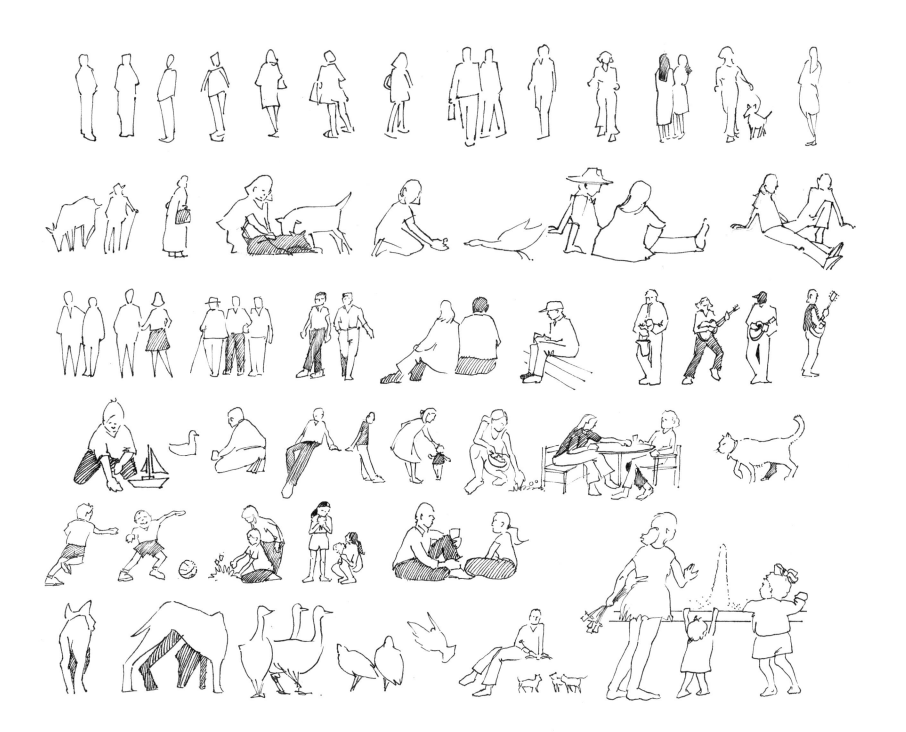

Exercises

7.1 Time squeeze trees

Media: Pen on trace paper of any size. It is best to treat this as a loosen-up exercise that will not be evaluated. If you are in a group, one person needs to have a stopwatch and monitor the start and stop times. For each part of this exercise read the instructions first then stay within the time limits. All trees should be about 3 inches (7 cm) tall. Have an appropriate page open in front of you for copying.

A. Two-minute foliage texture tree. Draw a tree with detailed foliage texture that illustrates shady side and sunny side texture toning.

B. One-minute branching pattern tree. Draw a tree with interesting branch texture.

C. Thirty-second texture outline tree. Draw a tree with an interesting outline leaf language doodle.

D. Five-second tree. Draw a tree with a simplified outline and trunk.

Now that you understand the concept here, repeat the exercise choosing different trees to copy. How about some fast music to set the pace?

7.2 Foreground symbols

Media: Pen on 8 1/2 x 11" (A4) butcher paper.
Create a composition of two foreground trunks and several foreground plants.

7.3 Rocks

Media: Medium (HB or B) pencil on 8 1/2 x 11" (A4) copy paper.
Fill the page with rocks and boulders copied from the appropriate pages.

7.4 Architectural Water

Media: Medium (HB or B) pencil on 8 1/2 x 11" (A4) copy paper.
Using both straightedge and freehand techniques, invent an architectural water feature. Copy ideas from the appropriate pages.

7.5 Cars and trucks

Media: Pen on 8 1/2 x 11" (A4) vellum or trace paper.
Trace a series of cars and trucks at different sizes. Fill the page.

7.6 People

Media: Pen on 8 1/2 x 11" (A4) vellum or trace paper.
Place a very thin horizontal line across the middle of the page.
Trace standing people at many different sizes making sure that all figures have their eyes on the horizontal eye line.

Perspective drawings

A perspective drawing is a fairly realistic view of space and objects that shows some of their three dimensional qualities. The plan view and section-elevation drawings described in chapters 5 and 6 are excellent for showing horizontal and vertical relationships that can be measured and evaluated in a quantitative manner. They do not, however, give a good feeling for the depth of space, and they are of limited value in describing the experience of moving toward, through or around a space.

Perspectives do convey this feeling of depth. They can communicate qualities of enclosure, privacy and openness; they can show relationships between space, time and light. They can predict much of the visual interest available in a space, such as shadows, reflections, textures, tones, colors and forms which are difficult to show on plans or sections. Thus they rarely need supporting labels, notes or abstract symbols.

There are two main uses for perspectives. The first is as a design tool, where they may take the form of fairly fast, rough and indefinite sketches. Designers who understand perspectives and use them as representative drawings in their own design process usually produce the best designs. The most valuable drawings for the design process are those that suggest more drawings or indicate where improvements should be made.

The methods shown here focus on quick, easy manual techniques to give confidence and encourage the use of perspective to externalize three-dimensional ideas early and frequently in the design process. Do not be concerned if initial perspectives look rough, bare, inaccurate and are not what you had in mind. Accept them; then revise, change, and enhance them. The more you try these techniques the more comfortable it will feel. Before long, your perspective drawings will communicate more realism.

After understanding the basic principles of perspective, it is recommended that you take advantage of the computer and camera for sales perspectives. There are several CADD programs that allow you to fairly quickly generate perspective drawings from plan and elevation data. There are also very sophisticated color- and shadow-rendering programs. These tend to be used more by specialist who work with them frequently rather than designers who are involved with a variety of design tasks. Computer generated and rendered perspectives can be almost photo-realistic and very convincing. Some clients, however, still prefer drawings that have at least some hint of the loose, manual touch.

Near the end of this chapter you will find two techniques that combine computer and manual applications. These techniques take advantage of the speed and accuracy of the computers yet preserve the opportunity for incorporating an individualized manual style.

The second use of perspectives is as a sales tool. Sales perspectives are meant to be persuasive drawings done when the design is substantially complete. Clients understand these drawings much more so than plans. For smaller scale, lower budget design projects, the techniques shown in this chapter are very appropriate. For larger budget landscape architecture projects with corporate or public agency clients, you will need to develop more accurate, polished and colorful renderings. The manual techniques required for these renderings demand more time investment, but this is appropriate and usually rewarding.

Development Sketch

Medium: Felt tip pen on tracing paper

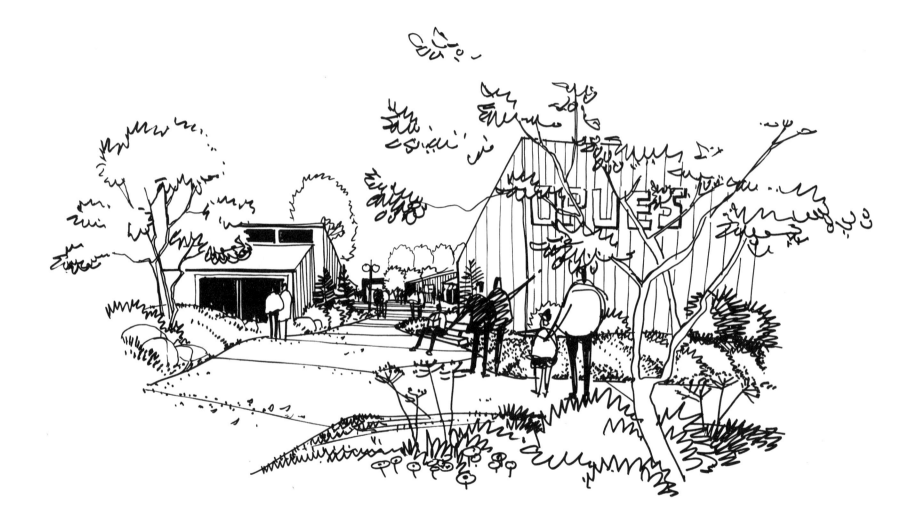

One-point Perspective

Start by doing exercise 8.1. This is a very quick way to establish a measure of your initial perception of perspective before studying this section.

Basic terms

Let's begin with a description of the commonly used terms.

1. On a sheet of tracing paper draw a long horizontal line freehand or with a parallel rule. Label this the **horizon line** or **eye line.**

2. Place a large dot somewhere on it labeled **VP,** for **vanishing point.**

3. Now draw a large rectangle surrounding the vanishing point, keeping all lines horizontal and vertical as shown.

4. Connect the four corners of the rectangle to the vanishing point. These **vanishing lines,** or converging lines, will form the edges of the space.

5. Place a smaller rectangle with vertical and horizontal sides inside the larger one so that the corners intersect with the vanishing lines. This shows the basic lines of a one-point perspective.

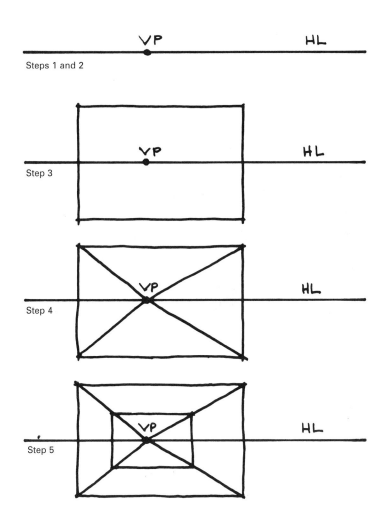

6. Add a large person with eyes on the horizon line at the vanishing point. Note the lines that represent **ground lines** on the **ground plane**.

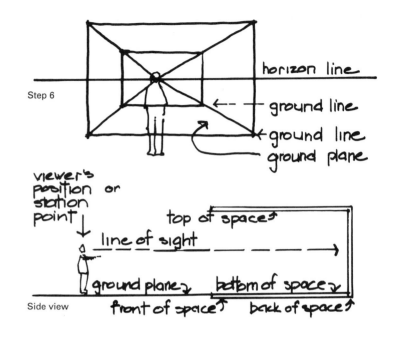

A side view, or section, of this one-point perspective setup would look like this. The **line of sight** is an imaginary line between the eyes of the viewer and the vanishing point on the horizon line. The viewer's position is called the **station point**.

Note these key aspects of a one-point perspective:

All lines parallel to the line of sight converge to one vanishing point on the horizon line.

All horizontal lines in the space are drawn horizontal in the perspective.

All vertical lines in the space are drawn vertical in the perspective.

Now do exercise 8.2: One-point cubes in space.

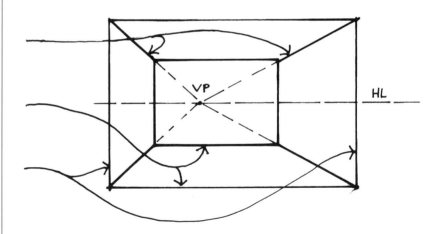

The human figure as a height measuring guide

Draw a horizon line and place several figures of different sizes, each with their eyes on the horizon line. Let's assume that the view of the space is the most natural one, which is from standing on the same level. In this case the distance from the feet to the eyes of each standing figure is 5 feet (1.5 m) no matter how large or small you draw them. A fast way to gauge the approximate height of an object anywhere in the perspective is to use multiples or fractions of the human figure at that point. For example; a 10-foot- (3-m-) high wall would be about the same as two figures stacked on top of each other, feet-to-eyes; a comfortable seat height would be a little less than 1/3 of the figure. This measuring method will be referred to as the **proportional method** in future references to calculating height in a perspective.

Ground-line scaling as a height measuring guide

This method is for use with one-point perspective charts only. It does not apply to two-point charts. The ground-line scaling method is very fast and more accurate than the human proportion method.

From the base or bottom corner of an object, project a horizontal line to the left or right. Count the grid divisions to equal the same dimensions as the known height. Now simply rotate this scaled ground line 90 degrees into a vertical position. This is the correct height of the object at that point on the ground plane. Use the same method, but with a downward rotation, for depths below the ground plane. This technique works best with "bird's-eye" views where the horizon line is well above 5 feet (1.5 m).

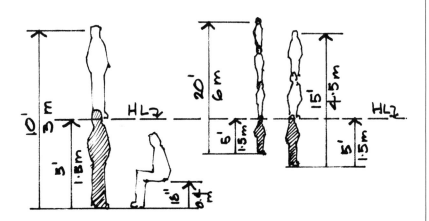

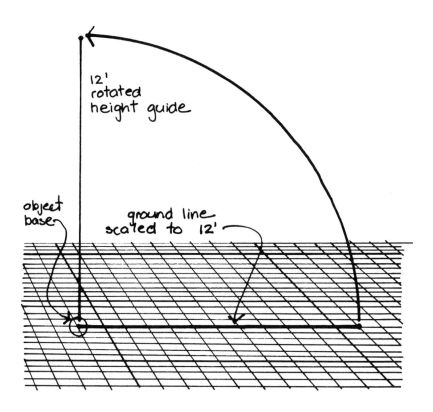

Perspective Charts (1 point)

The best aid for drawing perspectives by hand is the prepared perspective chart. Use an enlarged version of the perspective chart below (or a similar chart) to learn about one-point perspective. See the next section on two-point perspective for additional chart availability.

A typical one-point perspective chart will have the same three sets of lines we have been discussing: horizontal, vertical and vanishing. It is also referred to as parallel perspective because all the horizontal lines are indeed parallel. On the ground plane of this type of chart is a grid pattern that represents square units of measurement.

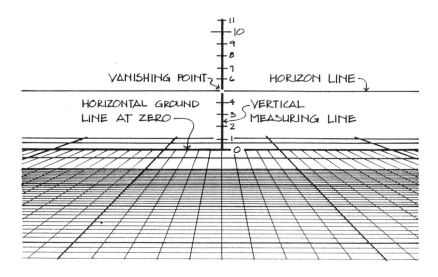

In this example they are 1 foot squares with every tenth line drawn thicker. The chart conveniently sets the compressed or foreshortened characteristics of the ground plane so that the lines get closer together as they get farther into the distance.

As we have seen, perspective space is composed of three dimensions: width, depth (or distance from the viewer) and height. To draw the width and depth, use the grid on the ground plane. To draw the height, use the vertical measuring line (see Appendix) or the proportion method.

Suppose you have a preliminary plan idea for an entryway, as shown here, and you wish to test it out on the one-point chart. The following diagrams show the drawing development process.

1. Place a grid on the plan that matches the exact dimensions of the perspective ground plane grid or multiples of the grid cell. The plan grid might be 2 feet (1 m), 5 feet (2 m) or 10 feet (3 m).

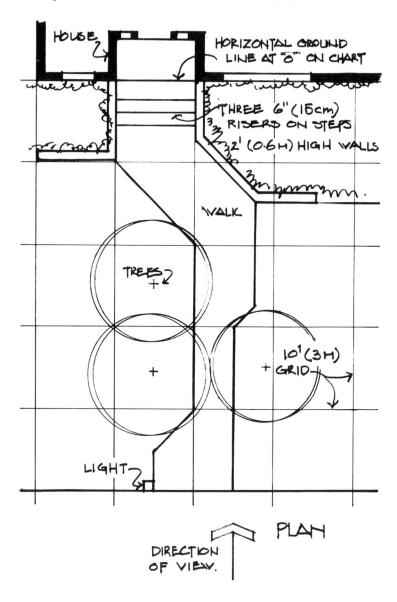

2. Make the grid, and therefore the viewing direction, perpendicular to the main lines of the plan such as the facade of a building. Adjust the station point to the left or right to obtain the most desirable view.

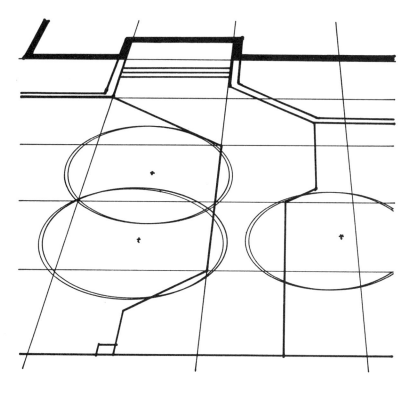

3. Transfer the plan data onto the perspective grid. There will be some trial and error at the beginning to decide how close or far away you want to place objects. Look at the sequence of perspective grids shown here and notice how everything becomes more compressed as you move from looking down in plan view to looking at the space from a 5 foot (1.5 m) eye level.

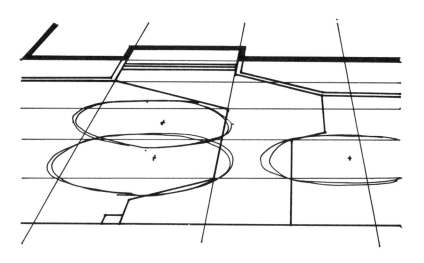

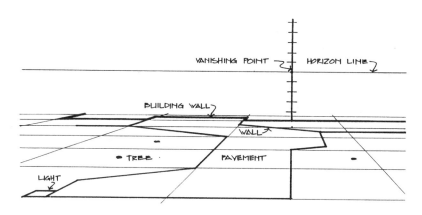

4. Once the foreshortened lines are on the perspective grid, draw vertical lines from the corners of objects to be raised or lowered. Mark their height by using the **proportion method** or the vertical measuring line (see Appendix). Finish the outlines of built objects by following the principles of one-point perspective.

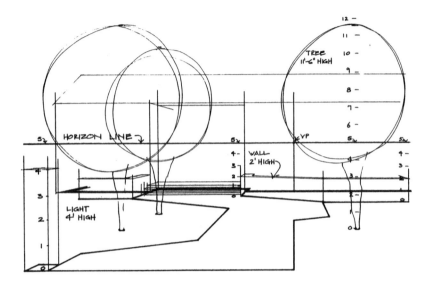

5. Outline some figures and other entourage, then redraw on an overlay, omitting all hidden and construction lines.

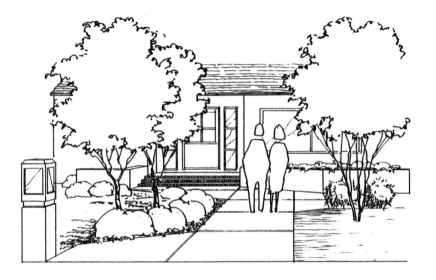

Do exercise 8.3 and compare it to 8.1

For more practice at one point try exercises 8.4 and 8.5

Two-point perspective

Instead of one vanishing point on the eye line, we now have two: the left vanishing point (LVP) and the right vanishing point (RVP). You will see that this format gives a more dynamic and representative view. One-point perspectives are good for streetscape views and other lineal spaces, but they tend to be more static and uncommon in terms of how we see space.

If you were to draw some simple rectilinear boxes there would be three types of lines.

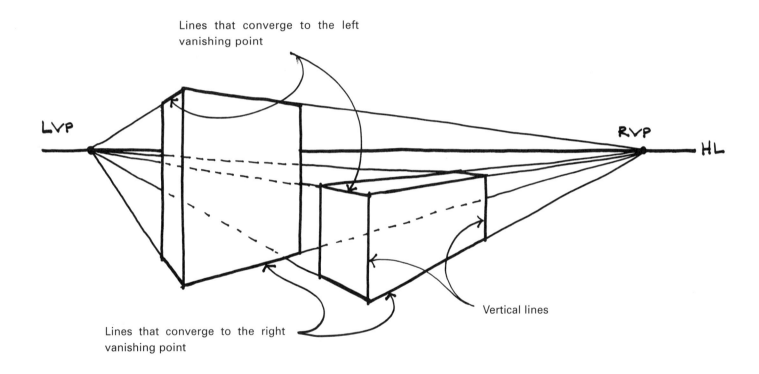

Lines that converge to the left vanishing point

LVP

RVP

HL

Vertical lines

Lines that converge to the right vanishing point

Unlike one-point perspectives, there are no horizontal lines except at the horizon line. An important principle to remember is that **all parallel lines on the same plane or object surface converge to the same vanishing point.**

Try exercise 8.6

Perspective charts (2 point)

Prepared perspective charts are also available for two-point perspectives. In the United States one of the best series is published by Dick Sneary and is available through Mike Lin Graphics Workshop, 2815 Amherst Ave., Manhattan, Kansas 66502. Web site: www.beloose.com

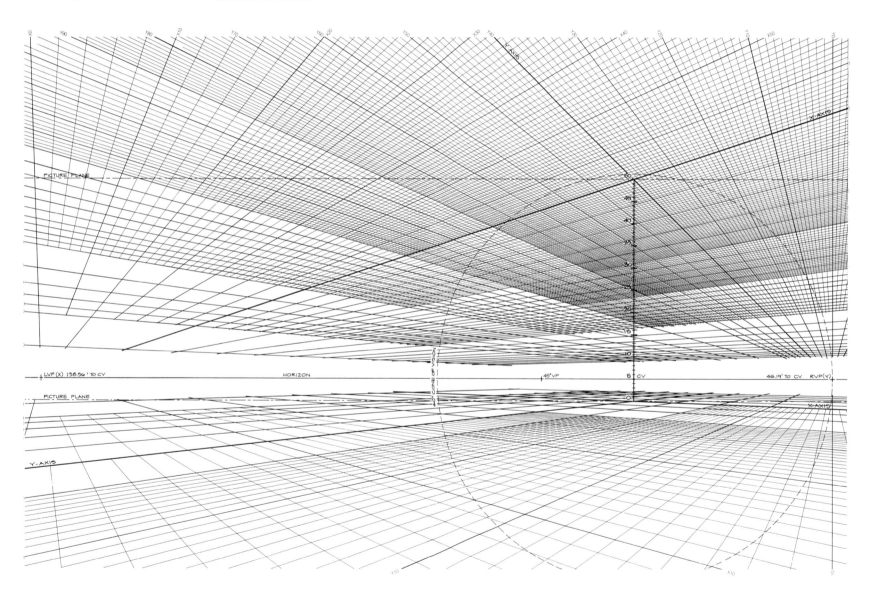

An excellent series of metric charts is available from ZEICHENWERK, Elmer-Fryer-Ring 84, 86391 Stadtbergen, Germany. Web site: www.zeichenwerk.de

Follow the same sequence described under one-point perspective for two-point setup when transferring plan outlines into a three-dimensional perspective drawing. It is also valuable to design directly in a 3-D mode by sketching on top of the perspective grid without the constraints of a plan view.

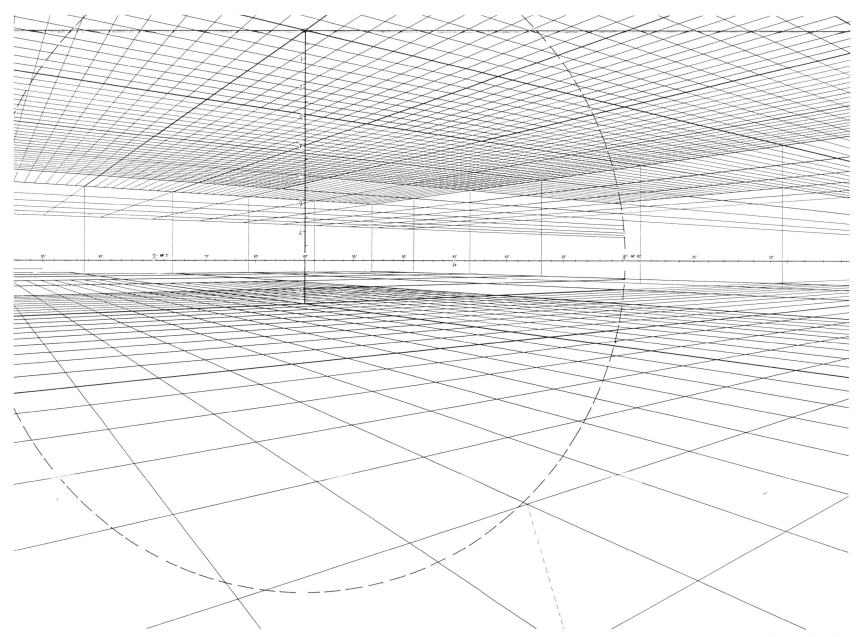

Experiment with charts that have eye lines higher than 5 feet (1.5 m). This moves you into an oblique or "birds eye" view of the landscape. The Dick Sneary charts, which use standard measurements, can be used inverted to make the eye line at 45 feet. Zeichenwerk's series of charts, which are metric, have eye lines at 1.5, 4, 8 and 16 meters. As the eye line gets higher, more of the designed space will fit into the perspective to the position where it seems you are looking at an inclined plan with all the relative heights showing.

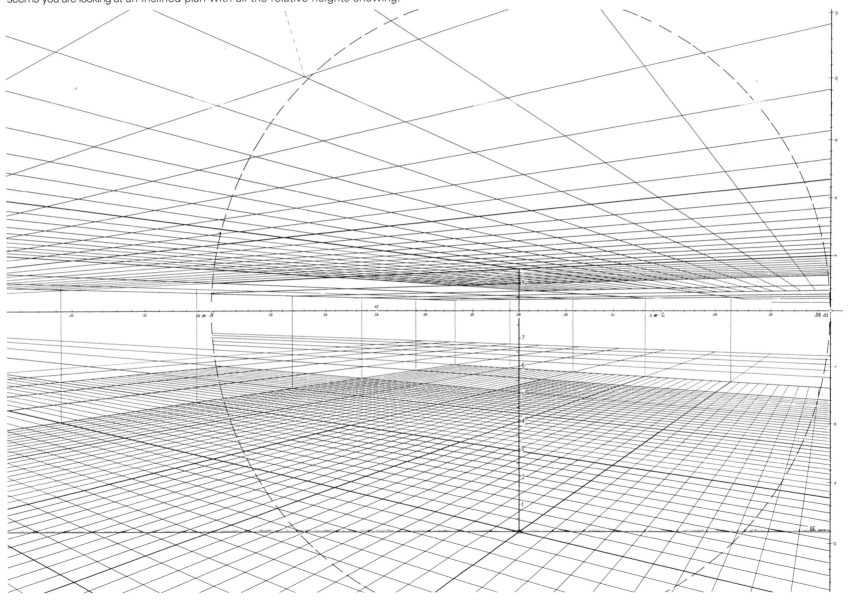

Now try the two-point exercise 8.7.

Bird's-eye view

Although the bird's-eye view is less realistic than an eye-level view, it is possible to show more of the site.
The focal zone has more detail and higher contrast.

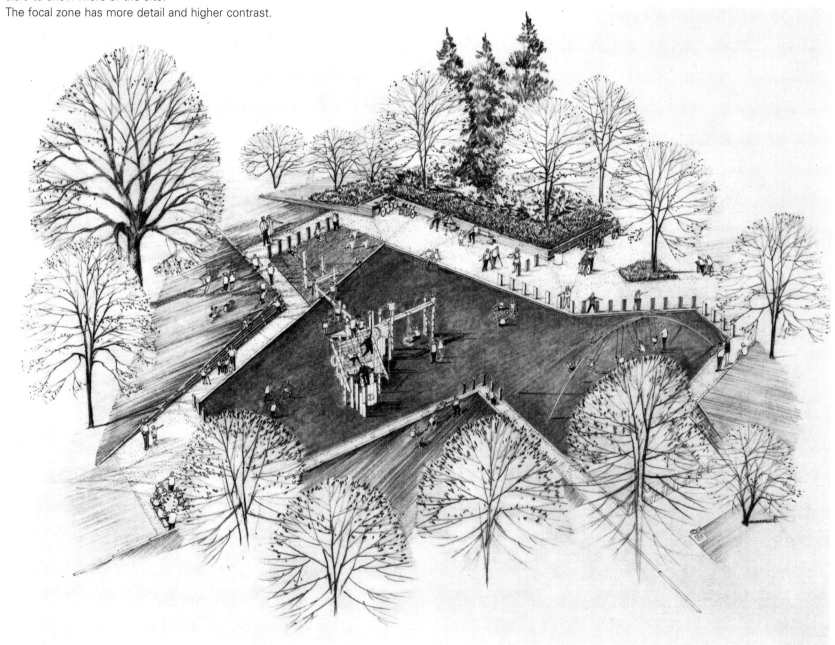

Overview

An overview can be a realistic viewpoint in mountainous areas. It allows the designer to show most of the plan elements.

The darker tones near the center of the sketch emphasize the zone of interest. These transition to white space near the edges.

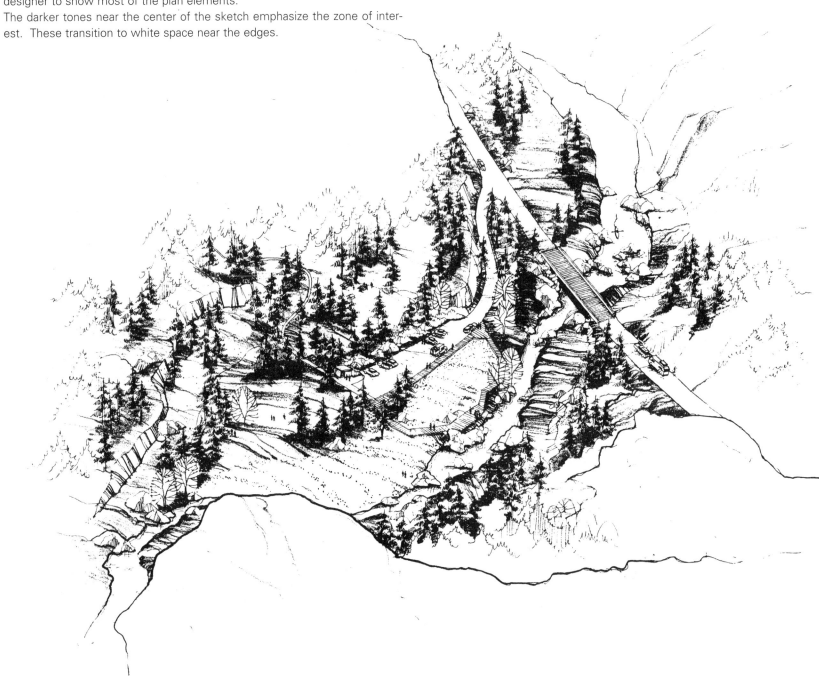

Refined Pencil Sketch

Cliffs and trees balance the left side of the composition.

Foreground trees block some middle ground and frame the sketch.

Simplified background elements.

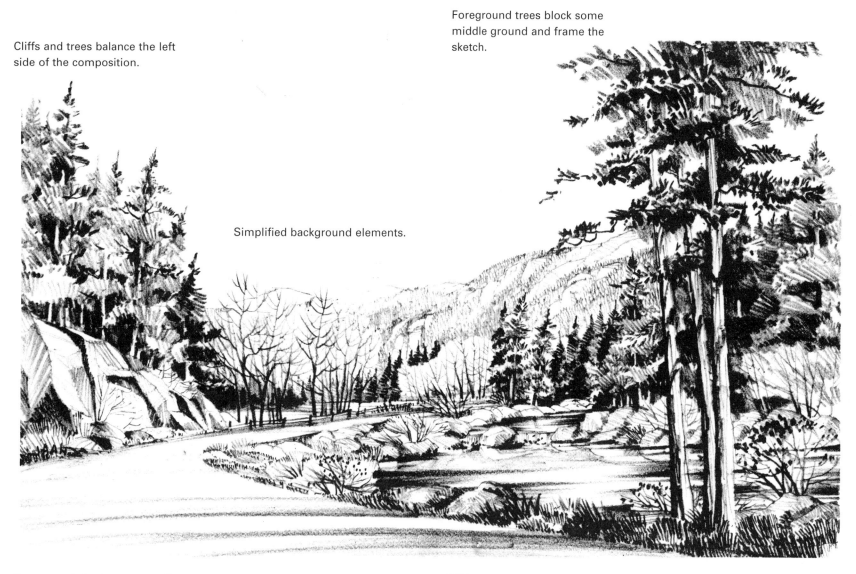

Foreground shadows across the road keep the eye within the sketch.

White space shows the reflective qualities of the water.

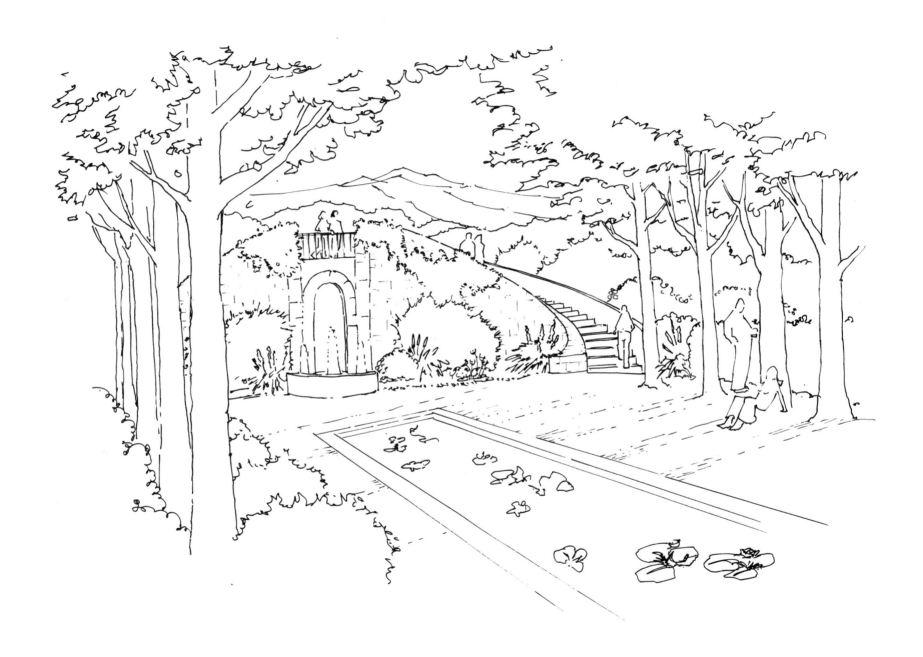

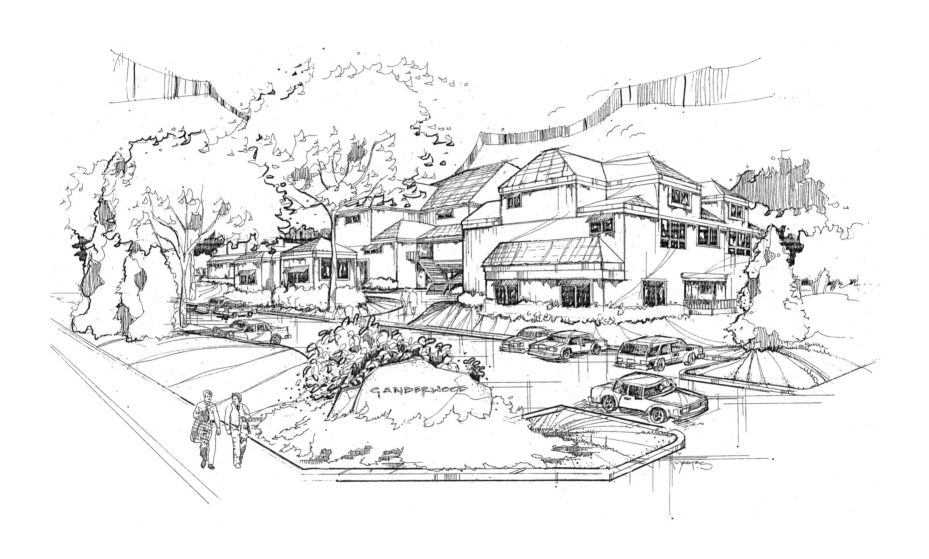

Perspectives Using a Digital Camera

The bird's-eye or oblique view of your design is a view from a position well above the most realistic 5 foot (1.5 meter) level. Even so, the results are very convincing and believable. This technique uses an oblique photographic image of the plan and projects objects vertically. Begin by deciding what portion of the design you wish to emphasize and the direction of the view.

Although more of the plan can be included than in the 5 foot (1.5 m) horizon-line perspective, you still may not want to show the whole plan. Now add a grid where one axis runs perpendicular to the direction of your view. If the plan scale is around 1″ = 10′ or 1/8″=1′-0″(1:100) then a 10 foot (3 m) grid works well. Adjust the grid size depending on scale.

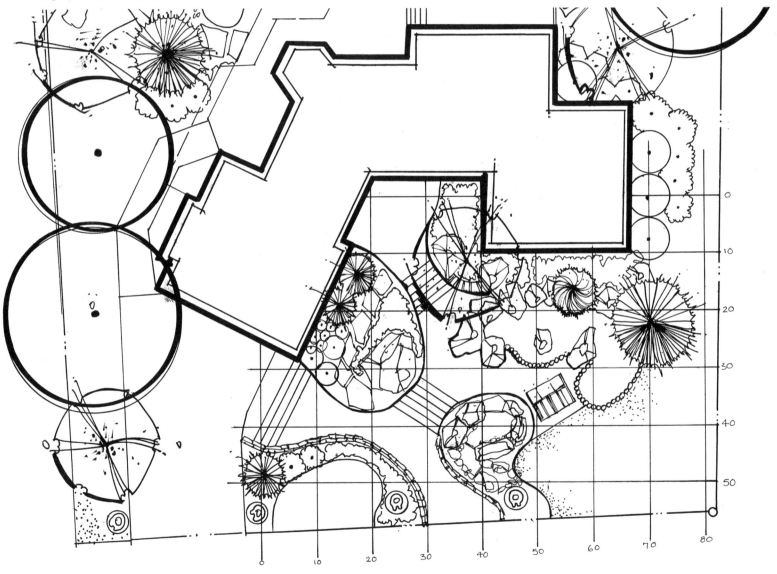

Set up your plan on a well-lit level surface and, with a digital camera, take several photographs at various angles from horizontal. Angles between 30 and 45 degrees seem to work best. Transfer the photographs to your computer and adjust the size to suit your ultimate drawing size.

Select the desired bird's-eye view photograph and print a copy. This will now
be used as a base for the perspective. Notice how the grid lines running par-
allel to the direction of the photo appear to vanish.

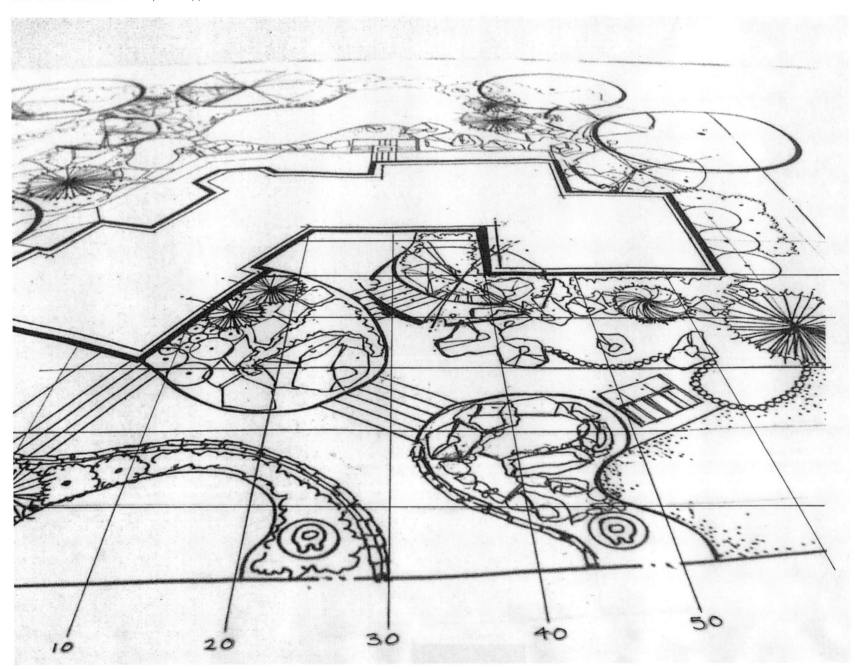

10 20 30 40 50

On an overlay, trace the outline of the main plane. In this case we have chosen the upper level of three levels. Your plan may have one or several levels. Using the horizontal grid lines as a measuring guide place vertical lines at key corners of structures. The heights of these vertical lines must be in proportion to the 10 foot (3 m) horizontal grid line which is very close to the particular corner. In this example we have dropped 3 foot (1 m) vertical lines at the corners of the series of six steps. We have assumed that each step riser is 6 inches (17 cm).

Now slide the overlay up vertically until the bottom of the stair box lines up with the same line on the bird's-eye view of the plan and trace the outline of the next level. In this case there is a middle level with water and rocks.

Stairway Construction

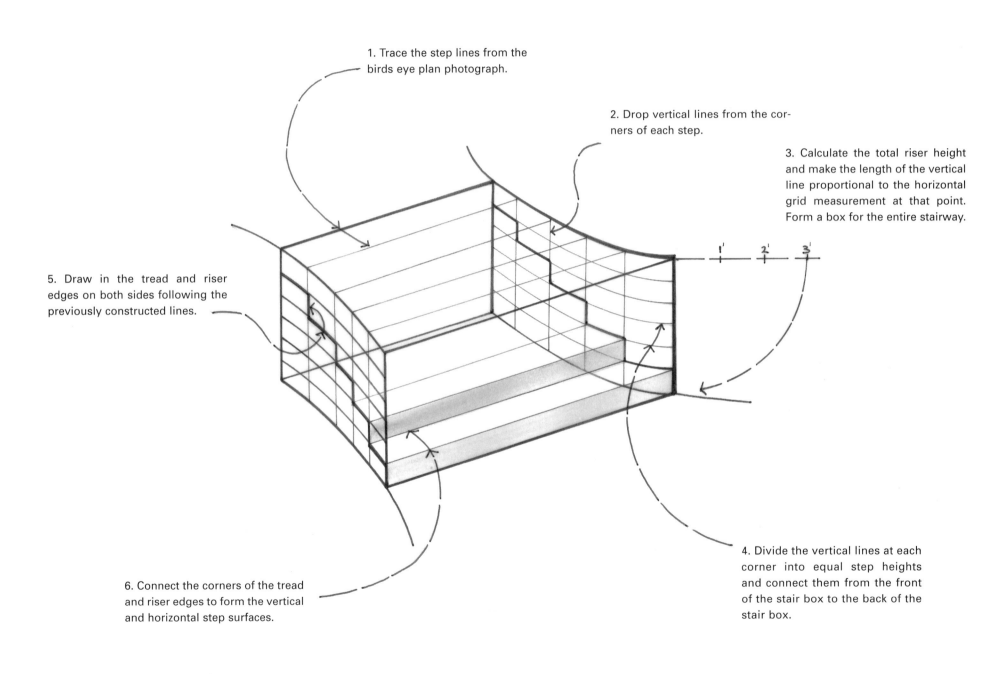

1. Trace the step lines from the birds eye plan photograph.

2. Drop vertical lines from the corners of each step.

3. Calculate the total riser height and make the length of the vertical line proportional to the horizontal grid measurement at that point. Form a box for the entire stairway.

5. Draw in the tread and riser edges on both sides following the previously constructed lines.

4. Divide the vertical lines at each corner into equal step heights and connect them from the front of the stair box to the back of the stair box.

6. Connect the corners of the tread and riser edges to form the vertical and horizontal step surfaces.

1' 2' 3'

Repeat if necessary to accommodate all the levels on your design. In this example there is another set of stairs, a second vertical movement of the overlay and a need to trace the lower level.

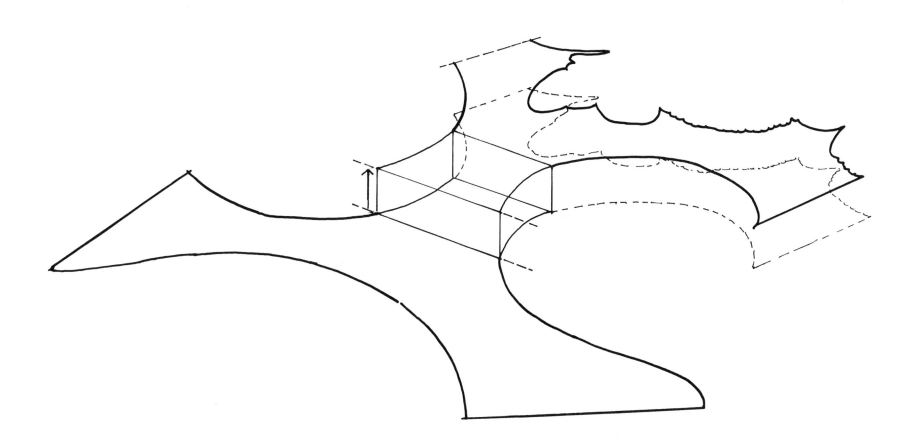

Complete a "wire frame" drawing that projects heights of all objects in proportion to the horizontal dimension of the grid at that point. In this example the arrows represent approximate heights of plant materials. If you extend the ground plane vanishing lines to the point (usually off the page) where they meet, then this is a vanishing point on the eye line. Both the vanishing point and the eye line may be used to structure the shape of other objects in the perspective.

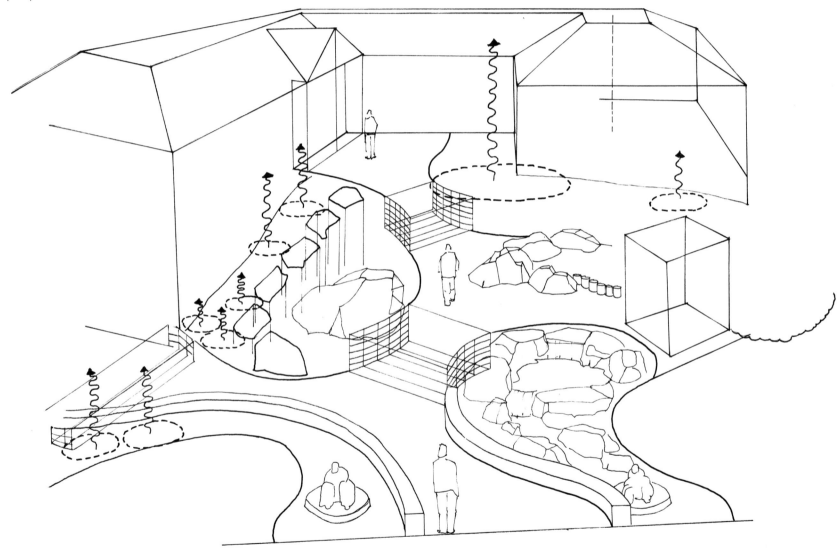

Complete the sketch adding form, texture and people.

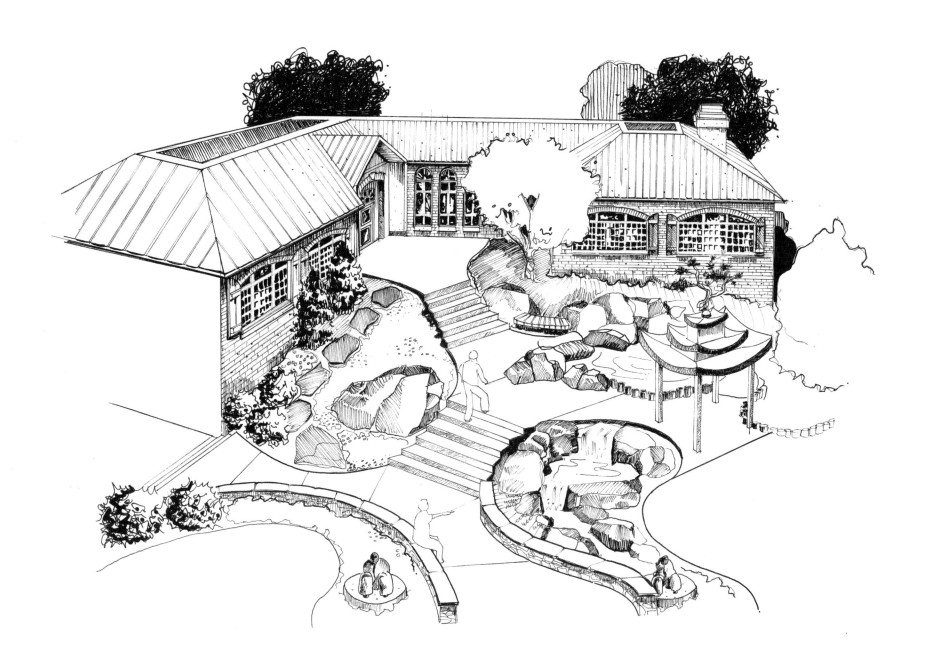

Perspectives Using Computer Wire Frames

Many designers are using 3-D computer programs to perform the task of perspective setup. Here is a preliminary plan from which a sales perspective is needed. It could be the entry way to a housing development or a corporate office park.

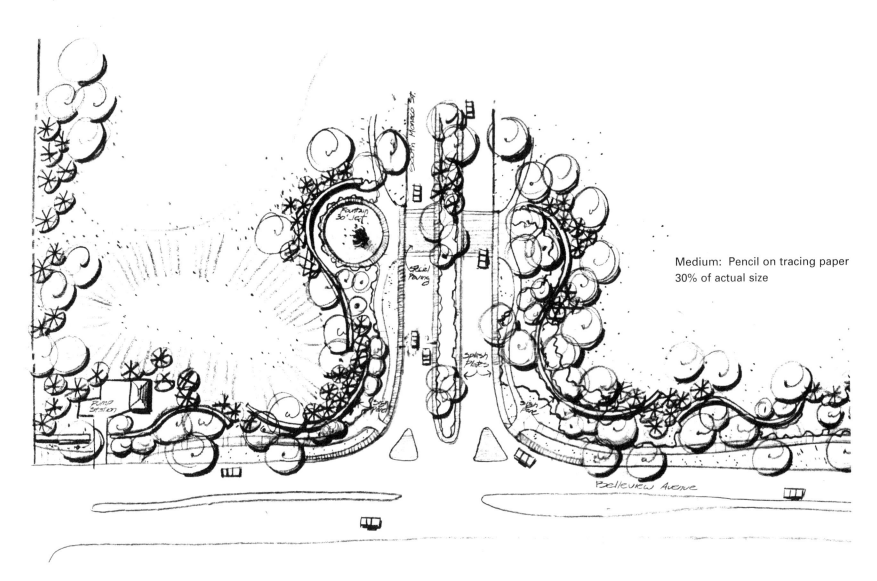

Medium: Pencil on tracing paper
30% of actual size

If the plan data is not already programmed into the computer, this is the next step. Create a grid over the plan and enter all height-related data such as topographic elevations, heights of buildings and heights of landscape structures.

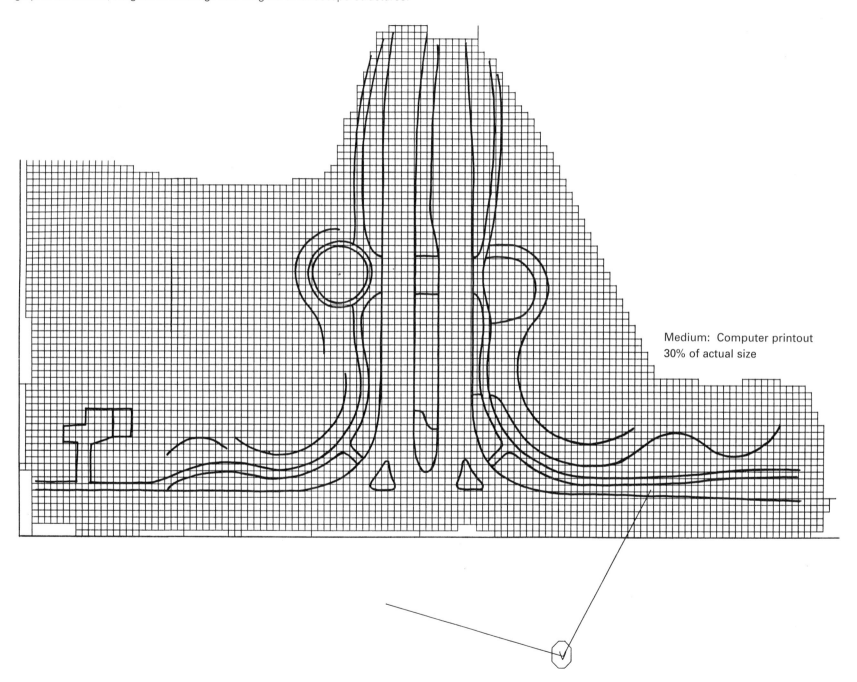

Medium: Computer printout
30% of actual size

The viewing height and direction can be easily selected, then a wire frame print can be made at the appropriate size. It is important to know the heights of objects in the wire frame, because these heights will be used to scale other elements (such as people and trees) that are added to the perspective. Another possibility is to include the horizon line and its height above the ground plane. Either method will work for calculating the relative proportions of new objects.

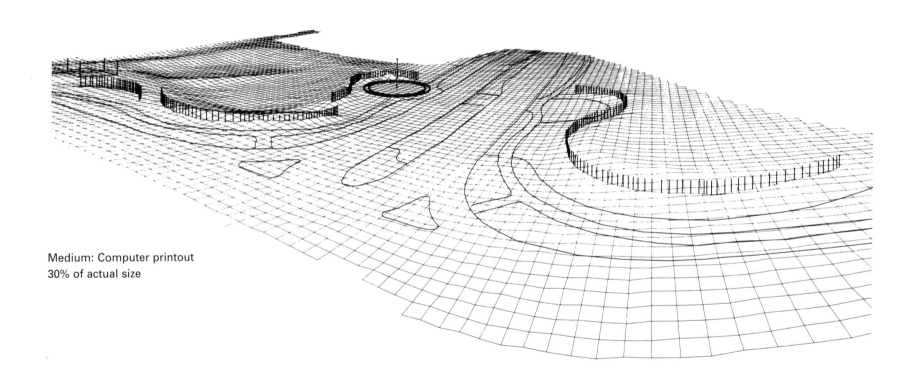

Medium: Computer printout
30% of actual size

Place an overlay on top of the wire frame print. With most of the difficult technical setup completed by the computer, it is now a relatively efficient process to bring the perspective to life using the manual techniques discussed in other parts of this book. Refer to the graphic symbol file and the section on perspective composition to find ideas on adding entourage, shade and shadow.

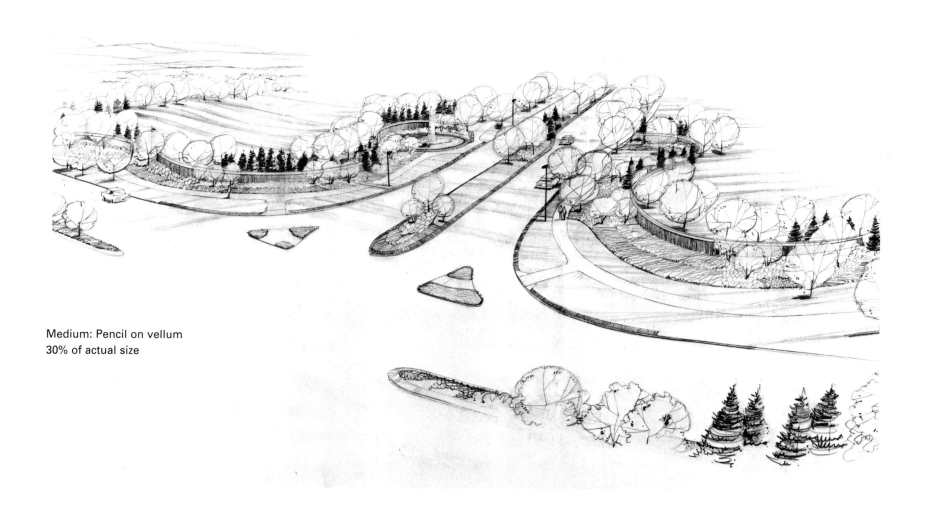

Medium: Pencil on vellum
30% of actual size

The following four pages shows the sequence of graphic products generated in the process of preparing a perspective from a computer wire frame. The site is a small garden.

Simplified plan of the garden

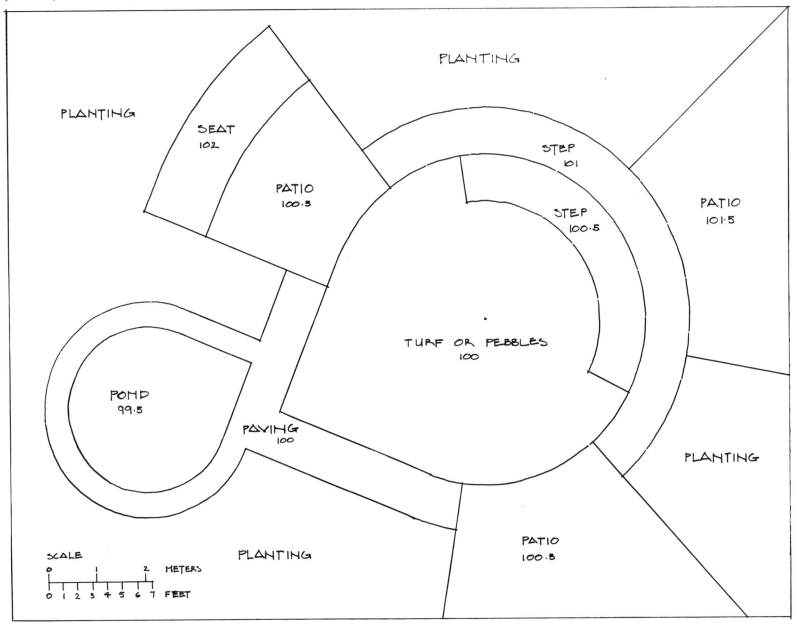

PLANTING

PLANTING

SEAT
102

STEP
101

PATIO
100.5

PATIO
101.5

STEP
100.5

TURF OR PEBBLES
100

POND
99.5

PAVING
100

PLANTING

PLANTING

PATIO
100.5

SCALE
0 1 2 METERS
0 1 2 3 4 5 6 7 FEET

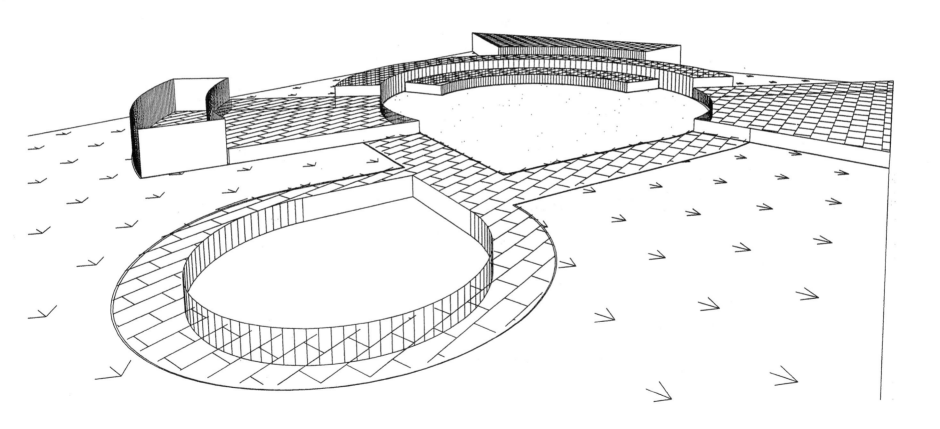

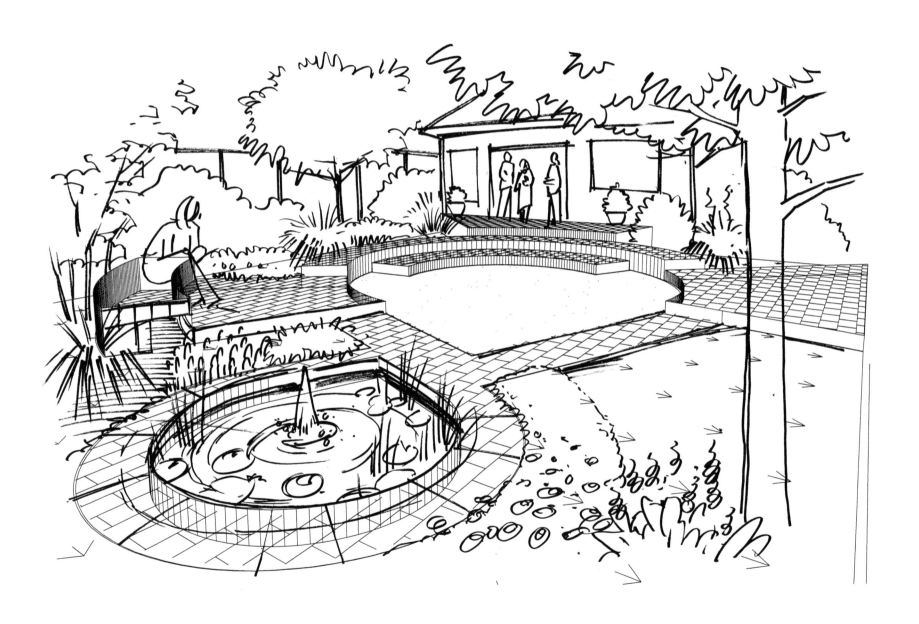

Finished perspective drawing

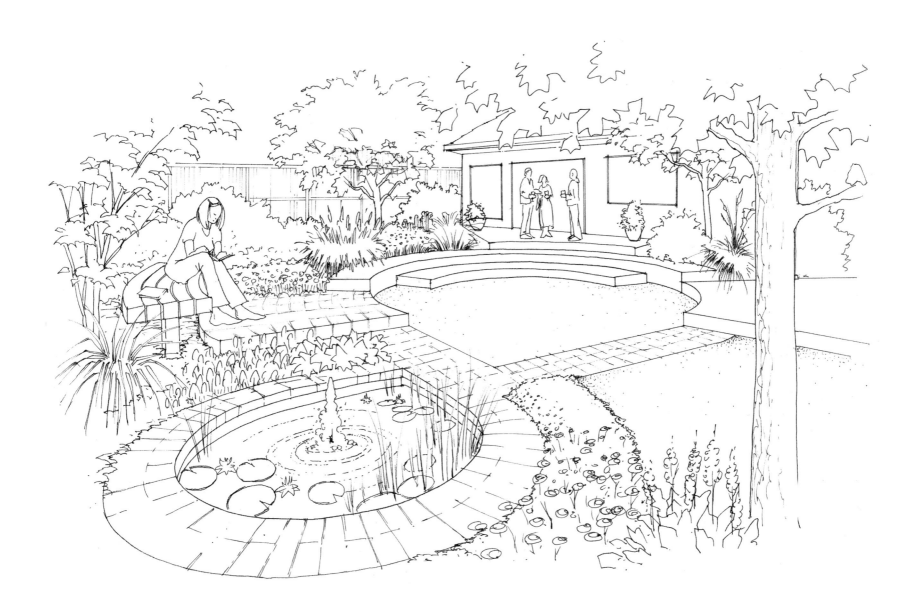

Composition in Perspective

Composition is about the relationships of the elements in the perspective to each other and to the overall space or paper.

The following principles of composition can be used separately or, with some exceptions, together as techniques to improve the power of your perspective. Practice each one, then decide which ones when used together will enhance your message.

Balance
Near and Far Relationships
Selective Finishing
Enclosure by Planes
Cluster and Void
Light and Dark Relationships
Outline
Open and Closed

1. Balance

This has to do with where you place the concentrations of interest in the drawing. If you were to visually divide your paper into thirds both vertically and horizontally there would be four points of intersection, which are usually the most effective places to locate your focal zone (Drawing A). If you place your main areas of interest in these zones the composition appears to have a dynamic informal balance. The viewer's eye is drawn through the sketch towards the focal area or areas (Drawing B).

Focal zones outside these 1/3 zones seem uncomfortably forced towards the edge.

A focal zone placed directly in the center creates a more formal static balance, which is further enhanced if the focal image itself is symmetrical. This may be appropriate when drawing a perspective of a formal space.

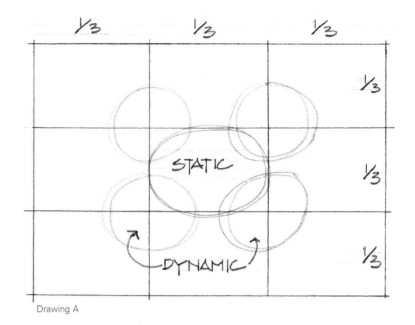

Drawing A

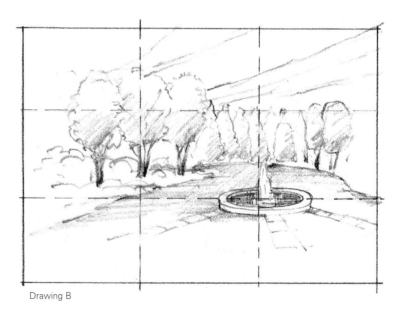

Drawing B

2. Near and Far Relationships

Incorporation of foreground, middle ground and background elements creates the greatest sense of realism in a sketch of outdoor space. Three interrelated ideas become important.

a. Smaller size with greater distance.

This is one of the basic principles of perspective whereby size is inversely proportional to distance (Drawing A).

Drawing A

b. Closer spacing with greater distance.

This is very similar to size change. To make objects look farther away the lines should be squashed closer together both in the horizontal and vertical planes (Drawing B).

Drawing B

c. Abstraction of form with greater distance.

As you reduce the size of the objects and squash them together, it becomes impossible to maintain the same level of detail. Therefore, close objects may be very intricate, and distant objects need to be very simplified (Drawing C).

Drawing C

d. Overlapping forms.

When more distant objects are partially obscured by closer objects, the sense of spatial depth and realism is increased. Don't try to show all elements in their entirety. A cluster of rocks should show only portions of each rock. A row of trees will reveal only part of each tree (Drawing D).

Drawing D

3. Selective Finishing

Here we deliberately disregard the near–far relationships discussed on pages 189-190 and select only the zones or objects of greatest importance to apply detail. For example the foreground, background and edge elements may be left "unfinished" with wispy outlines, while the middle ground or focal element may be richly detailed.

This is also referred to as "fade to edge" or "focal emphasis."

4. Enclosure by Planes

A perspective can be viewed in terms of three dominant planes: ground plane (e.g., paving, ground covers, water), vertical plane (e.g., walls, tree trunks, plant screens), overhead plane (e.g., underside of tree canopy or pergola). When all three planes are strongly expressed, a higher degree of enclosure results. Even if one of the planes is just a hint, the perspective becomes more interesting than if that plane was omitted all together (Drawing A).

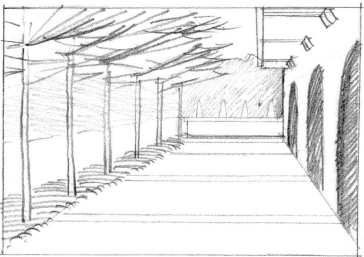

Drawing A

5. Cluster and Void

Groups and clusters of detail next to uncluttered white space brings excitement and interest to the sketch. Avoid evenly placed lines and tones. Strive for randomness in the placement and quantity of line clusters (Drawing B).

Drawing B

6. Light and Dark Relationships

a. Contrasting tones.

Powerful and interesting contrasts can be created by sudden, abrupt changes from light to dark tones. This placement of light next to dark accents the limits of each form and adds to their command for attention (Drawing A).

Drawing A

b. Same tones or lost and found edges.

In a few limited places it is fun to eliminate contrast by placing light next to light or dark next to dark. Edges of objects are "lost" to the eye. The drawing now invites some discovery by expecting viewers to "find" the missing edges in their imagination. For line drawings, a skipped line can make boundaries blur or disappear creating similar illusions of lost and found edges (Drawing B).

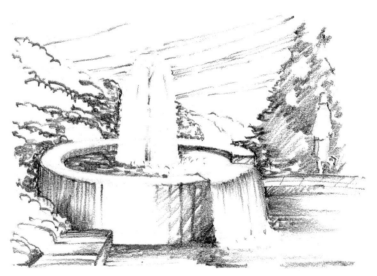

Drawing B

7. Outline

Outline drawings are often used as starting points for more refined sketches. Sometimes they can be the end point showing abstractions of the key space defining elements. They are quick to produce but lack the textural or tonal interest of a more refined drawing (Drawing A).

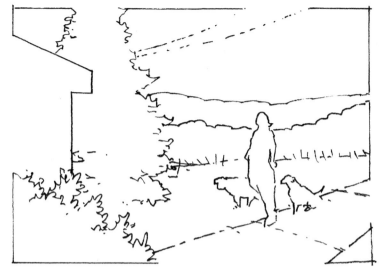

Drawing A

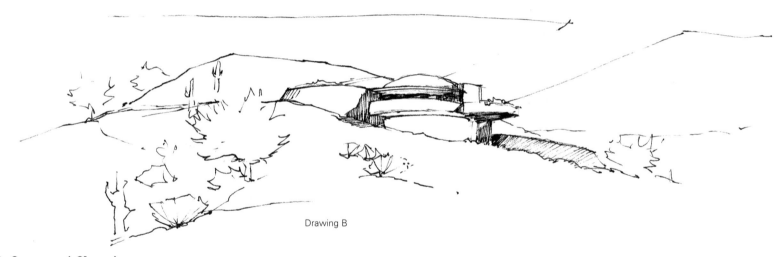

Drawing B

8. Open and Closed

Closed compositions are entirely contained by and extend right up to the edges of the paper or a strict boundary line. Open compositions appear to extend beyond the boundaries or may have indistinct boundaries as described in the "fade to edge" technique. If you prefer a more defined spatial message then the closed composition works best. If you are trying for a looser, undefined message try the open composition (Drawing B).

Expressing Light Quality, Shade and Shadow

Always establish a light direction before you begin to add texture and tone. The easiest way to do this is to assume the light is coming from the upper right or upper left side of the drawing.

Shade

All objects will have a dark shady side facing away from the sun, a light sunny side facing more directly towards the sun and various intermediate tones depending on the structure of the object. When you show how the light hits an object you are also expressing its shape and textural qualities.

Build up denser clusters of lines on the shady side. On smoother surfaces diagonal hatch lines with a soft pencil are appropriate. Cross hatch lines with fine point pens also work well. To indicate natural or architectural surfaces with distinctive texture, choose a line doodle that seems to match the character. For example, foliage texture could be drawn with a series of rounded doodles for broad-leaved trees or pointed doodles for coniferous trees. Similarly the ground plane could be rendered with an upward, sharply-pointed doodle indicating grasses, a rounded doodle indicating pebbles, or a simple horizontal line doodle representing smooth paving.

Gradual transitions of tone indicate flat and rounded surfaces with soft edges. Abrupt transitions of tone indicate sharper angular forms with hard edges.

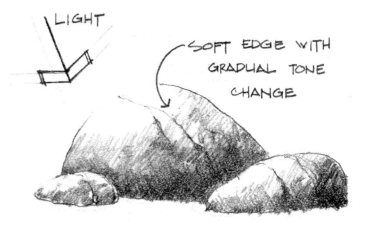

In most situations there is bounced and reflected light. This means that flat, even surfaces will seldom have a perfectly consistent tone. You can use this to bring interest to a bland surface and to force the contrast between the shady side and the shadow of the same object.

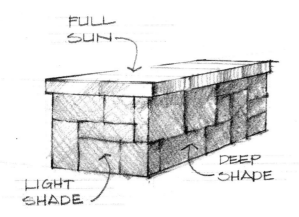

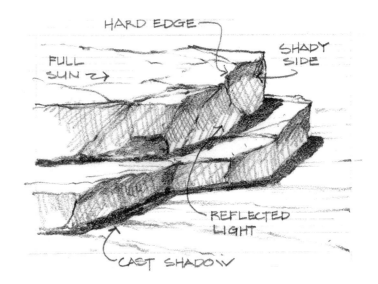

Shadow

Cast shadows are the darker places on one object or surface caused by the interruption of light from another object. In this book we will make no attempt to render technically accurate shadow shapes. This can get very complex as one convoluted form casts its shadow on another. Rather we will apply some gross simplifications so that shadows are somewhat believable.

For simple architectural objects on a level ground plane begin by defining the outer edge of the shadow on the ground with a vanishing line going to the same vanishing point as the edge interrupting the sun. Its distance from the object should be proportional to the object's height. Low objects such as seat height planters should be very close to the base. Objects twice the height will have the line twice the distance from the base. Now draw parallel lines from the bottom corners of the object, making sure that these lines are close to horizontal. You may need to add other vanishing lines on the ground for other edges that intercept the light.

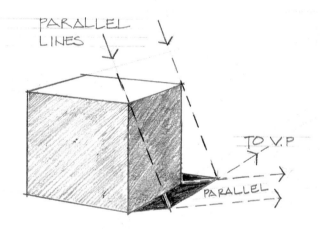

For vegetation and other natural elements, be sure to use the same almost horizontal direction for the shadow, then compress the shadow so that it is a fairly narrow strip.

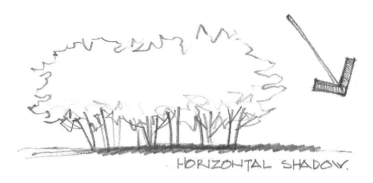

Avoid shadows coming towards the bottom of the drawing. Again try to keep some consistency with the length of the shadows as a proportion of their height.

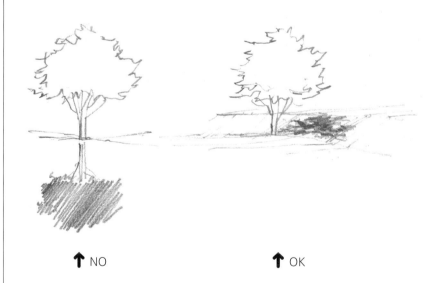

↑ NO ↑ OK

Express the shape of the ground plane. As shadows fall on vertical, sloping or undulating surfaces draw the shadow with directional changes that express these different slopes, pitches and level changes.

As with shaded surfaces, express the texture of shadowed surfaces with line doodles that capture the character of the ground plane or shadowed object materials.

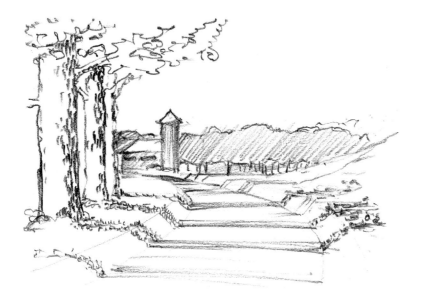

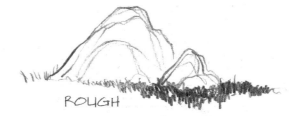

ROUGH

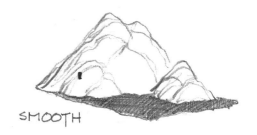

SMOOTH

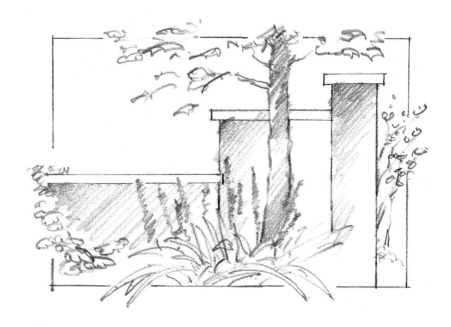

Exercises

8.1 Pre-test perspective

Media: Felt tip pen on 12 x 18" (A3) trace paper.
Without referring to any graphic images, draw what you perceive to be a realistic view of things. In plan view they might be like this.

A. On the left side of the sheet draw a railway line. You are standing in the middle of a set of railway tracks that run straight across an endless, flat desert which stretches as far as the eye can see. No trains are coming.
B. On the right side of the sheet draw a walled courtyard. You are standing about 20 feet (6 m) away from the front of the space looking directly into it. The three walls are all 20 feet (6 m) long and 10 feet (3 m) high.

8.2 Cubes in space: one-point

Media: Felt tip pen on 12 x 18" (A3) trace paper. Drawing entirely freehand, place a straight horizon line across the center of the sheet. Add a vanishing point near the center. Draw squares of various sizes all over the sheet below and above the horizon line. With light pencil lines connect the corners to the vanishing point. Guess where the back side of the cube will be in order to retain a cube-like appearance. It should be fairly close, getting less close as the cubes move away from the vanishing point. With the pen, draw in the back side, then the visible edges that vanish to the vanishing point.

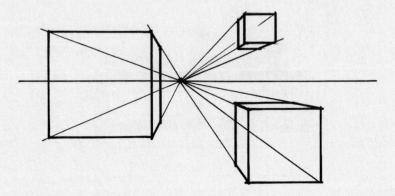

8.3 Simple Courtyard Space on One-point Chart

Media: Felt tip pen on 12 x 18" (A3) trace paper; straightedge drafting aids and freehand techniques combined.
Draw a courtyard that is 20 feet (6 m) wide
20 feet (6 m) deep and surrounded on three sides by walls 10 feet (3 m) high.
Follow these steps.

1. Place the trace paper over a one point perspective chart and draw in the horizon line and vanishing point.
2. Following the ground plane grid lines place the footprint of the courtyard wall with the open side near the bottom of the grid. Make the inside dimensions as listed but make the wall 1 foot (0.3 m) thick.
3. Draft vertical pencil guidelines from each corner of the footprint.
4. Use the proportion method to establish the height of one corner of the wall only. Follow the principles of one-point perspective to draw in the top edges of the wall.
5. Add rough outlines of some elements to this space; two 20 feet (6 m) trees and a box 3 feet (1 m) high, 5 feet (1.5 m) wide and any length. Place these elements in the space by first visualizing a person standing at that location. No matter what size the figure is drawn, it is always 5 feet (1.5 m). The new element will be a multiple or fraction of that person. Trace some people into the space.
6. Remove hidden lines. On an overlay of trace, re-draw the courtyard omitting the hidden lines.

8.4 Fountain courtyard: one-point eye level

Media: Felt tip pen on 18 x 24" (A2) vellum or marker paper (set up on trace paper); straightedge drafting aids and freehand techniques combined.

Draw a perspective of the fountain courtyard plan shown below.

Make the front edge of the space about 2 1/2 inches (6 cm) below the horizon line. Use the vertical measuring line to determine heights. Block out the vegetation and people before tracing the final. Copy entourage from the graphic symbol file.

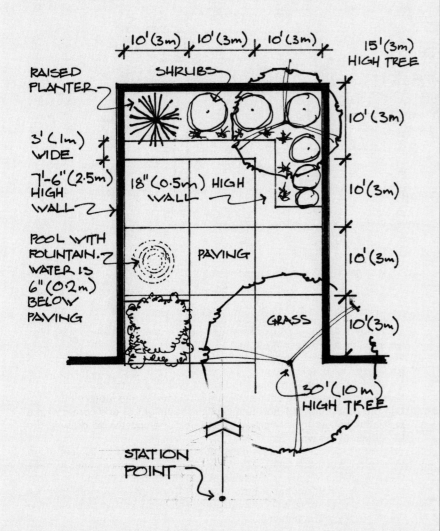

8.5 Pool courtyard: one-point birds-eye

Media: Felt tip pen on 18 x 24" (A2) marker paper (set up on trace); straightedge drafting aids and freehand techniques combined.

With the one-point perspective chart set up to obtain a 25 foot (8m) horizon line, draw a perspective of the pool courtyard plan shown below. Begin the front of the space (the zero line) about 6 to 9 inches (15 to 23 cm) below the horizon line depending on how large you want the perspective to be. After blocking out the paving, walls and overhead structure, add rough outlines for trees, shrubs, seating and people. Note that people should be drawn about 0.2 x the distance from the ground plane to the horizon line. Other heights may be determined by using the horizontal ground line scaling method.

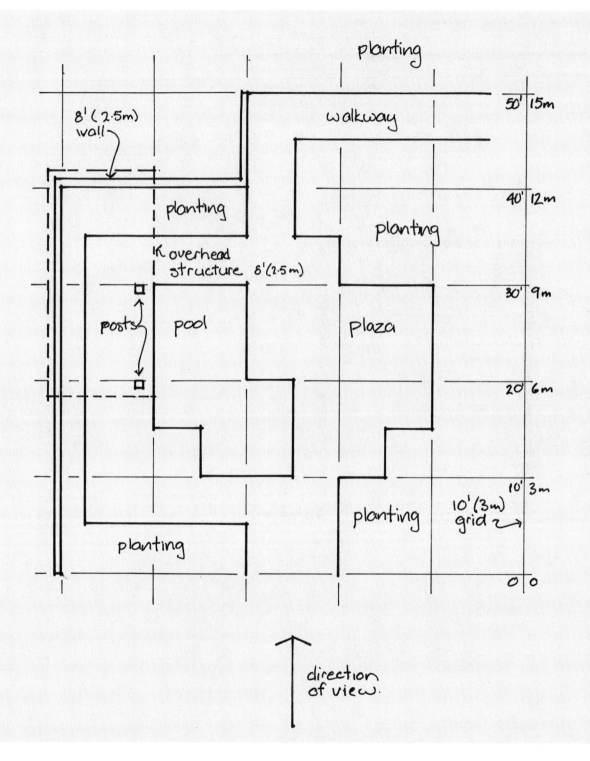

planting

8' (2.5m) wall

walkway

50' 15m

planting

40' 12m

planting

overhead structure 8' (2.5m)

30' 9m

posts

pool

Plaza

20' 6m

10' 3m

10' (3m) grid

planting

planting

0 0

direction of view.

8.6 Boxes in space: two-point

Media: Felt tip pen on 12 x 18" (A3) trace paper. Drawing entirely freehand place a straight horizon line across the center of the sheet. Add a left vanishing point and right vanishing point near the edges of the sheet. With a pencil and a straightedge draw a series of lines which radiate from each vanishing point. Draw six boxes in space. Two should be above the horizon line, two below and two straddling. Start each box with a vertical line. Add top and bottom vanishing lines in opposite directions, then guess at the back of the box. They need not look cubic. There should be no horizontal lines. Darken in the visible edges of each box.

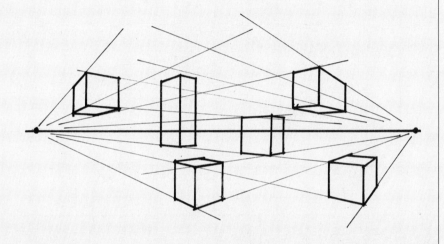

8.7 Geometric forms with chart: two point

Media: Pencil and felt tip pen on 18 x 24" (A2) trace paper. The objective is to become familiar with locating objects and finding their height in two-point perspective. Overlay the trace on a two-point chart with a 5 foot (1.5 m) eye line and the 60-degree vanishing point on the left side. (Suggested charts: Sneary, full size, reverse reading two-point chart; Lawson #7; Zeichenwerk, full size two-point chart.) Tape down the trace over the chart. The plan view below shows the location of four geometric forms. In pencil, first locate the footprint of each form on the ground plane. Next erect verticals from their corners. Now use the proportion method to establish the height of each form and draw in the tops obeying the vanishing lines of the two point chart. Re-trace in pen on another overlay omitting hidden lines.

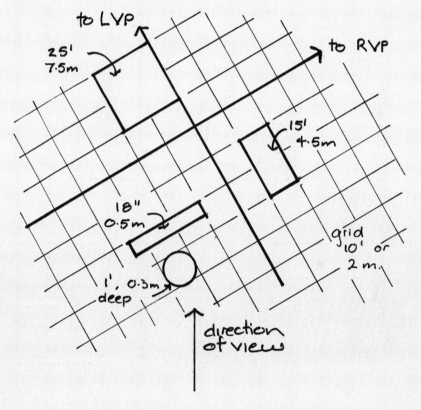

8.8 Camera-assisted perspective

Media: Final drawing should be done with pens on marker paper or Mylar. Choose a landscape plan with some modest level change. Follow the directions in the section called "Perspective Using a Digital Camera" to prepare a finished perspective.

8.9 Computer-assisted perspective

Media: Final drawing should be done with pens on marker paper or mylar. Prepare a perspective from a computer generated wire frame printout. Refer to the section called "Perspectives Using Computer Wire Frames". It is helpful to have the horizon line and at least one vanishing point shown on the wire frame. Know the elevation of the horizon line above the ground plane. This will allow you to make changes and additions at the correct height.

8.10 Tone Bars

Media: Soft (4B) graphite pencil and pen on 8 1/2 x 11" (A4) copy paper.
Draw the outline of two rectangular bars 1 inch (2 cm) wide and 8 inches (16 cm) long. Divide the rectangle into 1 inch (2 cm) segments. On each rectangle create a tone gradient from very dark black in the left segment to no tone in the right segment. Strive to obtain an even jump in tone from one segment to the next. On the top rectangle use the soft pencil and smooth even strokes. On the bottom rectangle use the fine felt tip pen and cross-hatching.

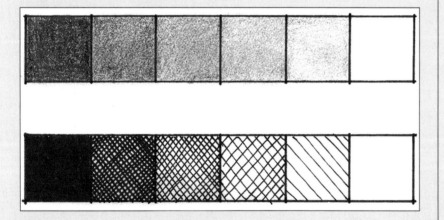

8.11 Shaded Objects

Media: Medium (HB or B) pencil on 8 1/2 x 11" (A4) copy paper.
Draw light outlines of the four geometric objects shown here. Indicate a light direction with an arrow and create shading on the surfaces. Use either the cross-hatching or the smooth shading techniques to obtain the tonal variations on each surface.

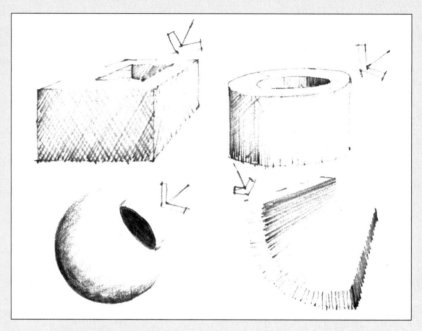

8.12 Pure tone drawing

Media: Soft (4B) graphite pencil on 8 1/2 x 11" (A4) copy paper.
Choose a simple solid or glass object and make a tone-only drawing with no outlines. Use tone change to suggest edges, form and light reflection.

8.13 Vanishing Eggs

Media: Soft (4B) graphite pencil on 8 1/2 x 11" (A4) copy paper.

Explore the various near–far relationships.

Draw a horizon line with a vanishing point near the right side of the paper. Add two vanishing lines to guide the bottom and top of each egg. Line up a series of eggs within the lines illustrating smaller size, closer spacing and overlap with distance.

Erase the hidden edges of each egg.

Now assume a light direction from upper left. Add graded shady side tone to each egg. Also explore the principle of lighter tone with distance.

On an overlay redraw the eggs as a row of trees using a textural doodle for shading. Explore the principle of abstraction with distance.

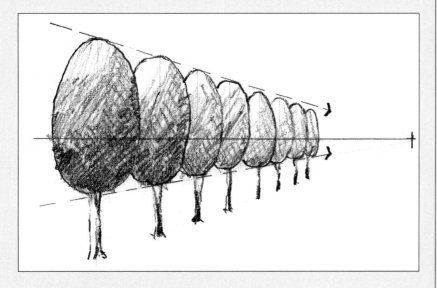

8.14 Cube with Shade and Shadow

Media: Pen on 8 1/2 x 11" (A4) copy paper.

On a 5 foot (1.5 m) eye line, two-point perspective chart, draw a 2 foot (30 cm) cube. Assume a light source of upper left and slightly towards you. Add a narrow shadow on the right and an even narrower one on the left of the cube. Use the information in the previous section to structure the shadow. Add tone of lines to each surface to indicate the different dark-light relationships of shade. Leave the top surface with little or no tone.

8.15 Rocks and Trees with Shade and Shadow.

Media: Medium (HB or B) pencil on 8 1/2 x 11" (A4) copy paper.

Draw a curving embankment in perspective.

A little to the left of the embankment draw two trees and a group of five rocks. Be sure to use overlap. Assume a light source from the upper left neither behind or in front of you. Draw shade and shadow exploring ground plane surface texture and the warping of the horizontal tree shadows as they fall across the uneven ground plane.

Appendices

Use of the Vertical Measuring Line on Perspective Charts

One-point Perspective

1. Draw base of object on ground plane.

2. Select an edge that vanishes to the VP and erect object vertical lines at each of the two corners.

3. Follow the base edge back to the horizontal ground line which intersects the zero.

4. Erect a vertical guideline at that intersection.

5. Select the desired height on the VML and draw a horizontal line across to intersect the vertical guideline.

6. Join this intersection with the vanishing point and extend (if necessary) to intersect the object verticals.

7. Draw a horizontal line from the front intersection to form the top of the object.

8. Erect the remaining verticals that are going to be visible.

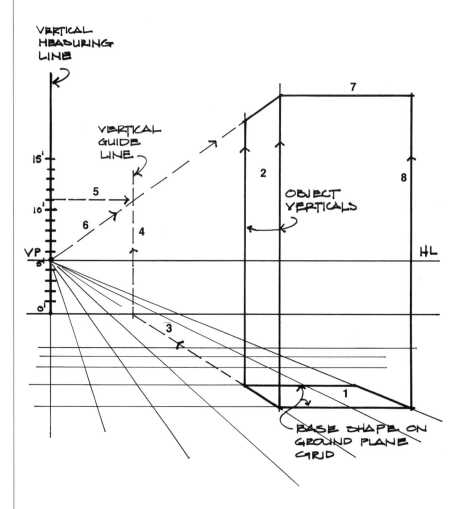

Two-point Perspective

1. Draw shape on ground plane.

2. Draw verticals from the two corners of one base edge.

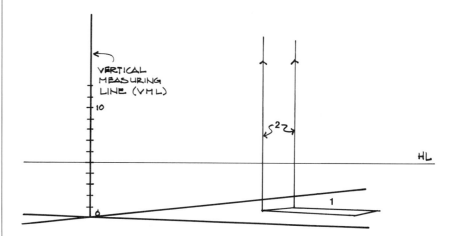

3. Extend this base edge back or forward to intersect one of the base lines through the zero of the VML.

4. Draw a key vertical from this intersection with the zero base line.

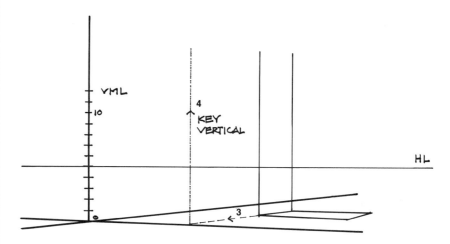

5. Determine which VP this zero base line goes to.

6. Connect this VP with the desired height, mark on VML, and extend (if necessary) to intersect the key vertical.

7. Connect this intersection with the opposite vanishing point and extend (if necessary) to intersect the verticals from the original base edge.

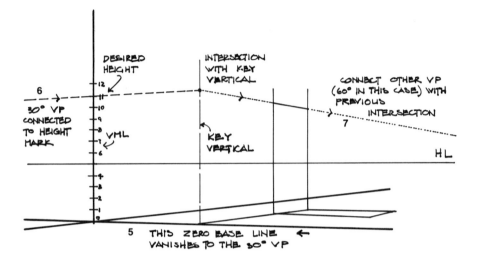

8. Construct the remaining verticals from the other corners.

9. Draw in the remaining top lines of the structure (a and b), making sure that the top and bottom lines of the same surface follow the same vanishing point.

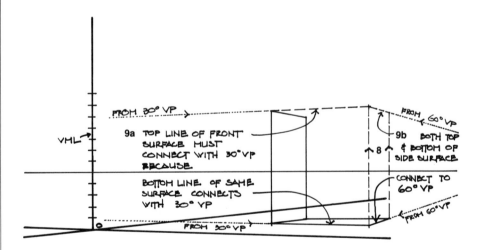

Conversions

inches	x	2.540	=	centimeters
centimeters	x	0.3937	=	inches
feet	x	0.3048	=	meters
meters	x	3.281	=	feet
yards	x	0.9144	=	meters
meters	x	1.094	=	yards
miles	x	1.609	=	kilometers
kilometers	x	0.6214	=	miles
sq. inches	x	6.452	=	sq. cm.
sq. cm.	x	0.155	=	sq. in.
sq. feet	x	0.093	=	sq. meters
sq. meters	x	10.76	=	sq. ft.
sq. yards	x	0.836	=	sq. meters
sq. meters	x	1.196	=	sq. yd.
acres	x	0.4046	=	hectares
hectares	x	2.471	=	acres
acres	x	4046	=	sq. meters
sq. meters	x	0.00247	=	acres
square miles	x	259	=	hectares
hectares	x	0.00386	=	sq. mi.
square miles	x	2.59	=	sq. km.
sq. km.	x	0.386	=	sq. mi.

Equivalents

Imperial Measurement Equivalents

1 foot	=	12 inches
1 yard	=	3 feet
1 mile	=	5,280 feet
1 acre	=	43,560 square feet
1 sq. yd.	=	9 square feet
1 sq. mile	=	640 acres
1 cu. yd.	=	27 cubic feet

Metric Measurement Equivalents

1 meter	=	100 centimeters
1 kilometer	=	1,000 meters
1 sq. km.	=	1,000,000 sq meters
1 sq. km.	=	100 hectares
1 hectare	=	10,000 sq meters
1 cu. meter	=	1,000,000 cu cm

Bibliography

- Ching, Francis D. K. *Drawing. A Creative Process*. New York: Van Nostrand Reinhold, 1989.
- Ching, Francis D. K. *Design Drawing*. New York: Van Nostrand Reinhold, 1997.
- Doyle, Michael E. *Color Drawing. A Marker/Color Pencil Approach*. New York: Van Nostrand Reinhold, 1981.
- Franks, Gene. *The Art of Pencil Drawing*. Walter Foster Publishing, 1991.
- Guptill, Arthur L. *Rendering in Pen and Ink*. New York: Watson Guptill Publications,1976.
- Hamilton, John. *The Complete Sketching Book*. London, Great Britain: Hillman Printers, 1999.
- Hamilton, John. *Sketching With Pencil for those who are just beginning*. London, Great Britain: Blandford, an imprint of Cassell and Co., 2000.
- Hanks, Kurt, and Larry Bellison. *Draw! A Visual Approach to Thinking, Learning and Communicating*. Los Altos, California: William Kaufmann, 1977.
- Johnson, Cathy. *Sketching in Nature*. San Francisco: Sierra Club Books, 1990.
- Laseau, Paul. *Graphic Thinking for Architects, Designers and Students*. New York: Van Nostrand Reinhold, 1980.
- Lin, Mike W. *Drawing and Design with Confidence. A Step-By-Step Guide*. New York: Van Nostrand Reinhold, 1992.
- Lin, Mike W. *Architectural Rendering Techniques. A Color Reference*. New York: Van Nostrand Reinhold, 1985.
- Nice, Claudia. *Sketching Your Favorite Subjects in Pen and Ink*. North Light Books, 1992
- Oliver, Robert S. *The Sketch*. New York: Van Nostrand Reinhold, 1979
- Petrie, Ferdinand. *Drawing Landscapes in Pencil*. New York: Watson Guptill,1992.
- Shen, Janet and Walker, Theodor W. *Sketching and Rendering for Design Presentations*. New York: Van Nostrand Reinhold, 1992.
- Turner, James R. *Drawing with Confidence*. New York: Van Nostrand Reinhold, 1984.
- Wang, Thomas, C. *Pencil Sketching*. New York: Van Nostrand Reinhold, 1977.
- Wang, Thomas, C. *Projection Drawing*. New York: Van Nostrand Reinhold, 1984.
- Wester, Lari M. *Design Communication for Landscape Architects*. New York: Van Nostrand Reinhold, 1990.

Index